WEDDING PHOTOGRAPHY FROM THE HEART

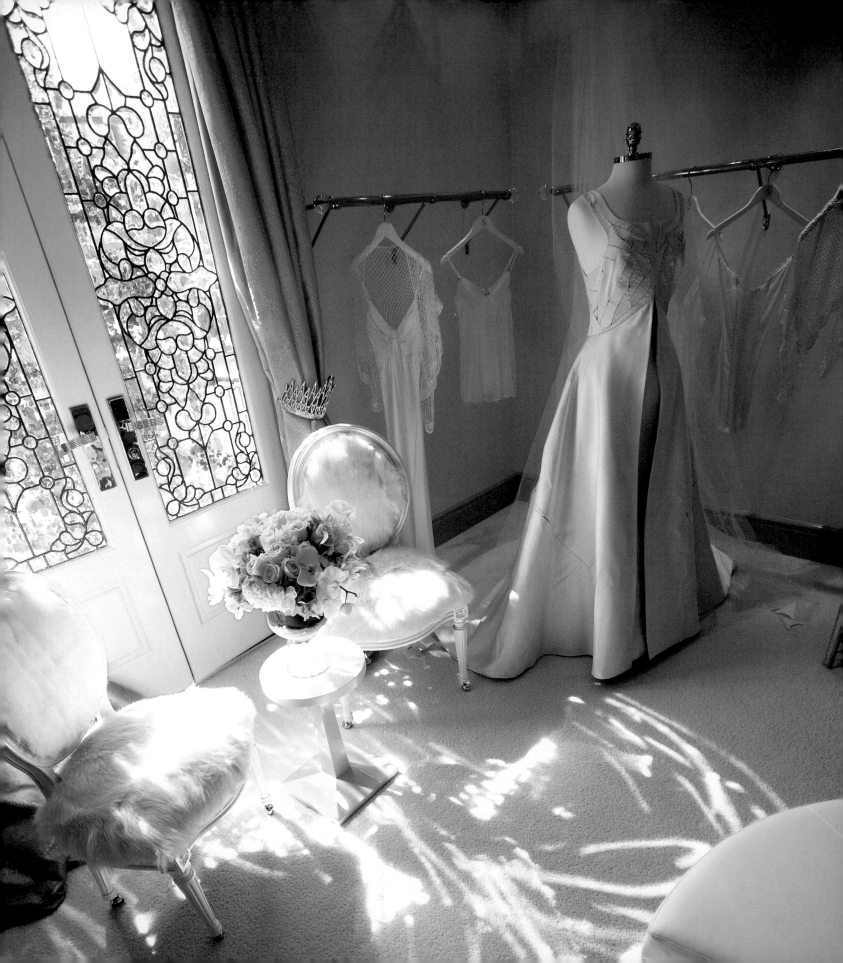

WEDDING PHOTOGRAPHY FROM THE HEART

Creative Techniques to Capture the Moments that Matter

BY JOE BUISSINK AND SKIP COHEN

PHOTOGRAPHS BY JOE BUISSINK
FOREWORD BY DENIS REGGIE

AMPHOTO BOOKS

AN IMPRINT OF THE CROWN PUBLISHING GROUP / NEW YORK

First published in 2009 by Amphoto Books, an imprint of the Crown Publishing Group,

a division of Random House Inc., New York

www.crownpublishing.com

www.amphotobooks.com

Library of Congress Cataloging-in-Publication Data

Buissink, Joe.
 Wedding photography from the heart : creative techniques to capture the moments that
matter / by Joe Buissink and Skip Cohen ; photographs by Joe Buissink ; foreword by
Dennis Reggie.
 p. cm.
 Includes index.
 ISBN 978-0-8174-2454-1 (pbk. : alk. paper)
 1. Wedding photography. I. Cohen, Skip. II. Title.
 TR819.B85 2009
 778.9'93925—dc22

 2009019208

Printed in Malaysia

First printing, 2009

1 2 3 4 5 6 7 8 9 / 15 14 13 12 11 10 09

CONTENTS

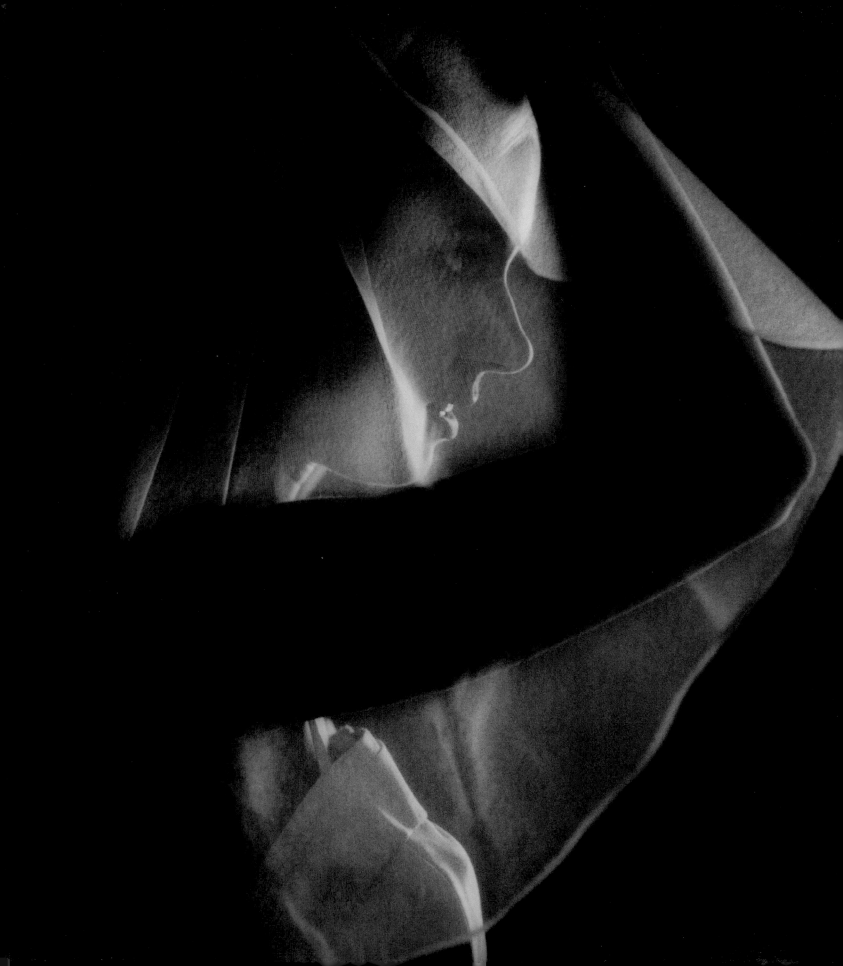

Dedicated to our children

Justin, Benjamin, Sarah, and Sebastien Buissink, and Jaime and Dane Pickles and Adam and Lisa Cohen

Acknowledgments

No book project like this is ever the result of the authors' efforts alone. Without the support of our families, friends, and the subjects of this book, its contents—as well as our careers—would be sorely lacking. We would especially like to thank Denis Reggie for his friendship, support, and inspiration; Bambi Cantrell for her never-ending enthusiasm; and Marilyn Buissink for her patience and unending love. Last, but certainly not least, we are grateful to all the wonderful brides, grooms, and their families and friends who allowed us the privilege of documenting a brief but intimate chapter in their lives.

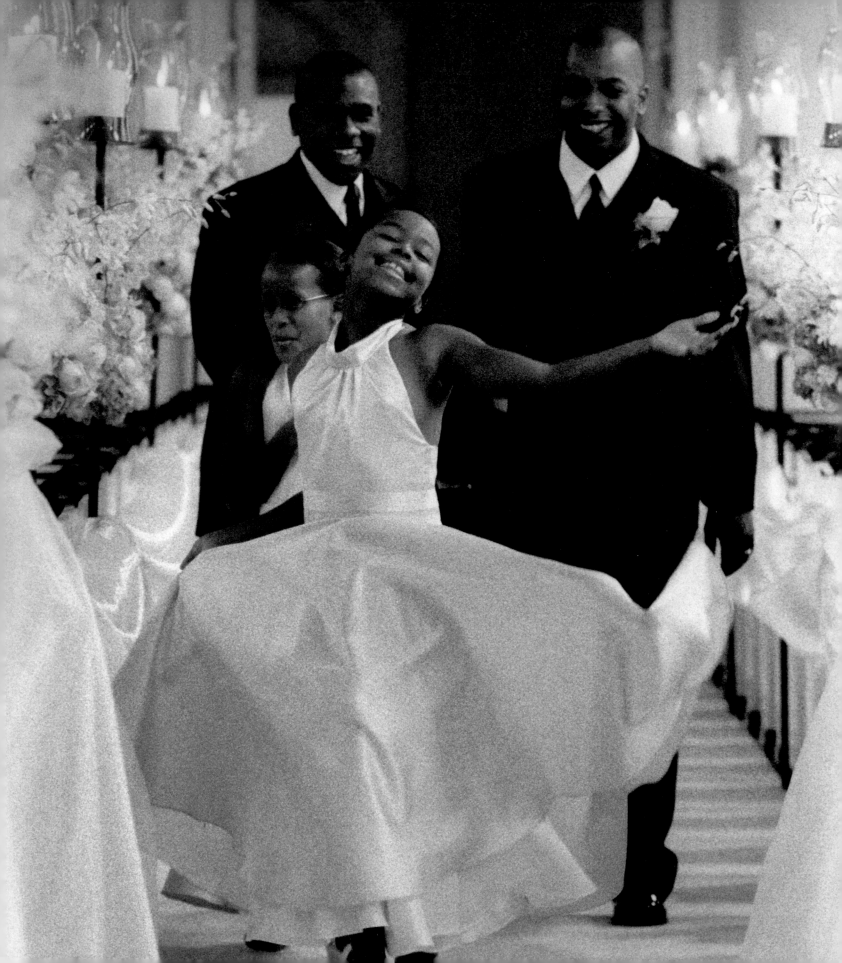

FOREWORD

When I look at photographs, I often try to imagine the mindset and personality of the man or woman behind the camera. I initially assess portrait and wedding photographs for their candor and their ability to communicate in two dimensions the inner feelings of the subject. Although technical precision may be a key element in a good photograph, I am moved more often by those rare images that convey an unmistakable reality and depict more about the subject and the moment than about the photographer and his technique. In the end, it seems that, more often than not, interesting and warm photographs are taken by interesting and warm photographers. Such is the case with Joe Buissink, rightfully regarded as one of the world's greatest and most sensitive wedding photographers.

What mind's eye could capture more tenderly the unmistakable feelings of love and true happiness that are revealed at a wedding than the images of Joe Buissink? Years before we met, I knew and loved his work and had wondered about—imagined, actually—the mindset and heart of such a photographer who could seemingly effortlessly convey the essence of a subject and a moment so powerfully.

Only later, and to my amazement, did I learn that he had survived a difficult, loveless childhood in an abusive household. Joe was born a Dutch citizen in Indonesia during the time of that nation's transition to independence, to parents who had been imprisoned in concentration camps during World War II. When he was seven years old, Dutch residents were sent packing, and his family headed to the Netherlands for what proved to be four more difficult years. With his mixed pedigree and slightly darker skin, Joe was considered a foreigner and a ready target for schoolyard ridicule. Searching for the tolerance that had eluded them, his parents packed once again and headed to America. Joe mastered English and came of age in California during the 1960s, the height of the Vietnam era.

Together with twelve of his friends, Joe enlisted through the military's "Buddy Program" and was assigned to the Army's 82nd Airborne Division to serve his adopted country. After his discharge, his long quest for inner peace continued. Beginning as a line worker at an LP pressing plant for a California record company, Joe worked his way up to head of operations, but still longed for more in his life. In 1987, he headed to Cal State Northridge and earned his degree in general psychology. While doing research at UCLA and continuing studies at Northridge in the early 1990s, he pursued both master's and PhD degrees in neuropsychology. It was during that time that he took a part-time position as a printer in a photo lab and became proficient in black-and-white and color printing techniques. He then began considering photography as the optimal means of exploring and expressing the inner life of his subjects, and himself.

The defining moment that spawned Joe's career came in 1995, when he photographed his son Ben in a loving moment with his mother. That powerful black-and-white image inspired Joe to become a professional photographer; it had unleashed his own sensitive perceptions and provided a means to uncover the love that had eluded him for so long. In 2007, Joe became an American citizen and, in 2008, voted for the first time in the presidential election. As a father of two children with autism spectrum disorder, he saw fit to illustrate the best-selling book *Autism Heroes*, featuring original poignant black-and-white photographs taken over a two-year period.

As a viewer of fine photography—and a photographer who has worked professionally for over thirty years—I know well the rarity of such a talent. As a longtime member of the human race, I also know the exceptional wonder of a person of such genuine warmth and kindness. Joe seeks and finds goodness in most everyone he encounters and has the uncanny ability to connect with them in heartfelt empathy. I am always struck by his reply to, "How's it going, Joe?" With a smile exuding his high-spirited optimism, he often replies, "It's all good." As his photographs attest, Joe respects and connects with the goodness in everyone from every walk of life and circumstance.

It turns out that the love Joe sought for half a lifetime was within him all along. Once he became empowered by this inner peace and love (giving due credit to his wife, Marilyn), he turned his camera outward and began capturing the very essence of his fortunate subjects.

These images are a lasting testament to the inner journey and discoveries he has made and reveal the many tender moments witnessed through his lens thereafter.

—DENIS REGGIE, November 2008

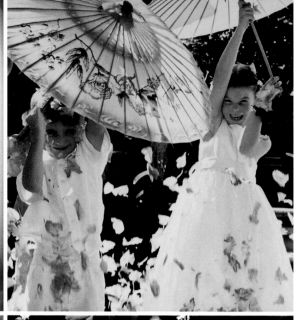
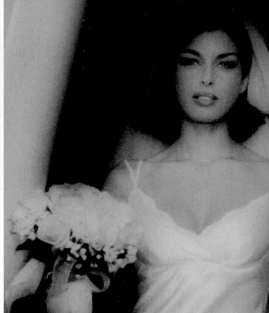
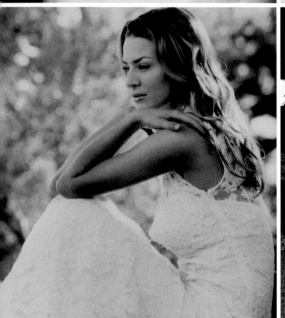
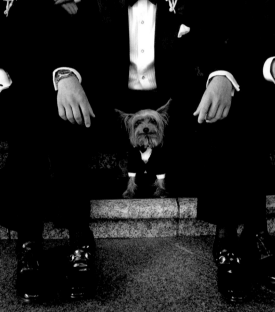
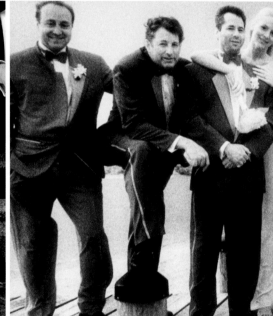
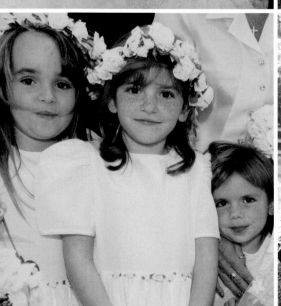
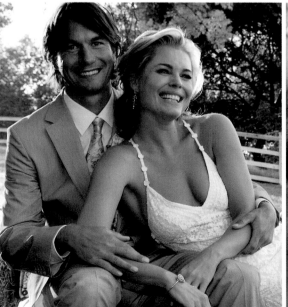
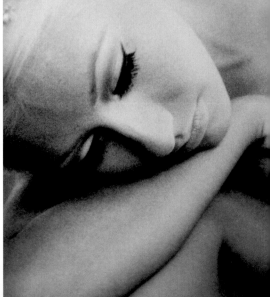

INTRODUCTION

While sitting on a plane, headed to yet another destination, Joe and I started talking about doing a project together. We've spent a lot time collaborating at Wedding and Portrait Photographers International (WPPI), share many of the same friends, and have always had a close relationship. Well, one thing led to another, and by the time we got off the flight, a book project was in the making.

Unlike many photography books, this one isn't about the "how to" technical aspects of photographing a wedding. No book can cover every aspect of this subject, and furthermore, a book by Joe Buissink on technical specifications and direction would really be a waste of talent, because Joe is all about inspiration and the creative process, not about how to use your gear. However, before we share some of Joe's best images and his philosophy on being a photographer, we've made some serious assumptions about you, our readers, as photographers in today's digital era.

First, we are assuming you know how to use your camera and that you understand all its bells and whistles, which interact when you make that authoritative click of the shutter button. If you don't, then put this book down for a little while and spend time reviewing the manual that came with your camera.

Second, we are assuming you understand the art and technique of photography. With so many pseudo-pros out there today, taking every available shortcut and spending days at their computers cleaning up images, this may well be our most important assumption. Every image in this book looked good right out of the can, without alteration, whether photographed on film or digitally. The magic of a master printer like Robert Cavalli or the creative toolkit of Photoshop were used only to enhance the images, not to invent them. That is because Joe made it a point to understand exposure, lighting, and composition *before* he was hired by his first client. This is not to say that he didn't make mistakes or

that his style hasn't changed in fourteen years as a professional photographer. It means he understood how to get the shot right before Photoshop came along. And it means that when he was hired to photograph and document the start of a new family with his first wedding assignment, he refused to compromise on the quality of his images. He knows not to waste potential time and talent spending hours on end behind the computer using image-editing software to clean up easily avoided mistakes!

Professional photography is all about building relationships and trust with your clients. Your most valuable resource isn't your gear—it's you! You've got to be out there in the market, attracting business and getting to know your potential clients. If you're wasting time at your computer readjusting exposures and compositions after the shoot, then you're putting too much time into the click of your mouse instead of the click of the shutter.

Third, we're assuming you understand all your equipment—especially your lenses. This is a critical component when developing your creative skills. You won't be able to relax and find your own pace if you're worried about depth of field and focal lengths. It takes years of practice to get to the point where selecting the right aperture and shutter speed becomes completely instinctual.

Fourth, we're assuming you understand a little about film. That's a tall order today, but in fact, all the techniques in Photoshop are based on techniques that were first tried in the darkroom. If you understand film, then you understand exposure. We believe that, in order to elevate the quality of images throughout the professional photographic industry, every photographer would be required to spend six months learning to shoot with traditional film, working in the darkroom

and printing their own work before even being allowed to touch a digital camera.

That said, we don't want to put you on the defensive! This is simply a key point on our wish list. Digital technology has given all of us a gift in the form of the ability to access more creative tools than at any other time in the history of photography. Sadly, however, it has brought too many people into the market who are taking shortcuts and often producing an inferior product. If you're worried about competing with Uncle Harry at every wedding you photograph, then you haven't worked hard enough to develop all your skills; you're simply not operating at full potential.

In the chapters ahead, you will hear us refer many times to employing your "mind's eye." It is a critical part of the creative process and an invaluable skill that Joe has developed over the years. The technique has helped him capture some of the most beautiful fine-art wedding images in professional photography, along with some of the most poignant moments.

Welcome to the world of Joe Buissink: a world that is simply at peace with the creative process.

—SKIP COHEN

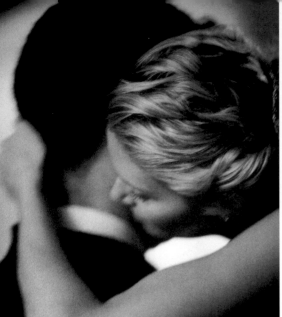
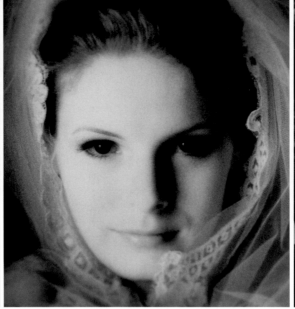

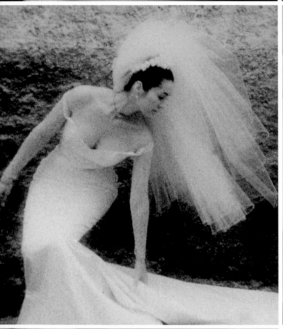

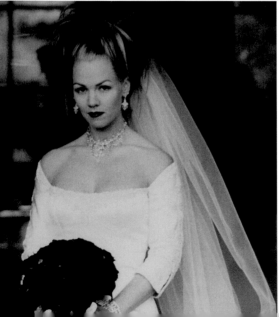

CHAPTER 1 *Seeing with Your Heart:* Using Your Second Pair of Eyes

I t is hard to describe why wedding photographs look so different from one another. Many of us shoot with similar gear and have a long-standing love affair with film (though lately, technology has allowed us to explore the incredible images we can capture digitally). Many of us love shooting in natural light, use long telephoto lenses, shoot with a narrow depth of field, and favor black and white, which often has more impact than color. This description alone could apply to thousands of professional wedding photographers. So what is it that makes some images stand out? In our experience, the difference lies in the ability to work with two sets of eyes. Not only your physical eyes, but the pair responsible for creating some of the most powerful images— those in your heart.

As sentimental as that sounds, think of this idea as you look at the images on the following pages and you'll understand. There are very few that were simply produced through random luck. You know the ones—sweet light, being in the right place at the right time. Most of the images that make us go "wow" were taken from the heart. They may have been spontaneous, but took a different sort of approach to isolate the moment and capture it with a camera.

Seeing with your heart enables you to portray a unique perspective of the world on the day of the wedding—understanding your clients and what's important to *them*. It's about honoring the trust they've placed in your ability to be their eyes for the day. Above all, it's about keeping your mind completely focused on the event, the couple, and their families and friends. In fact, the first step in *learning to see* is simply gaining a deeper understanding of what it means to be a professional photographer.

To me, the responsibility of photographing a wedding is that, twenty years from now, when the couple looks at the album, they should remember what they were feeling at the time. I want them to really remember what they were actually thinking. In the image on page 21, for example, there were 250 people surrounding the couple on the dance floor, but to the two of them, no one else mattered. This was *their* moment. Remember—you're learning to see the world through *their* eyes and to look into *their* hearts for a split second.

"My job as a wedding photographer is to crystallize moments in time, so they live on forever, from generation to generation."

Even without seeing the bride and groom's faces, one can still feel the passion in this moment. We can't see the flower girls' facial expressions either, but we can hear them thinking, "Someday, I'll be a bride like her!"

Canon 1V, 70-200mm F2.8 lens, f/8.5 at 1/200 sec.

Seeing with your heart doesn't mean that every image has to be about intense romance; rather, it's about capturing the immediacy of the day. Look for moments that are unplanned, when your subjects allow themselves to relax, step away from being the center of attention, and simply be themselves. The photographer's goal is to document everything that happens on the day of the wedding, saving these ephemeral moments for posterity. There's no need to pose your subjects when you're relaxed behind the lens. Simply document everything you observe, letting your instincts set the pace instead of a list of typical poses and situations.

Every image need not be perfect in order to be beautiful or have impact. Train yourself to snatch stolen moments in the bride and groom's day. Don't let yourself become overly focused on the technical aspects of creating your images. If you become obsessed with technology, you will lose the ability to simply relax and shoot. A good comparison is a runner in a long-distance race. The winner comes across the finish line relaxed, jogging another few hundred yards to stay loose. The runners farther back come across the finish line tense, under stress to win,

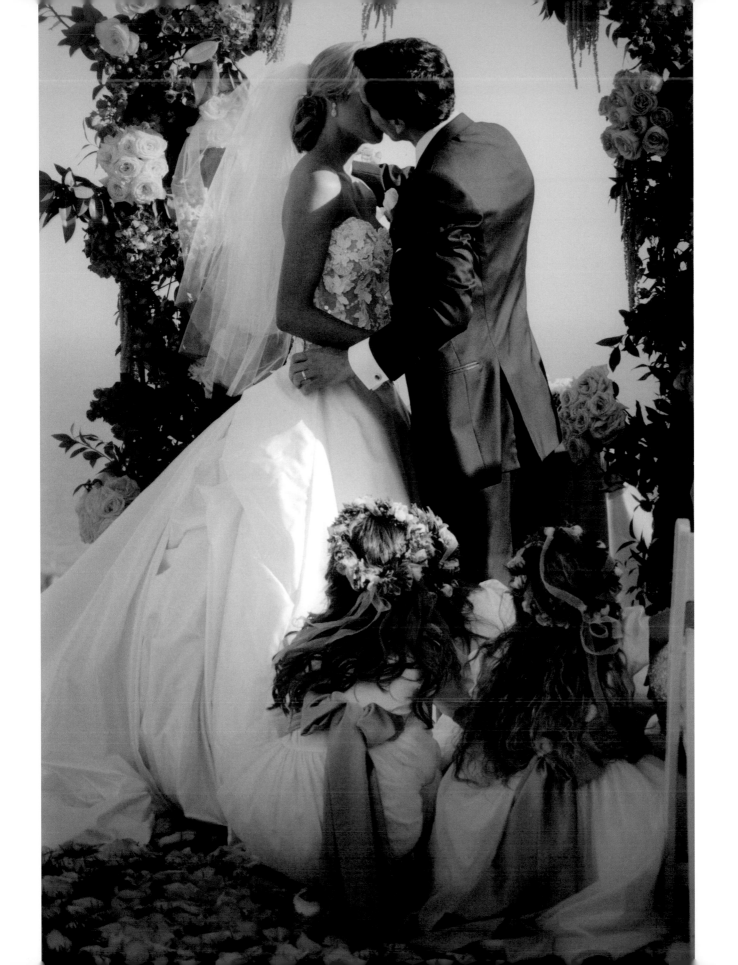

struggling to finish, and often stopping at the exact end of the race. As a photographer, if you stay relaxed and enjoy the "race," you'll realize it's not a race at all. You're there to enjoy the moment as much as your clients, and by doing so you will be using two sets of eyes: the ones in your head, to identify the moment, and the ones in your heart, to capture it. It's not a time to put pressure on yourself. If you have to strain to do your job, you're going to miss the very best moments.

Train yourself to see images by simply walking around and observing. Even in a supermarket, if you see an image, slap your leg or snap a finger to reinforce the moment, as though you were releasing the shutter. When it comes time to actually photograph an event, instead of snapping a finger or slapping your leg, you will have a camera in your hand.

Another terrific exercise for learning to see is to look back at any photo album or images you've previously created. Make yourself a 2 x 3-inch cropping square. Now run it over any 8 x 10-inch print and ask yourself these questions:

- Are there any images in the crowd you might have missed?
- What about cropping an image differently? Could a print have had more impact by tightening it up, focusing in on the bride's or groom's eyes, or capturing a smile from someone in the crowd?
- Are there images you missed because you were too intent on what you were seeing rather than on what you were *feeling*?
- Could you have done a better job if you knew your clients better and understood more about them or their relationship?

This image captures the essence of a couple who only have eyes for each other—even in the middle of a crowded dance floor— because at this moment in time, that was exactly how they felt. Taking advantage of available lighting and using a narrow depth of field isolated the bride and groom from their surroundings.

Nikon F6, 80-200mm F2.8 lens, *f*/2.8 at 1/15 sec.

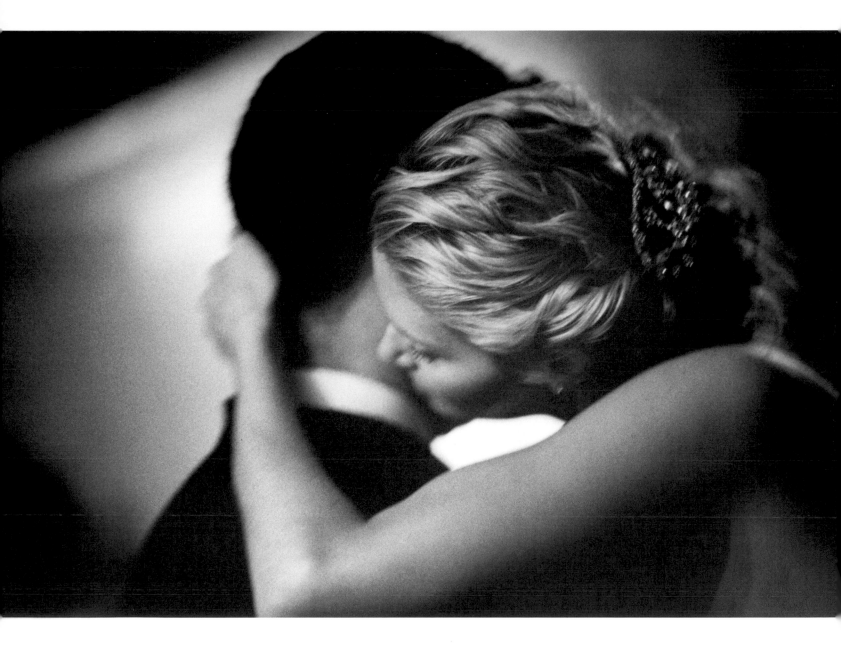

"Train your brain to see the moments."

Want more? Simply write down a dozen words for feelings and emotions, such as *pensive*, *thoughtful*, *worried*, *happy*, *sad,* and *passionate*. Now take your camera out for the day and find images to illustrate these words. It might sound like a standard photo assignment for any first-year student, but it's not as easy as it sounds, and it will help train you to be alert to such moments.

And here's a final tip: The next time you photograph a subject, pretend you have only twelve frames to tell the story. The joy of digital photography is wonderful, as we've all learned to capture endless frames (often coming close to being a videographer), but what if your work method were based on the opposite assumption—limited frames—which forced you to be more discriminating?

Anyone can learn to use equipment to capture an image, just as anyone can learn to cook. But you don't want to cook the same dishes that everyone else does. Learn to take photographs the way truly fine chefs develop their signature dishes. Train your eyes to see with your heart, listen to your subjects, and then create images that are unique. Artistic talent may be innate, but creativity can be learned! It's one thing to create an exquisite image, but if you have no insight into the mindset of your clients, none of it matters. Learn to see the world through their eyes and, at the same time, fine-tune your own.

This groom had finished getting ready and, just before starting the formal portrait session, asked if he could take a quick cigarette break. No formal portrait could have topped this!

Nikon F6, 80-200mm F2.8 lens, *f*/8.0 at 1/125 sec.

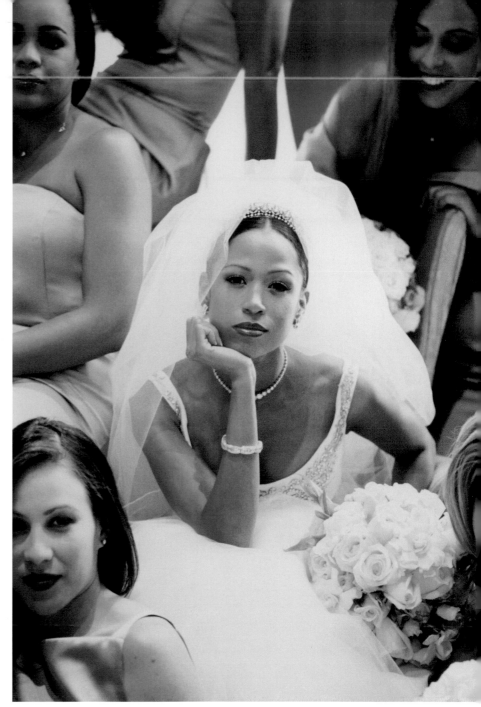

Here's a wonderful trick: If people are posed too rigidly, simply stop and say that you need a minute to change your film or put in a new memory card. They'll relax, thinking they're waiting for you, and meanwhile you'll be clicking away without their knowledge, as happened here, at actress Stacey Dash's wedding. You're sure to wow them with your shots if you're interpreting the moment instead of directing it.

Nikon F6, 80-200mm F2.8 lens, *f*/5.6 at 1/80 sec.

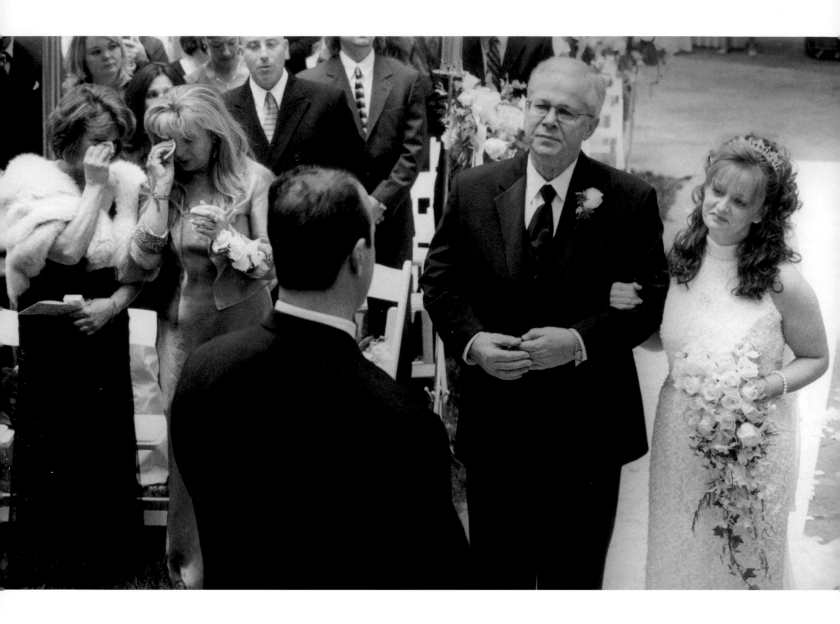

You can just imagine what the groom's face looks like simply by
looking at the bride's expression and at the two women crying
in the background. There's a certain mystery in the image, and
yet when you absorb the scene as a whole, it tells a story.

Canon 1V, 24–70mm F2.8 lens, *f*/7.1 at 1/100 sec.

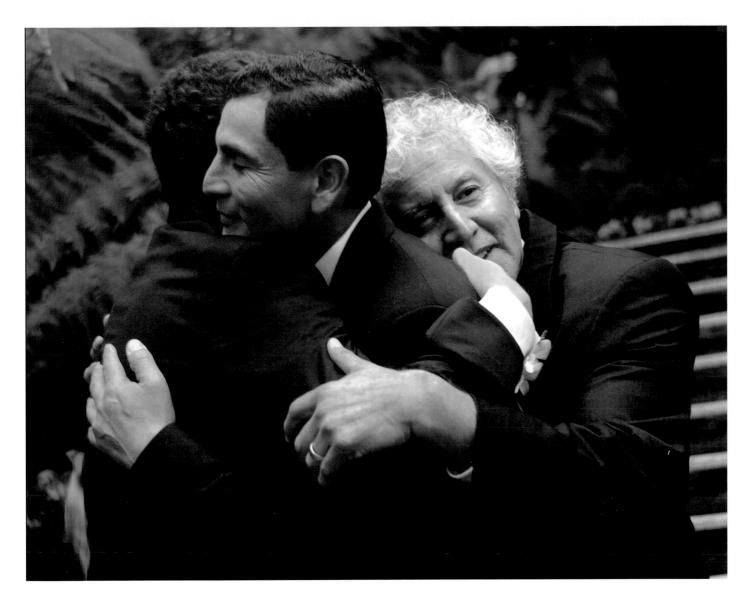

*"Be passionate about the gift
you've been given: photographing
the start of a new family."*

You could never choreograph an image like this, with a father and his two sons embracing, the groom in the middle. If you're looking the wrong way, you will miss moments like this. Images that grab hearts and take your subjects back to everything they were feeling on that day can be captured only when your "radar" is working. Also, never underestimate the importance of having at least two cameras set up with different lenses. Without a longer lens on hand, this image would have been lost.

Canon 5D, 24–70mm lens, f/6.3 at 1/125 sec.

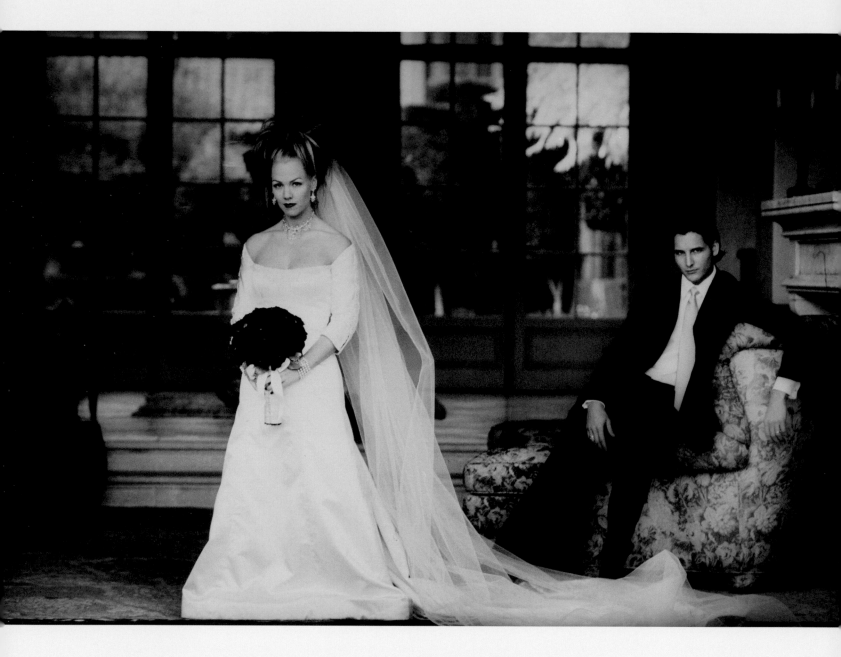

When asked to do a more traditional portrait, stay attuned to any opportunities
to capture more than what's been asked. Any photographer can shoot a portrait
session of the bride, but a photographer who sees more than just his subject can
create an image that conveys passion. Here, the groom asked whether it was
okay to sit on the sidelines while the bride, actress Jennie Garth, was being
photographed. He never knew he was part of the portrait. This became one
of their favorite images: posed and yet not staged at all.

Nikon F6, 28–70mm F2.8 lens, f/5.6 at 1/80 sec.

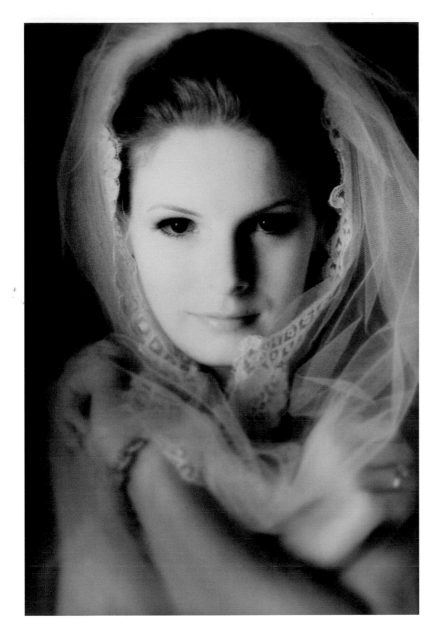

This image isn't just about the lighting, but about the subject, location, and texture—all the resources at your disposal that establish, create, and capture a mood. The darkness of the bride's eyes and the absence of catchlight add to the atmosphere and the sense of passion. Photographing with infrared film increases contrast and adds impact; it changes the relationship between light and dark "colors" in black and white, which is one of the things we love most about infrared film. The shift in tones was done in the darkroom, using a technique done by many expert printers that allows the printer to highlight an area of the image simply by changing the exposure during the process. Did this bride know she was being photographed? Of course. But if you're comfortably in tune with the feelings of the bride and groom, your images will reflect your passion as well as theirs. It's another example of using the eyes of your heart.

Canon A2E, 85mm F1.2 lens, *f*/3.2 at 1/80 sec., infrared film with yellow filter

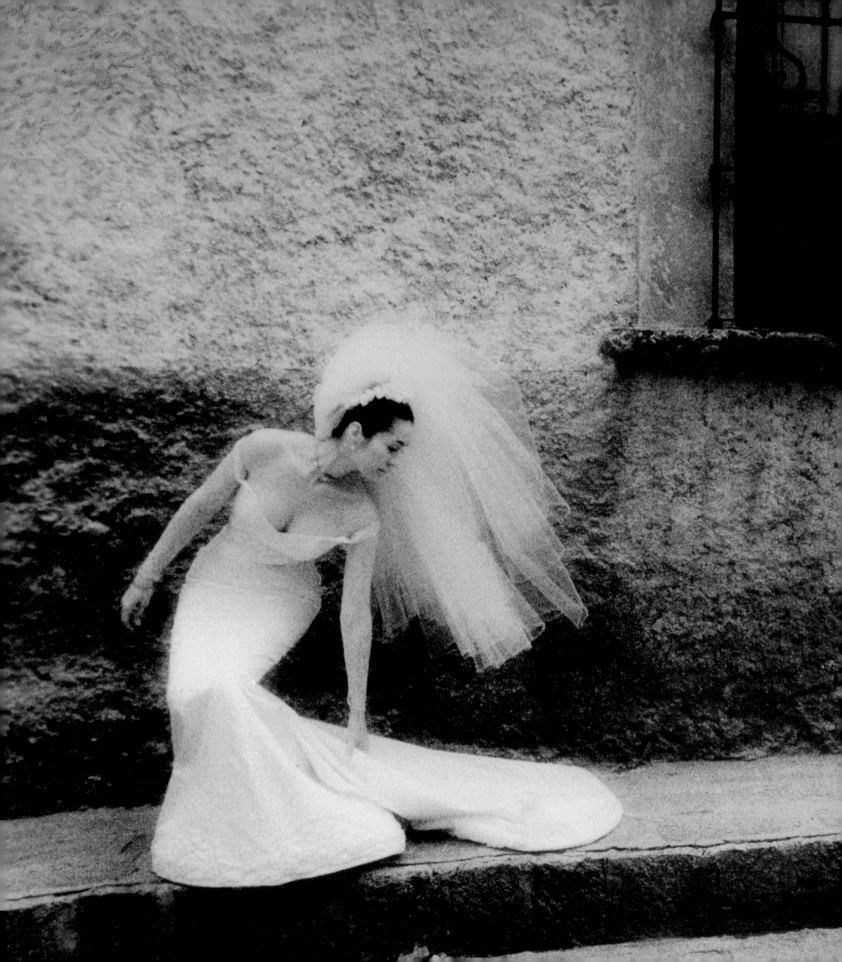

Train yourself simply to pause and capture a moment out of time—such as this bride adjusting her train—and turn it into a beautiful portrait.

Nikon N90S, 17–35mm F2.8 lens, *f*/5.6 at 1/90 sec., infrared film with yellow filter

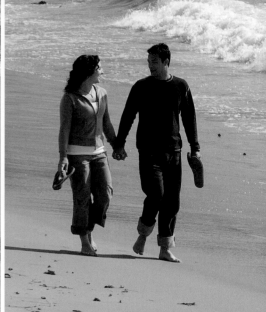

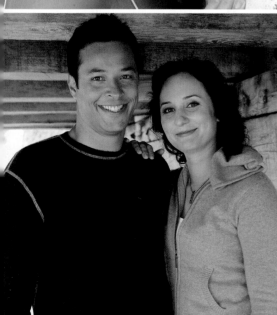
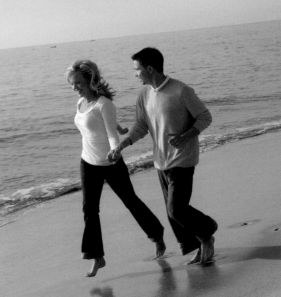
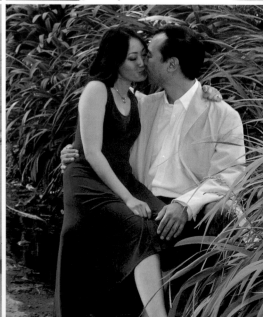

CHAPTER 2 *Relationship Building:* The Engagement Session

There are two key components to building a relationship with your client. One is how you position yourself—your staff, your location, your hours of business, the look of your studio or office, and so on—all the basics. The other centers on developing a relationship of trust, integrity, and confidentiality.

Some people might argue that a pure photojournalist doesn't need to know his or her clients personally. We disagree. You have to know the client to convey the emotion in the images you want to capture. And you can get your clients to open up only if they trust you. Trust needs to be the foundation of your work with every client. After all, the product you're selling isn't the finished photo album—it's you, the photographer! Trust starts building with the very first client "meet and greet" session. You have to work to help your clients understand that on the most important day of their lives, you are going to be their eyes, to capture not only what they see, but also everything that they might overlook.

The best way to start developing a level of trust and understanding is an engagement photo session. For you, the engagement session, depending on how you look at it, is the most important event that precedes the wedding. It's where your clients get to know you and, more importantly, it's where you get to know your clients.

Unless the client is a celebrity, the first meeting should always be in your studio. This enables them to see you as a professional in your own environment, which aids trust and gives you more control. If an engagement session is being considered, direct the conversation with questions like, "Would you like a romantic setting?" "Would you like to go where he proposed?" "Would you like to be photographed where you first met?" "Would you like to be photographed in your home?" Ideally, look for engagement

locations that trigger wonderful memories. This session is all about storytelling, and the goal is to re-create the atmosphere of the day that the relationship went into high gear.

In terms of timing, early morning is always sweet photographically, but late in the day is just as nice. It's not always about emphasizing the light, though. For example, the middle of the day works fine if you're inside a café or restaurant.

"You have to understand how your clients see the world before you can capture how the world sees them. I spend a lot of time in our first meetings learning what makes them unique. As I understand them better, I'm able to envision the mood I need to capture."

Once the engagement session is under way, how do you get the bride and groom to simply relax and trust you? Often merely being yourself and loving what you do is enough to melt the toughest heart. Humility, humor, empathy, sensitivity—all these are tools you can use. It's also important to be playful with your clients. Let the couple enjoy the moment; you're there just to observe and document their interaction, and the less interference on your part, the more appealing the images.

One strategy is to turn the engagement session into a trip down memory lane. Ask pointed questions like, "Where did you meet?" "Where did he propose?" "How did he propose?" "How did you feel when you guys first met?" You'll never need to say, "Show me all the love in your eyes as you look at your husband-to-be." Why? Because, most likely, she will already have that look in her eyes when she answers the very first question. The goal of these questions is to get the clients thinking

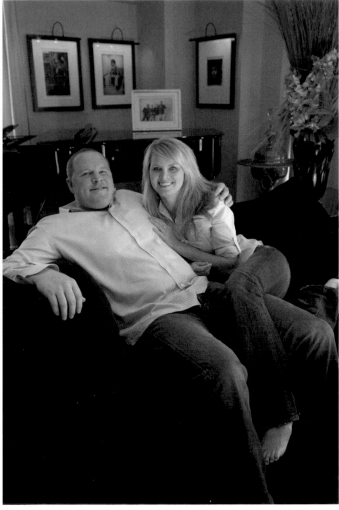

Many couples live together before getting married, and photographing them at home may bring out their personalities even more. This is their environment, and seeing them interact in their domestic setting will help you better understand your clients.

Nikon D2X, 28–70mm F2.8 lens, *f*/5.6 at 1/125 sec.

Always include the family pet, which represents not just another member of the family but often a great source of personality. Pets also may bring out other, more tender and playful sides of your subjects.

Nikon D2X, 28–70mm F2.8 lens, *f*/5.6 at 1/125 sec.

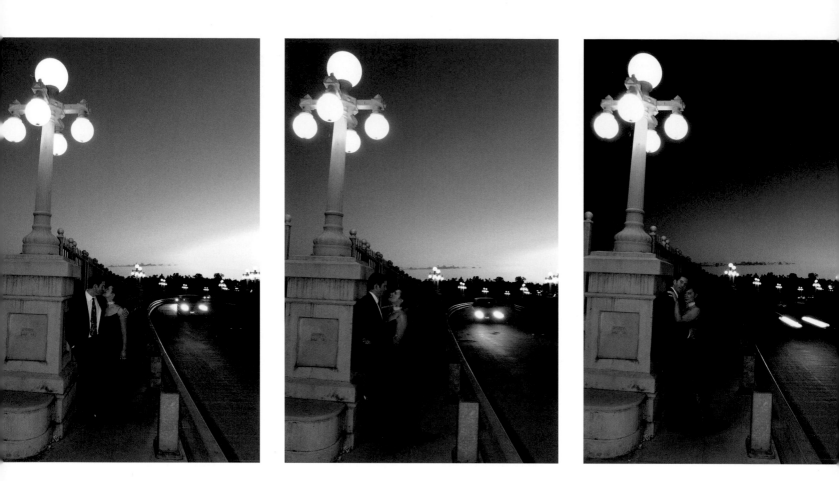

Shooting portraits at dusk can create an incredibly romantic, dramatic mood. The contrast in lighting adds to the mystique of the image. Photographers refer to late daylight and early morning light as "sweet light" because morning light tends to be soft and cool, while evening light is naturally warm. That look and feel continues right into dusk.

Nikon D2X, 17–35mm F2.8 lens, *f*/2.8 at 1/4 sec. Nikon Sb80 fill flash used, set at –2 stops from ambient.

about how they feel about each other. As the session progresses, the emotions will surely start to flow. A natural glow emerges that could never be prompted by you. But, with the right questions, once the couple starts talking, what follows will be heartfelt and ready for you to capture.

"Bring memories to the surface. If you can do that, you'll get nothing but emotion. Ask, 'What did he say to you that first time?' and within seconds, the bride might start crying."

If you understand the basics of exposure and composition, your camera can be used as another incredible tool for jump-starting enthusiasm and emotion. With digital photography, you can show your clients images right out of the can, so do so intermittently throughout the session. The images will speak for themselves, and if you convey your excitement over each of them, your enthusiasm will be infectious.

The key is to work quickly, preferably in available light and using multiple cameras simultaneously. I recommend having one camera fitted with a 70–200mm lens, another with a 24–70mm lens, and the third with a 16–35mm lens. Each camera should be totally set up and ready to go. The first shot is typically tight, often taken with the 70–200mm lens. After the first few images, it's time to drop the camera and go to a wider position. And after six to seven frames, it's time to move on to another location. Pay close attention throughout the session and observe how your subjects position themselves. This preparation will help make the images on the day of the wedding that much better, since you have already been privy to the little nuances that make each engaged couple unique. Remember, in the end, all that matters is how the clients respond to their images.

Engagement sessions also offer the opportunity to photograph each member of the couple separately. Often these images become cherished gifts that the couple will give each other, and possibly their parents, at a later date.

BOTH IMAGES: Nikon D2X, 28–70mm F2.8 lens, f/5.6 at 1/125 sec.

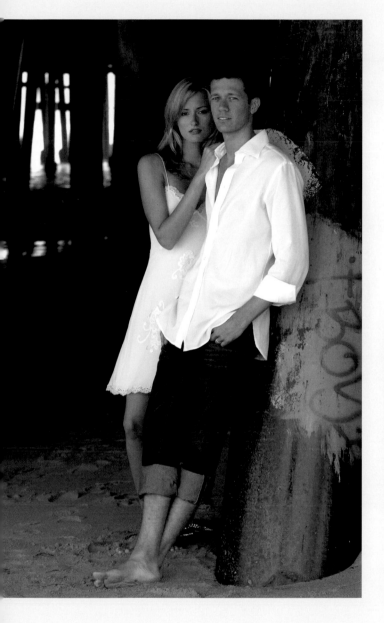

Horizontal or vertical format? Both have impact; both are beautiful engagement images. Show each interpretation to your clients so you can start learning their style and preferences.

BOTH IMAGES: Nikon D2X, 28–80mm lens, *f*/5.6 at 1/100 sec.

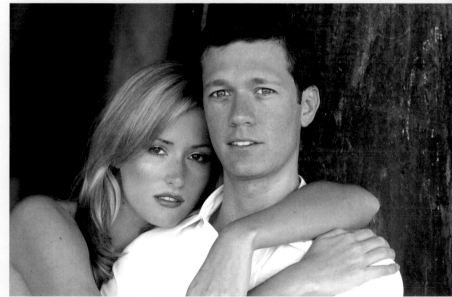

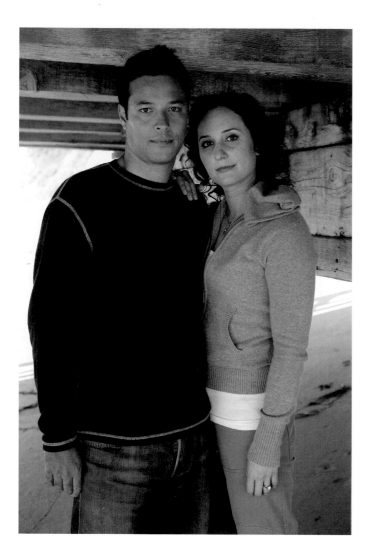

This first photo was taken before the couple was ready, while the second was taken when they knew the image was being shot. Both photos are effective, but there's a huge difference in intensity between the two. Those unprepared moments are the key to making a strong impact.

BOTH IMAGES: Canon 5D, 24–70mm F2.8 lens, *f*/4.0 at 1/80 sec.

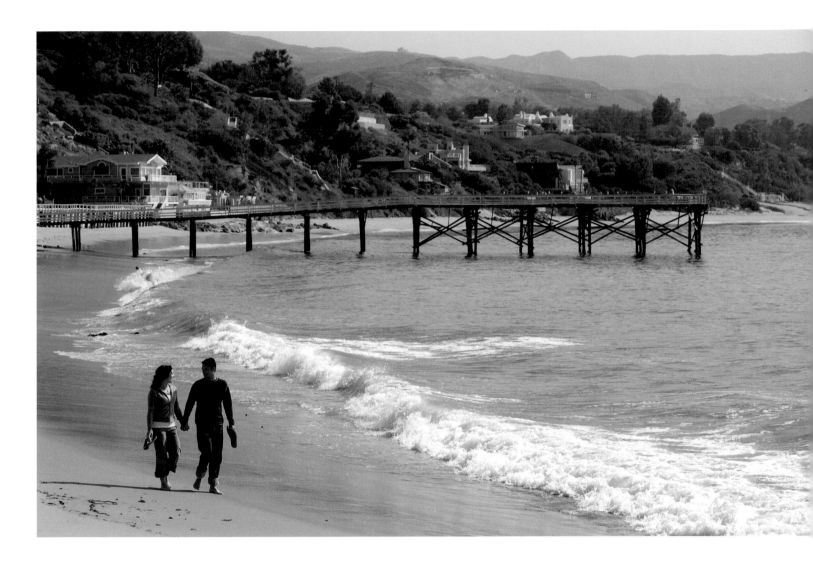

You don't need to direct any action. Just let the couple be themselves and enjoy the afternoon.

Canon 5D. 24–70mm F2.8 lens, f/8 at 1/200 sec.

The photographs from the engagement session are usually used to announce the engagement, publicize the wedding date, and/or to accessorize the wedding itself on seating cards and other elements. They are rarely used in the final album. But remember, the main purpose of the session is not to produce images but to establish trust. This is all about promoting your skills and getting to know your clients. They will see how competent you are and get familiar with your style at the same time. They're learning to trust you and understand what to expect on their wedding day.

When the wedding day finally does come around, the couple will typically be relieved to see you. You'll be received as a member of the family, an old friend. All barriers that normally confront photographers meeting clients for the first time will be gone. I recently shot the wedding of a bride I had also photographed seven years earlier. This was her second wedding, and when the bride saw me, she was so happy that she gave me a big hug. She and her father reminded me that I needed to be there for the next wedding in the family—that of the bride's sister.

Each assignment carries a great deal of responsibility; there are no second chances. This relationship with the client is so important that, ideally, you'll turn down jobs if you don't click. You may not have the freedom to do this when you're just starting out, but it's a worthy goal: to get your business to a point where you can pick and choose your ideal clients.

The key to success is to be yourself and to be relaxed. If you're comfortable and confident, that attitude will rub off on the couple. Come the wedding day, you'll have an incredible advantage, knowing your clients and having them know you.

With just a click of the shutter, you can become a time traveler, bringing back all the emotions the couple felt when the proposal took place. With a few pointed questions and your camera, you can take the couple back to that moment, or to a moment months or years earlier, when they first met, first spoke, or first caught sight of each other.

Canon 5D, 24–70mm F2.8 lens, *f*/4.5 at 1/100 sec.

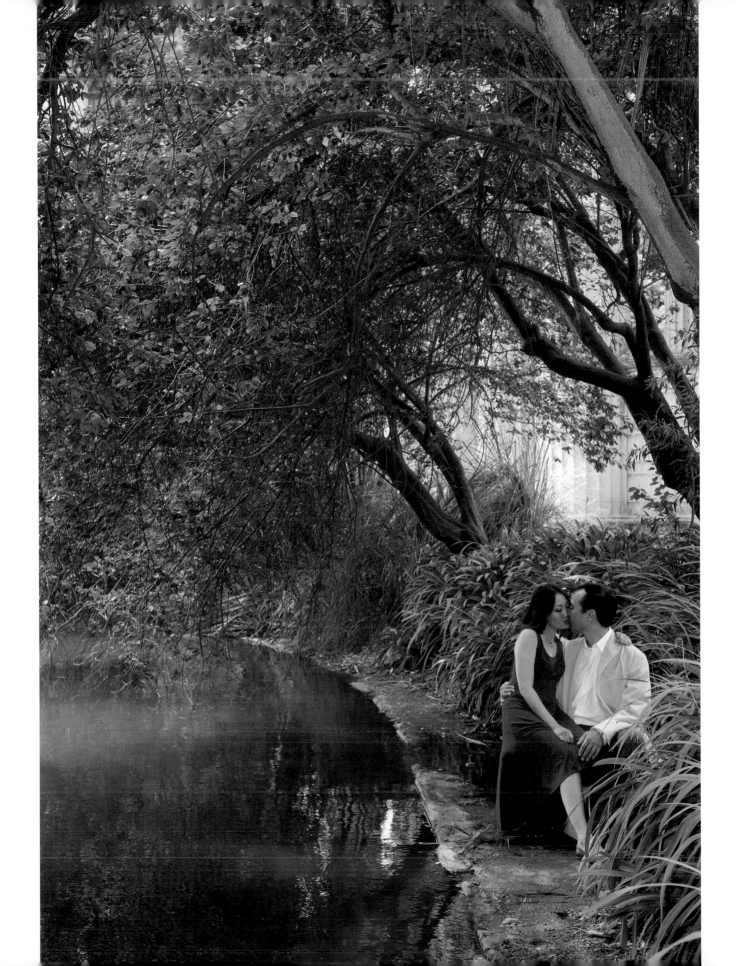

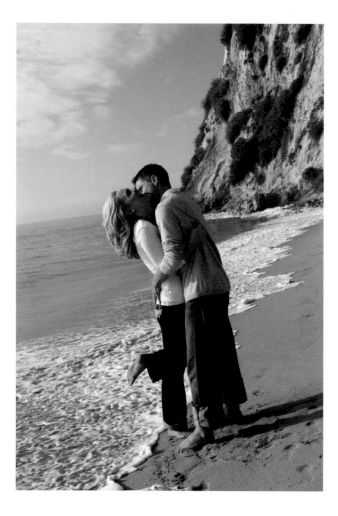

This sequence is a great example of just letting the couple enjoy themselves during the engagement session. You're there to capture what comes naturally to the couple as they have fun and, as a result, each frame stands on its own as a special moment.

LEFT: Nikon D2X, 28–70mm F2.8 lens, *f*/8 at 1/200 sec.
BELOW: Nikon D2X, 28–70mm F2.8 lens, *f*/6.1 at 1/100 sec.
BOTTOM: Nikon D2X, 28–70mm F2.8 lens, *f*/5.6 at 1/125 sec.

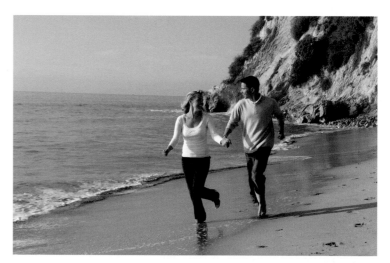

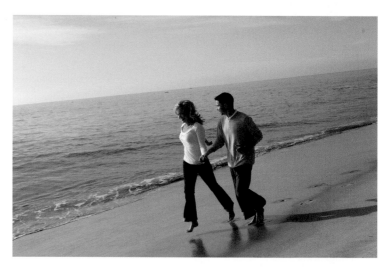

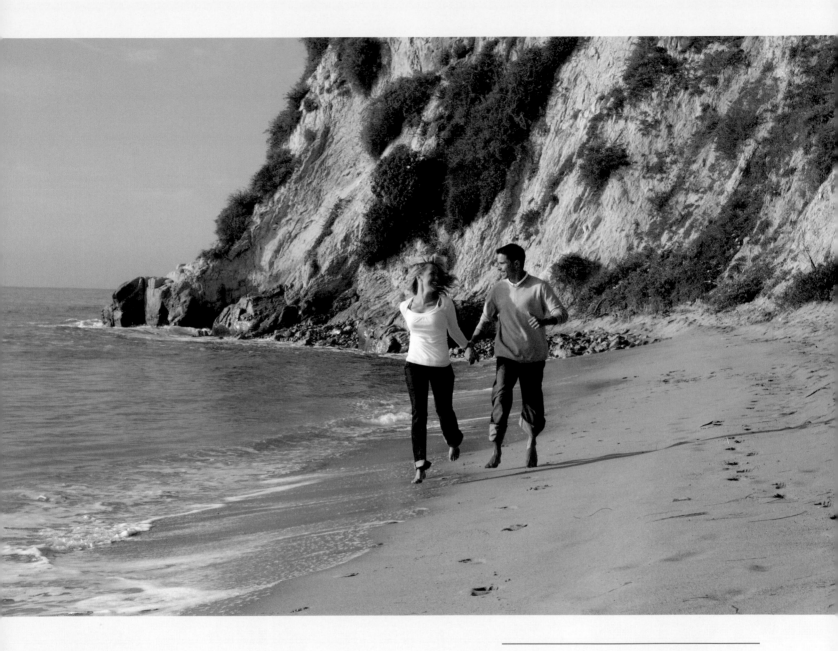

Nikon D2X, 28–70mm F2.8 lens, *f*/5.6 at 1/80 sec.

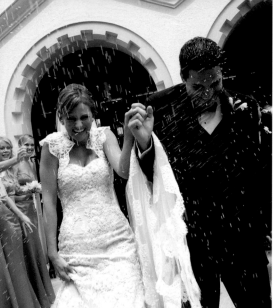
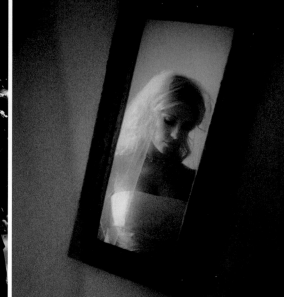
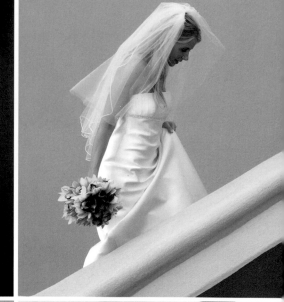
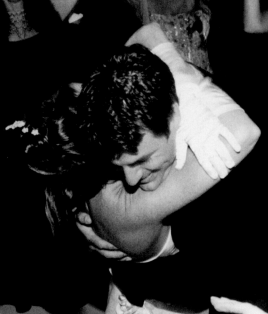
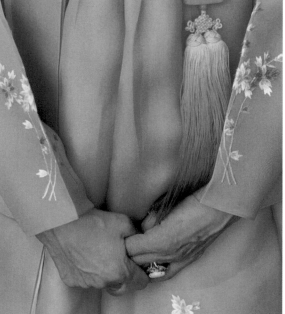
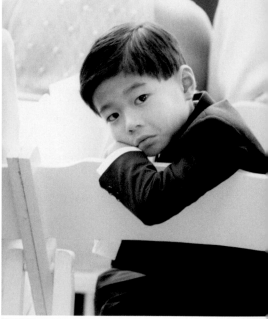

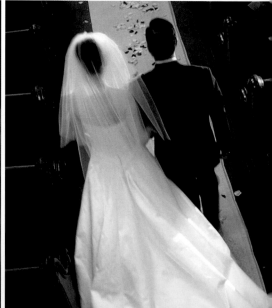

CHAPTER 3 *Telling the Story:* Details, the Ceremony, and the Reception

No book about wedding photography would be complete without covering some basic techniques and standard images necessary to tell the whole story. Remember—it's all about being relaxed on the wedding day. Translated into photographic terms, that means using natural light and natural images rather than forced posing. It also means being at ease and ready to simply enjoy the moment.

Is it necessary to be a purist when it comes to photojournalism? Absolutely not, but the right combination of natural light, simple poses, and the trust you've established with your clients can impart a wonderful fine-art feel and softness to your images. That softness carries over into the way you depict the details of the day itself.

Two important components to telling the story of the wedding day are details and scene-setters, a certain number of which will usually be included in the final album. These are background detail shots that tell the story of every wedding, many without people in them. Details enhance the story, capturing subtle elements the bride and groom might have missed. Every wedding is different, and the details you capture might range from the rings, to the dress, to something as simple as a place setting. They're all important elements that go into telling the story. Don't worry about wasting film or filling up a digital card; detail shots demonstrate your versatility and ability to be a good observer.

If details represent the microcosm of a wedding, then scene-setters are like shooting the macrocosm with a fish-eye lens. Take advantage of the quiet moments before things really get started and document the location, looking for high-impact images to enhance your story. You're looking for a variety of elements—from where the event was held to what the weather was like that day. Scene-setters provide an album with a foundation to build on as the events of the wedding unfold. They give your detail images, together with the memories of the day, a place to "live."

It's always an advantage to be familiar with the venue. Make it a point to arrive a few hours early so you can walk around the venue and look for the ideal vantage points from which to photograph. As the day unfolds, you have the power to choose the decisive moments. Learn to shoot quickly, training your shutter finger until it feels as natural as blinking. Learn to shoot the second you see the image and not spend unnecessary time setting it up. Having a camera set up with one long lens is a necessity. A long lens lets you dissect each scene into its most dramatic components.

Whenever possible, include a second photographer in your normal wedding coverage. This will give you the opportunity to watch for special moments, while your assistant can be responsible for capturing images considered more traditional. We know that having a second set of hands is a luxury, especially when you're first starting out. However, having another pair of eyes to shoot the required subjects will give you time to isolate and capture more spontaneous moments.

For example, one creative opportunity is the bride walking down the aisle with her father. The second photographer should be in the traditional position of the first pew, photographing the bride as she enters the room or sanctuary. This then gives the primary photographer the ability to take pictures from a low angle behind the bride and her father. With a long lens comes an opportunity to capture the groom's expressions as the bride approaches. Those images of when he first sees her are simply priceless.

It pays to find out where your subjects will be throughout the evening. I saw this shot in my mind's eye before it was going to happen, after asking the bride which set of stairs she'd be going up. It's important to arrive at every wedding well in advance, so you can find the various locations that will form the strongest backdrops. Look for strong dynamic lines to draw the viewer into the story.

Canon 5D, 70–200mm F2.8 lens, *f*/8.0 at 1/250 sec.

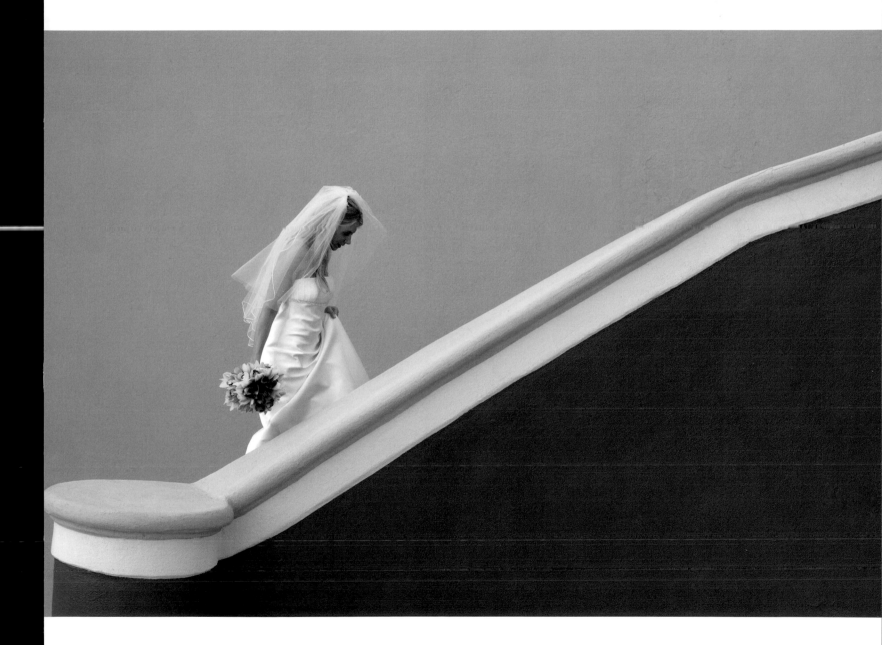

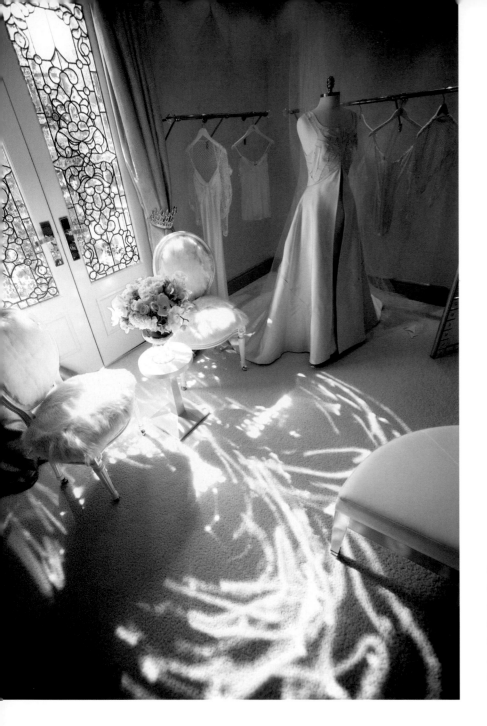

The composition and use of shadows and light in this image capture the unique serenity of the bride's dressing room. Most photographers would attack this room with a shot list—the dress, the flowers, the stained glass—but why not step back and shoot from a wider angle?

Canon 5D, 16–35mm F2.8 lens, *f*/7.1 at 1/50 sec.

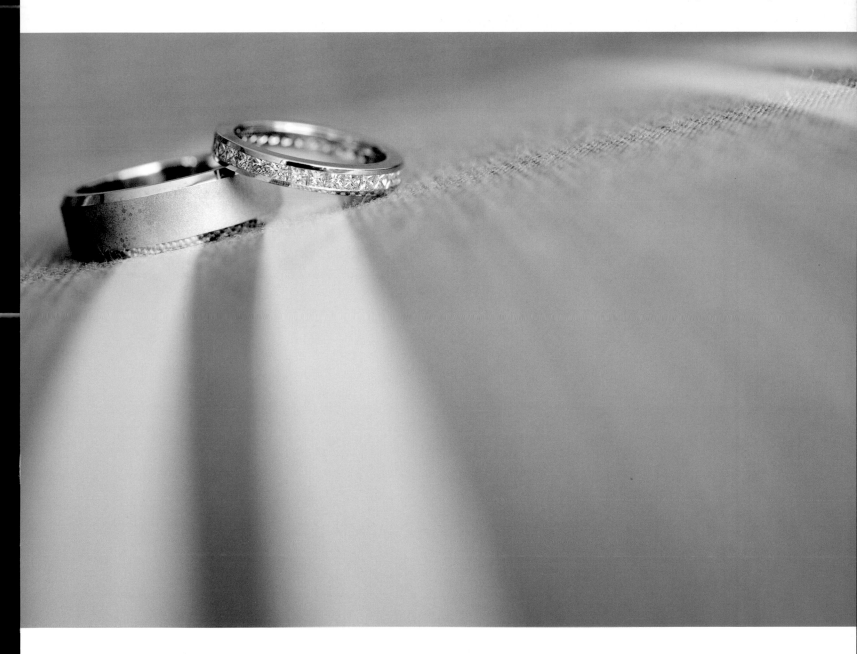

Looking for a compelling backdrop? This image uses nothing but an upholstered chair in the bride's dressing room against which to feature the wedding rings. Shot with the macro lens wide open, it has the added benefit of a shallow depth of field, which makes the image more appealing. Often the simplest items and techniques can be used to create a dynamic composition.

Canon 5D, 60mm macro F2.8 lens, *f*/2.8 at 1/100 sec.

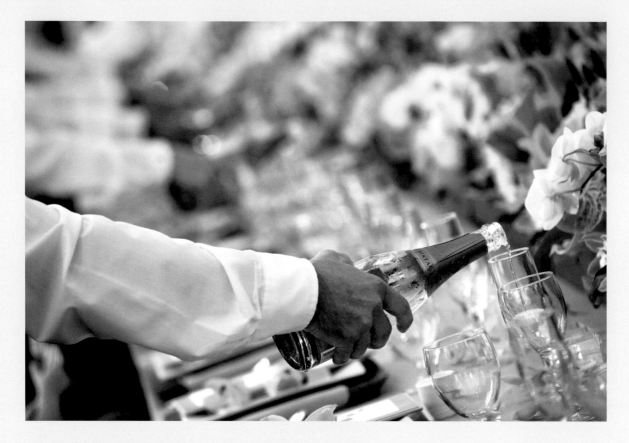

Two of your best "cast members" in telling the story are natural light and a shallow depth of field. Both play key roles in creating images with impact.

Canon 5D, 70–200mm F2.8 lens, *f*/3.5 at 1/80 sec.

Sometimes the most ordinary subject matter creates a dramatic opportunity. Not every photograph has to scream "wedding." Just as a cook adds different seasonings to create the final dish, images like this become part of the arsenal of detail shots that help tell the story. This was shot at an outdoor wedding, when they were just setting up the tables. The sun was bouncing off every surface and was too appealing to pass up. This photo wound up being one of several to show the setup of the reception, an important element of the day's events. Images like this can also be used in your portfolio for nonwedding applications.

Canon 5D, 60mm F2.8 macro lens, *f*/7.1 at 1/125 sec.

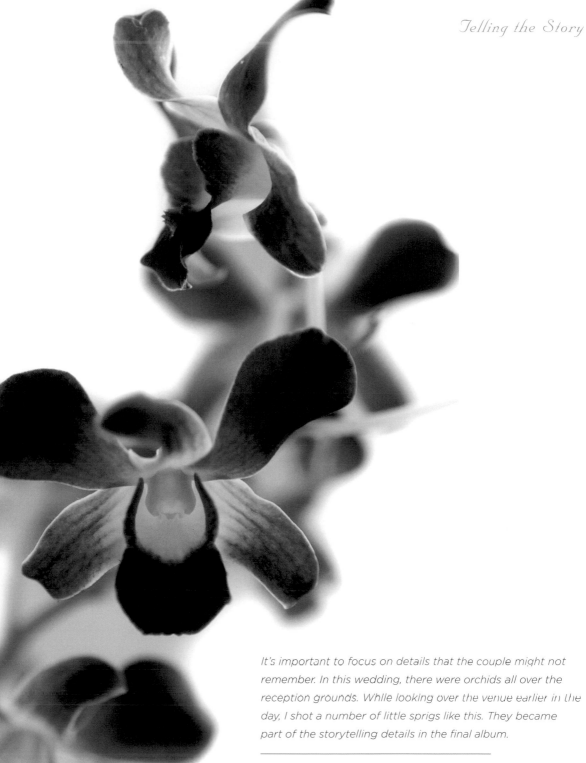

It's important to focus on details that the couple might not remember. In this wedding, there were orchids all over the reception grounds. While looking over the venue earlier in the day, I shot a number of little sprigs like this. They became part of the storytelling details in the final album.

Canon 5D, 85mm F1.2 lens, *f*/2.0 at 1/60 sec.

Often the simplest of subjects help narrate the story. Printing this final image in black and white and adding sloppy borders added to its impact. This was taken after the ceremony, and it served as a great lead-in to the post-ceremony section of the album.

Nikon F6, 17–35mm F2.8 lens, f/8 at 1/125 sec.

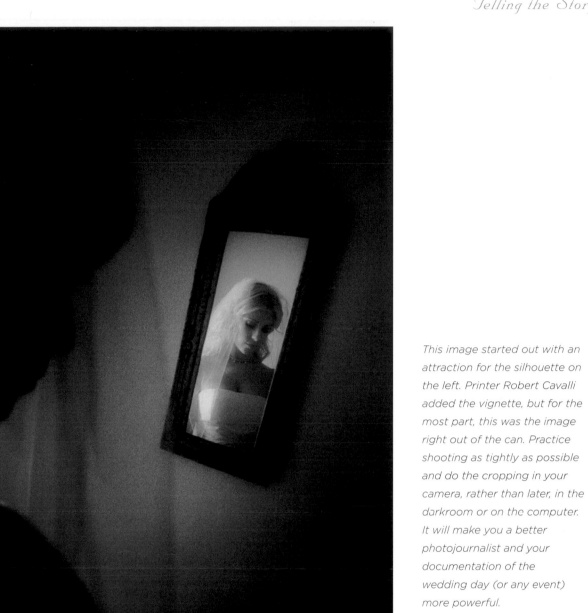

This image started out with an attraction for the silhouette on the left. Printer Robert Cavalli added the vignette, but for the most part, this was the image right out of the can. Practice shooting as tightly as possible and do the cropping in your camera, rather than later, in the darkroom or on the computer. It will make you a better photojournalist and your documentation of the wedding day (or any event) more powerful.

Canon 1v, 16–35mm F2.8 lens, *f*/4.5 at 1/40 sec.

Little girls, little feet, and a moment many people would miss. As often as you look directly at your subjects, remember to also look up, down, and around! You never know where you might find another precious detail of the day.

Nikon F6, 17–35mm F2.8 lens, *f*/4.0 at 1/200 sec.

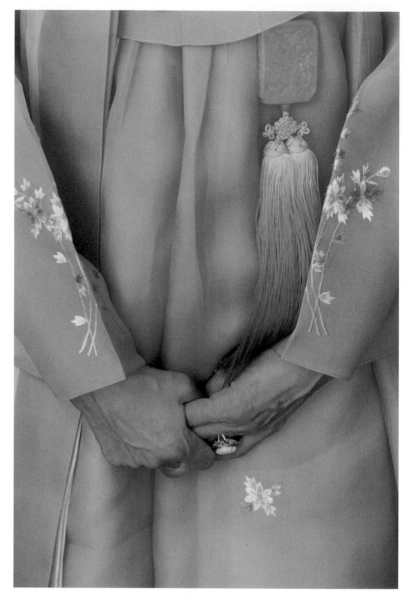

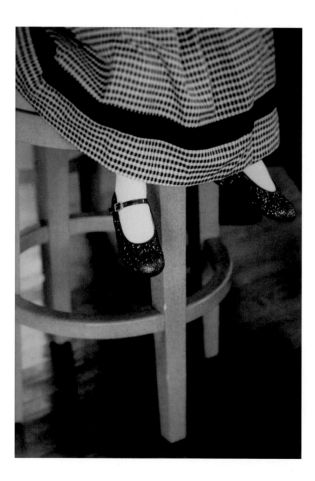

This mother of the bride was experiencing a pensive moment before walking down the aisle. You don't need to see her face; her hands speak volumes.

Nikon D2X, 80–200mm F2.8 lens, *f*/5.6 at 1/100 sec.

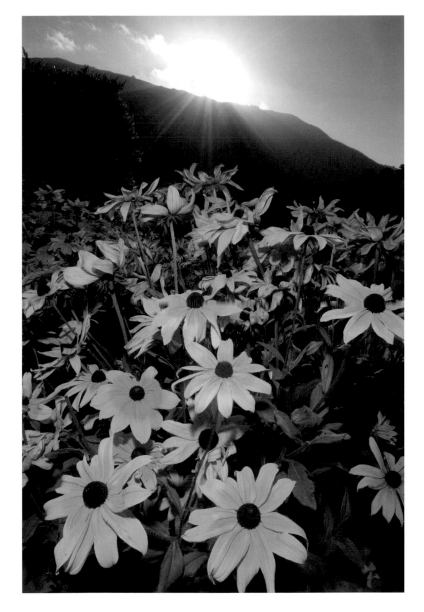

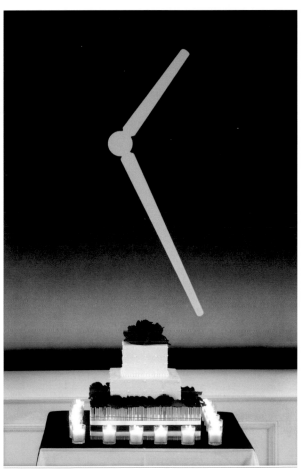

Every wedding demands a few cake shots, which you know will end up in the final album, so you should give your client a wide selection of images to choose from. Check out the cake early on so that you're not scrambling to get the shot during a flurry of activity. Take several exposures, including a macro and a more environmental wide angle like this one, which shows an abstract painting of a clock on the wall behind the cake.

Nikon D2X, 70–200mm F2.8 lens, *f*/4.0 at 1/160 sec.

Flowers are always part of the story, but one can always look for new ways to capture them. Here, the flash was set at +3, fooling the camera's light meter. The background was underexposed and fill flash illuminated the foreground, picking up bright beams from the sun as well.

Nikon D2X, 17–35mm F2.8 lens, *f*/9.0 at 1/100 sec.

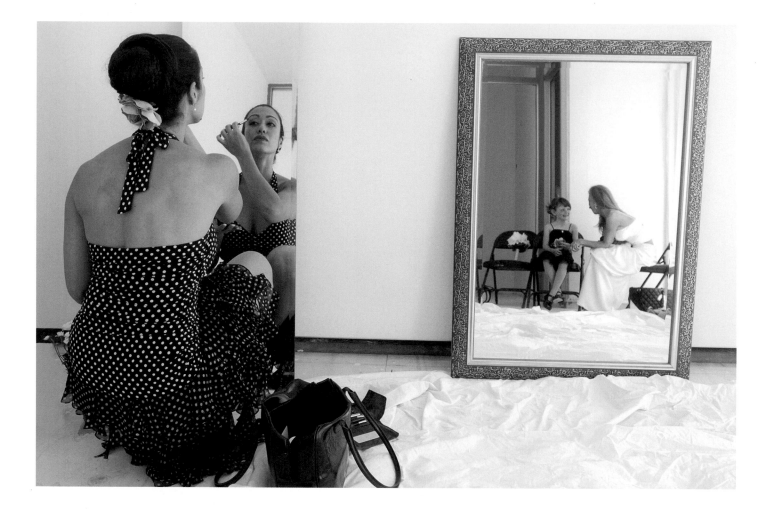

ABOVE: *There are two stories going on in this image: The maid of honor is finishing her makeup, while the bride shares stories with her flower girl. Nothing was moved—the mirrors were actually in that position—but many amateurs might have missed this shot. Train yourself to be an observer, constantly in tune with everything around you. In your mind's eye, you might be shooting wide angle one minute and telephoto the next. Keep an open mind and you'll see a wide variety of stories unfold.*

Nikon D2X, 28–70mm F2.8 lens, *f*/6.3 at 1/80 sec.

RIGHT: *Rarely do people consider using infrared film indoors. But notice the way this shot and vantage point, despite being so commonplace, are much more powerful with infrared film. The challenge with an image like this is deciding how to rate the film, because you can't go above ISO 320 per the "formula" (the recommended ISO from the manufacturer is ISO 50 using a 25A filter). I have discovered that ISO 250–320 and a medium yellow filter are a better fit for the desired look and feel I prefer. This image was shot at f/4.0 at 1/15 sec. The camera was set down on the balcony's banister, held by hand, and it took three frames to get the final image.*

Canon A2E, 16–35mm F2.8 lens, *f*/4.0 at 1/15 sec., infrared film with yellow filter

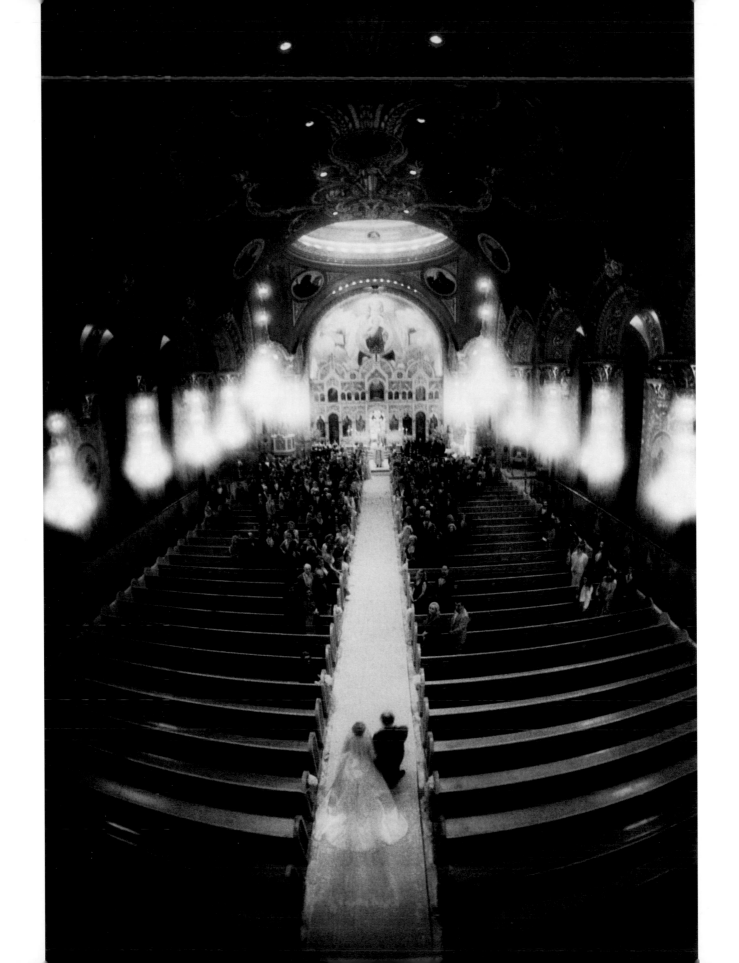

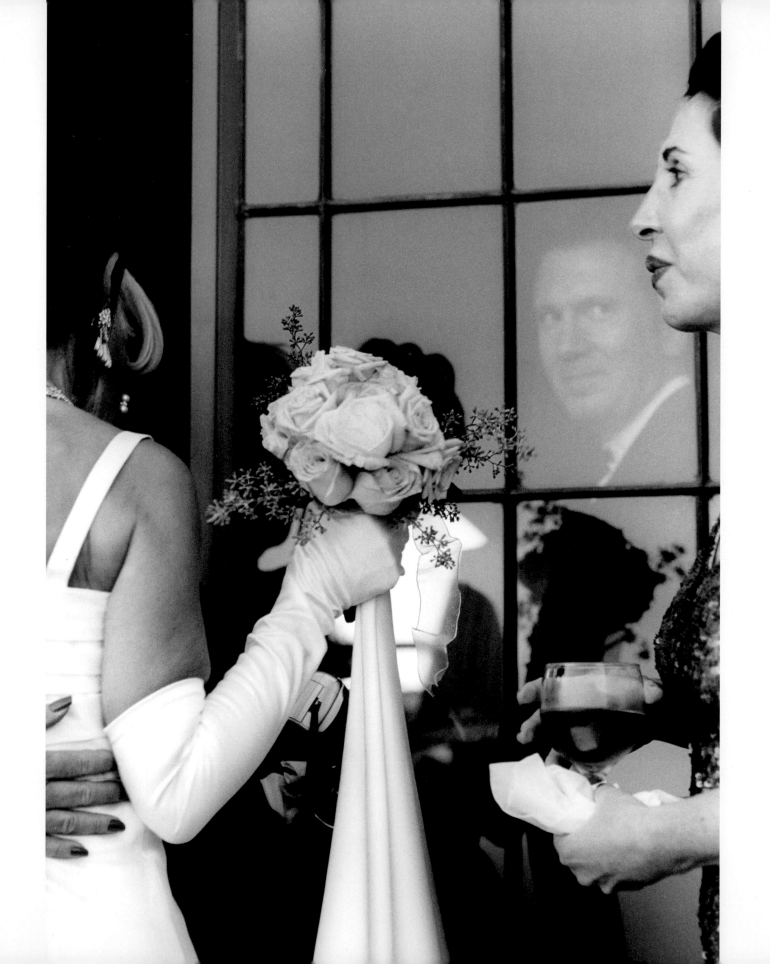

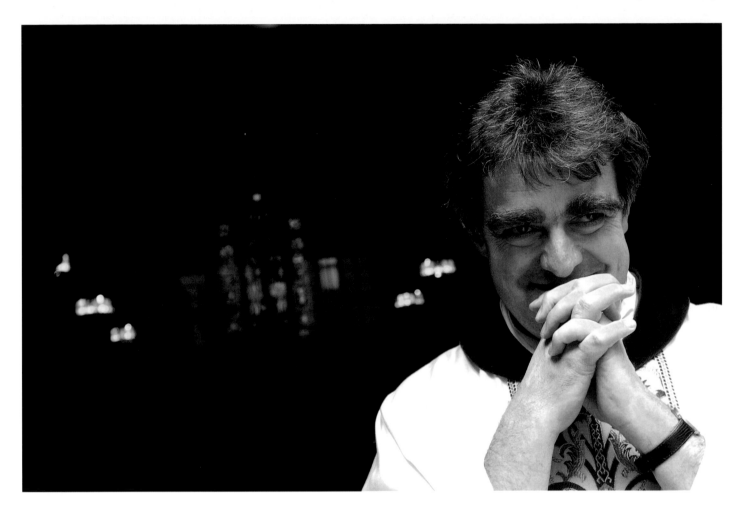

LEFT: *Everything in this image just fell into place. It was the perfect moment in terms of light, composition, and storytelling. Notice we said perfect* moment, *not perfect* image. *There are at least three stories going on here: the bride being guided into the reception by her mother; the woman on the right waiting patiently to congratulate the bride; and the man inside checking out the scene.*

Canon 1v, 70–200mm F2.8 lens, f/4.5 at 1/200 sec.

This priest was flown in from Ireland and was waiting on the steps of the church as the bride arrived in a limousine. He had no idea he was being photographed. It's a "grab shot" of a fleeting moment. As you practice being a better observer of everything around you that day, don't forget the clergy or officiant. Often he or she has known the bride and groom since they were little, is like another member of the family, and shares the same joy at watching the happiness of the day unfold. Again, you are the eyes of the bride and groom, who have hired you to document all the passing events they may miss.

Nikon D2X, 80–200mm F2.8 lens, f/5.6 at 1/160 sec.

This informal portrait of Bishop T. D. Jakes was taken as he waited for the photographer, with no idea he was being captured in a solitary moment. The camera meter reading was taken off the subject, and when averaged out, it blew out the background, adding even more power to the foreground. Remember, the story of the day is going to be made up of hundreds of different elements. Often you can capture just as much feeling from the back of your subject as from the front.

Nikon F6, 28–70mm F2.8 lens, *f*/3.5 at 1/125 sec.

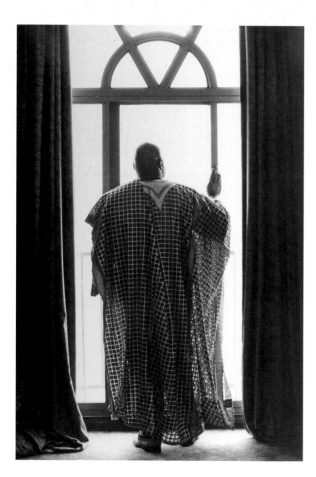

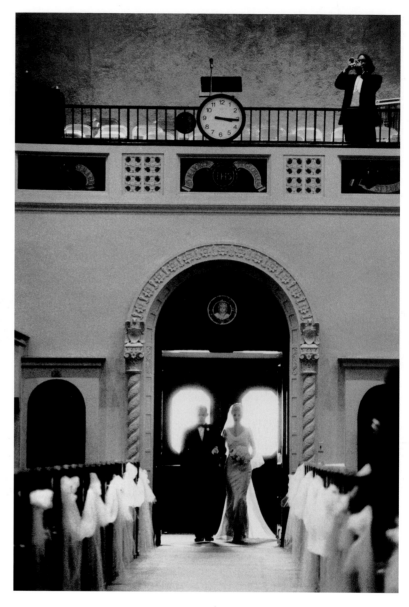

At 3:15 P.M., Dad walks his daughter down the aisle while a trumpet blares from the balcony. Nothing you could add would tell the story any better!

Nikon F6, 80–200mm F2.8 lens, *f*/4.5 at 1/125 sec.

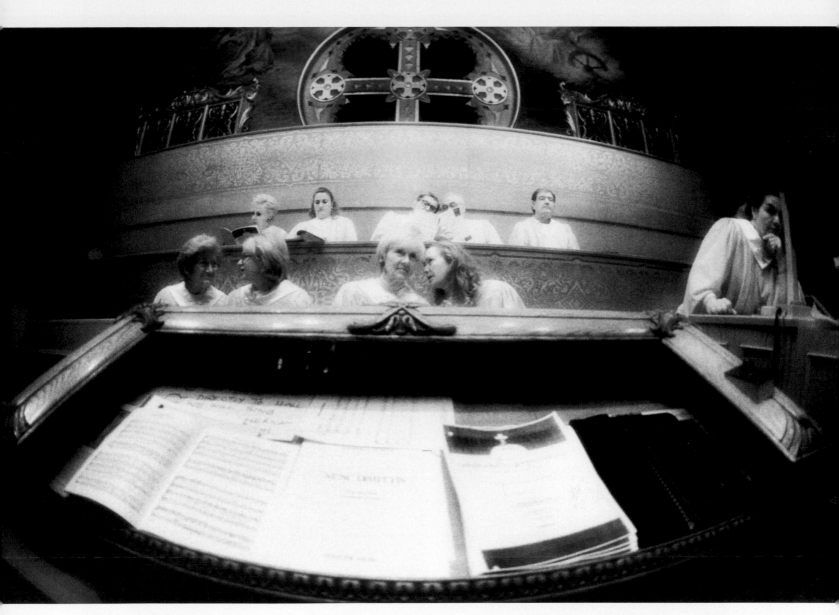

Here, infrared film was used inside again, this time in the choir loft. Notice the effect of a fish-eye lens. It's not a lens you'll use often, but it is a necessity to have in your camera bag, as it helps you tell the story with a unique perspective.

Canon A2E, 15mm F2.8 fish-eye lens, *f*/4.0 at 1/20 sec., infrared film with yellow filter

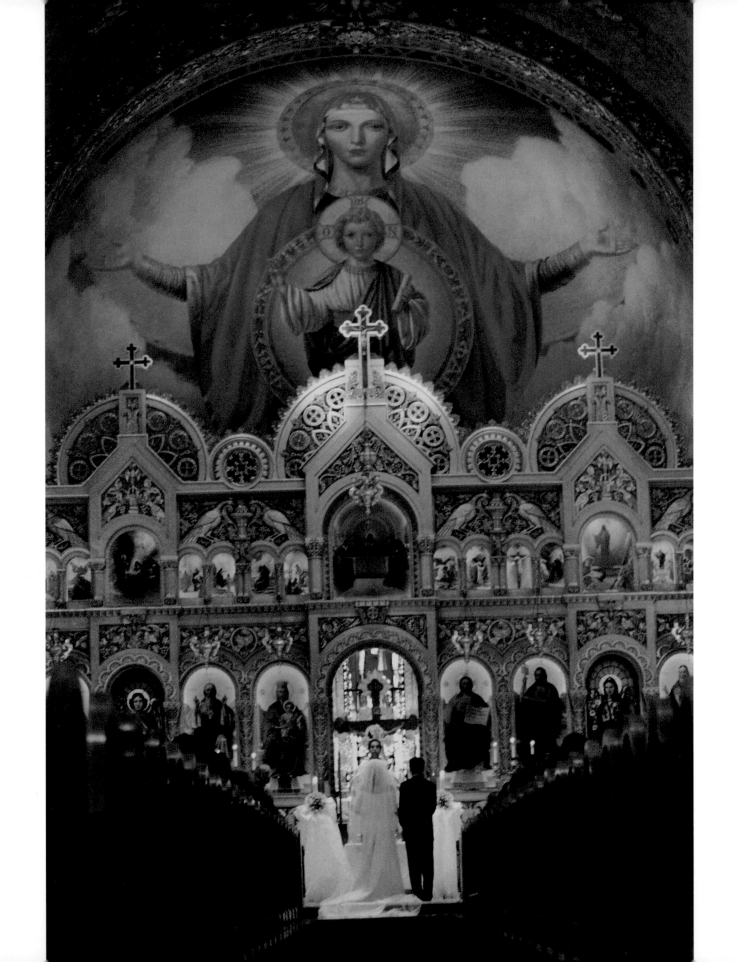

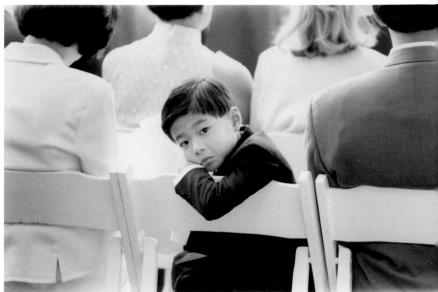

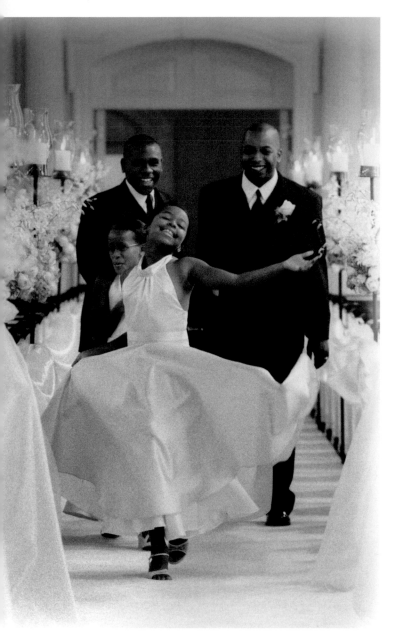

ABOVE: *As the ceremony unfolded, this little boy heard the shutter click behind him and turned around. Seconds later, he was aware of being photographed and broke into a big cheesy grin. This shot is infinitely more authentic, however.*

Canon 1V, 70–200mm F2.8 lens, *f*/5.6 at 1/160 sec.

No one knew this young girl was going to come down the aisle like this—unrehearsed, unannounced, she set off jauntily. Be ready for unexpected moments when anything can—and often does—happen. This is a prime example of why it's important to have two cameras set up with different lenses at all times: With a wider-angle lens, the power of this image would have been lost.

Nikon F6, 80–200mm F2.8 lens, *f*/4.5 at 1/160 sec.

LEFT: *Sometimes you have to lie down on the floor to get the shot. This one required a low camera angle to get the full impact of the icons covering the altar screen and apse. Because everyone is focused on the ceremony, no one will see you lying down on the job!*

Nikon F6, 28–70mm F2.8 lens, *f*/3.5 at 1/40 sec.

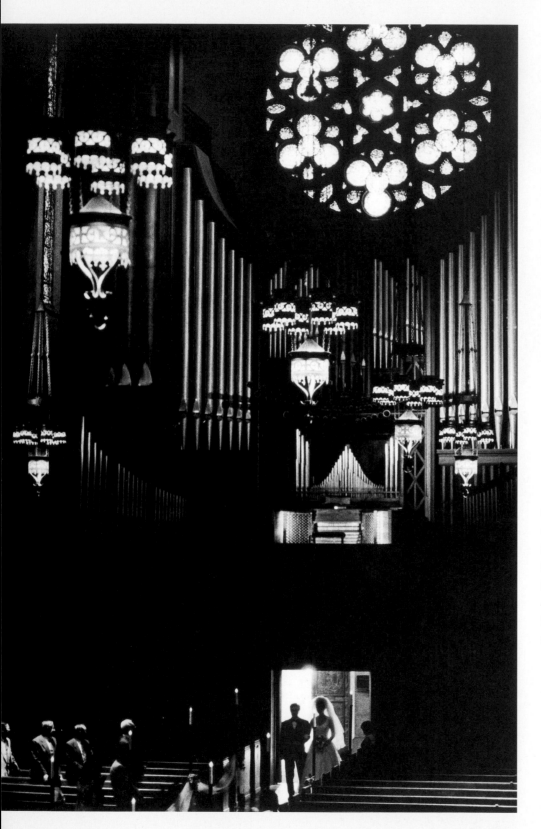

Always look for a unique and unexpected perspective, especially during ordinary moments. In this image, the goal was to find an unusual angle to capture the bride coming down the aisle. I used ISO 3200 film, handheld f/2.8 at 1/15 sec., with a telephoto rather than a wide-angle lens. The result is a dramatic effect capturing the architecture of the church organ, chandeliers, and stained glass, while spotlighting the bride and her father at the head of the aisle.

Nikon F6, 80–200mm F2.8 lens,
f/2.8 at 1/15 sec.

RIGHT: *I captured this moment by chance, clicking the shutter at the same time that a flash went off on a guest's camera. Notice how that flash threw a trail of light onto the bride's veil and dress—a happy coincidence.*

Nikon D2X, 28–700mm F2.8 lens,
f/6.3 at 1/50 sec.

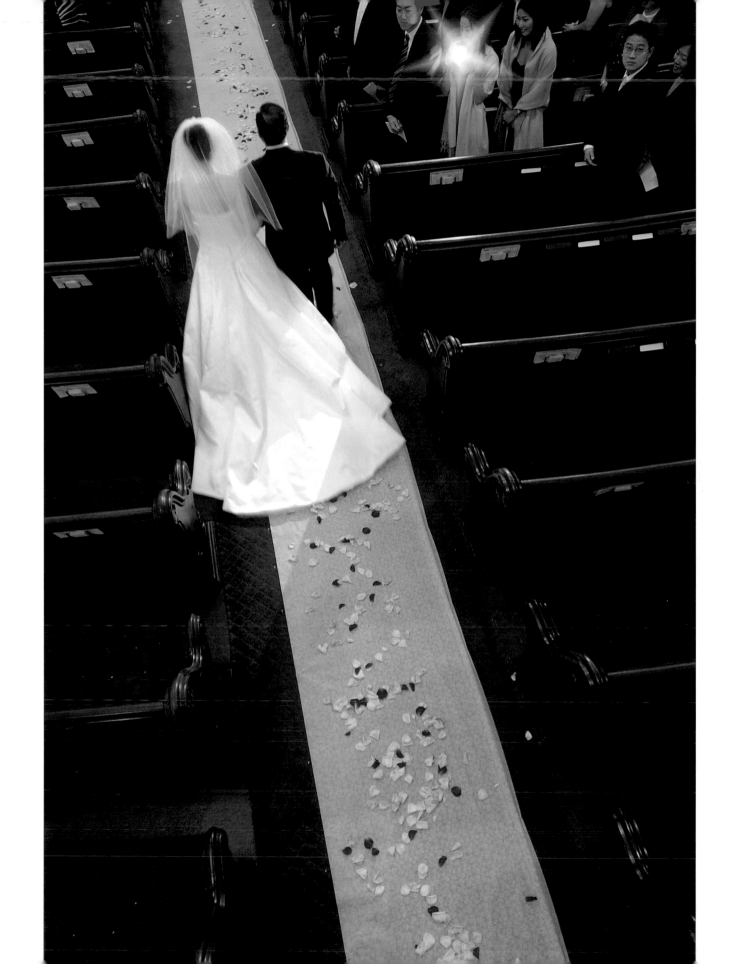

"*Each wedding is unique, and no two weddings will have the same moments. I'm a traditional photographer, but I'm also a photojournalist who always tries to tell the story.*"

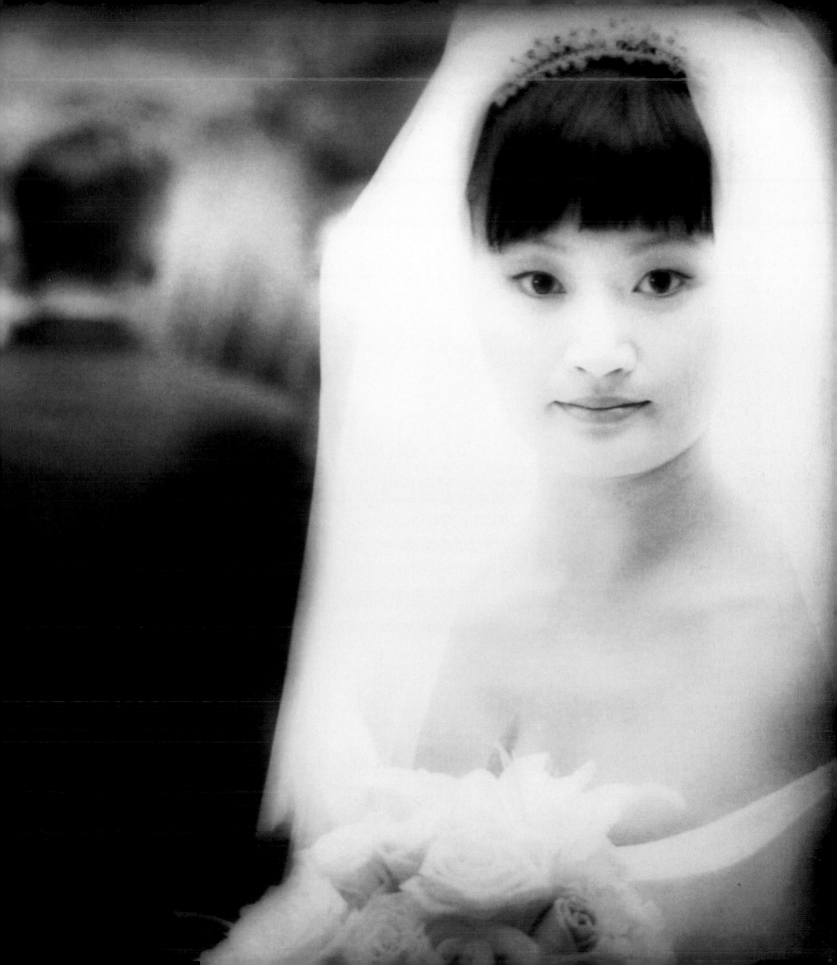

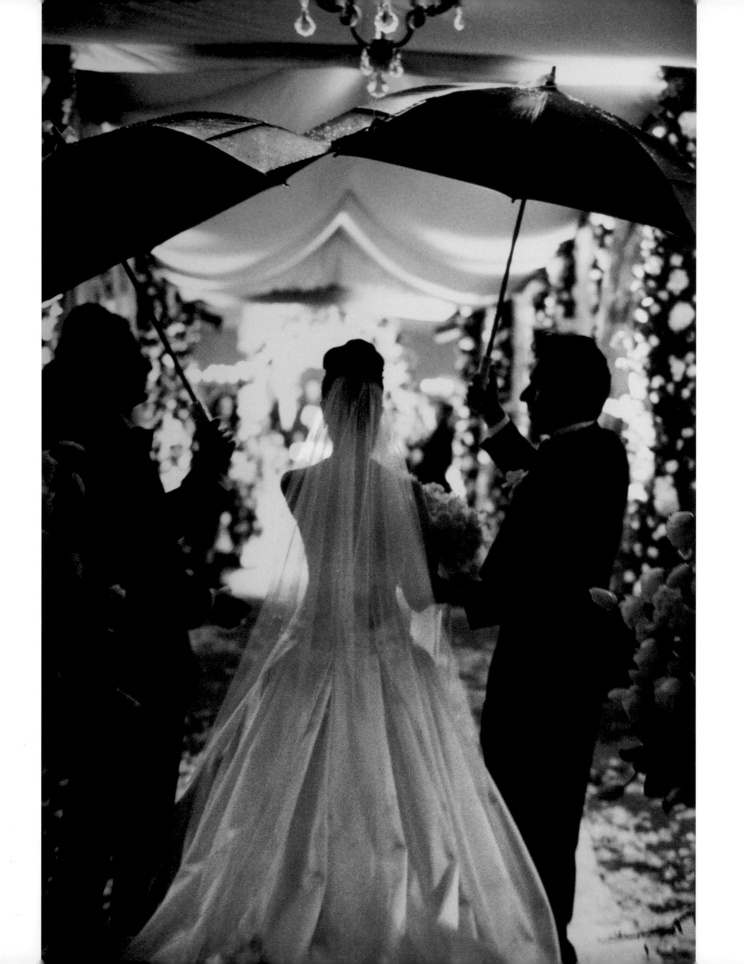

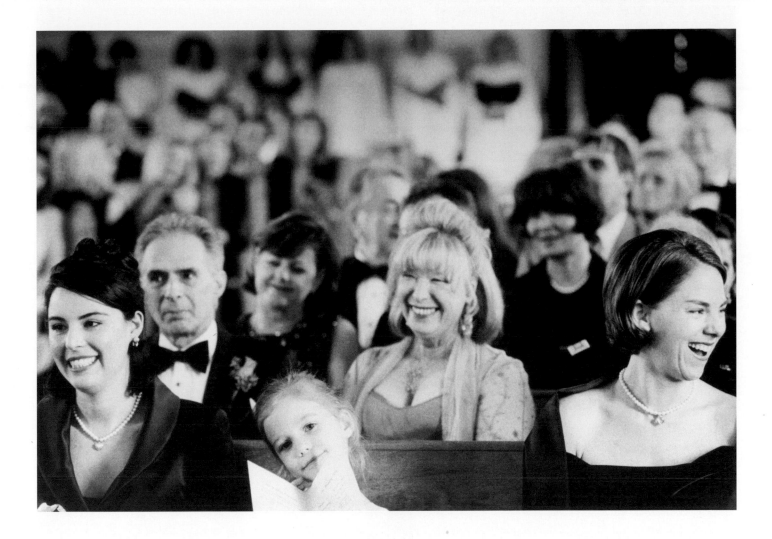

LEFT: *It was raining, and I, the photographer, was simply following the bride down the aisle. Again, it's all about telling the story of the day—which, unfortunately, included rain showers during the ceremony.*

Nikon F6, 28–70mm F2.8 lens, f/2.8 at 1/30 sec.

Remember—if you don't turn around, you'll never catch images like this. As the little girl in front connects with the camera, those around her share a laugh over the couple's vows, and the contrast between her innocent expression and their amusement adds to the moment. Too many photographers spend the wedding day focused entirely on the bride and groom. It may be their day, but it's your job to see and document everything they'll miss. The more special moments like this you can capture, the greater the clients' satisfaction with the final album will be. Always exceed their expectations in telling the wedding story.

Nikon F6, 80–200mm F2.8 lens, f/4.0 at 1/100 sec.

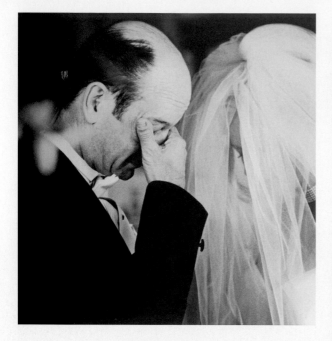

This groom is actually a commercial photographer with a very strong, stoic personality, but when his bride said her vows, he completely lost control and was flooded with emotion. Find these moments and isolate them so they can be cherished for generations.

Nikon F6, 80–200mm F2.8 lens, f/4.0 at 1/100 sec.

This image was taken with ISO 3200 film, shot at 6400 speed, and "processed by inspection" by expert printer Robert Cavalli. Processing by inspection is a lost art: It simply means that the printer closely examines the film at different times during the processing, ultimately developing images to perfection.

Nikon F6, 80–200mm F2.8 lens, f/2.8 at 1/50 sec.

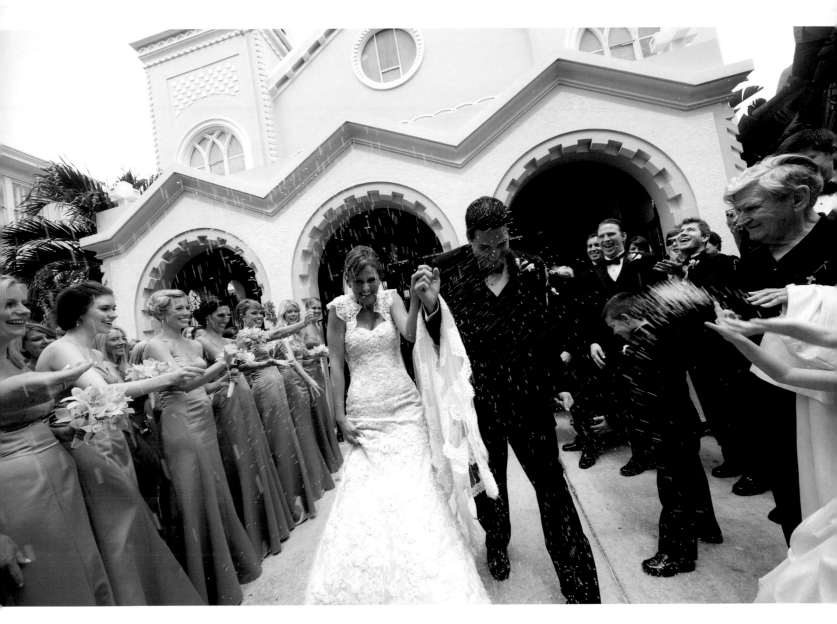

This is a scene that very likely shows up in most wedding albums, but your challenge is to capture it just a little differently. Notice how the camera angle captures the church, the rice in midair, and—most importantly—the expressions on everyone's faces. Timing is everything.

Canon 5D, 24-70mm F2.8 lens, f/7.1 at 1/80 sec.

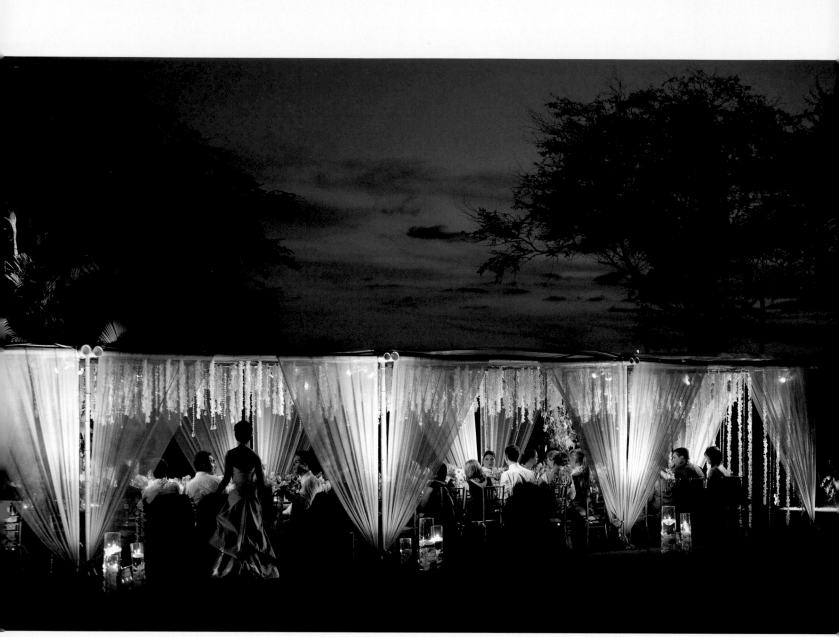

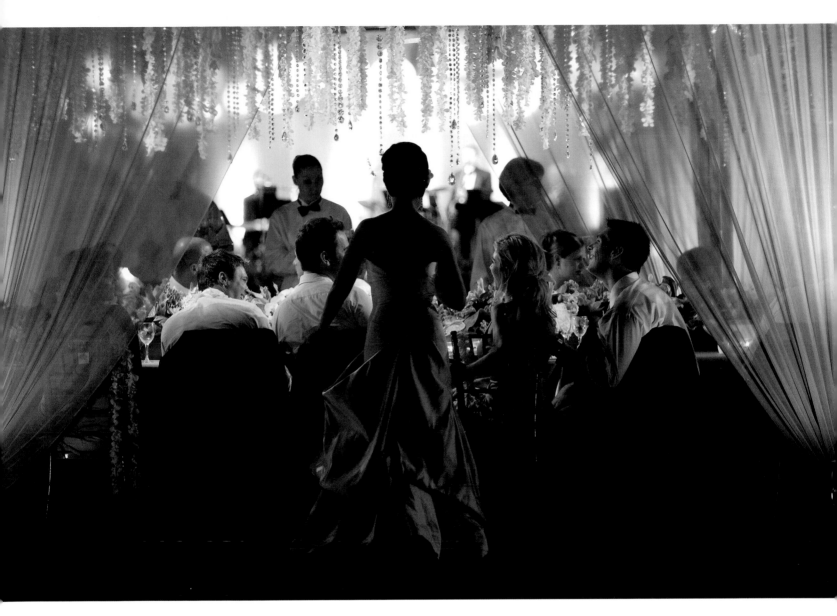

These images of the bride thanking her guests were taken from almost the same position, just a minute or so apart, with two different cameras. One serves as more of a scene-setter, taken from a distance; the second isolates the subject with a telephoto lens for a more intimate dynamic.

LEFT: Canon 5D, 24–70mm F2.8 lens, *f*/6.3 at 1/60 sec.
ABOVE: Canon 5D, 70–200mm lens, *f*/5.6 at 1/40 sec.

This is the kind of Hail Mary shot you can get only by accident
(and it's low risk if you know what you're doing!). The camera
was held in the air, pointed down, the lens was racked out, and
the shutter was clicked—all done with a little prayer to get the
shot. Of course, not every shot result is a guarantee, but if
you know your equipment, you'll reduce the odds of being
disappointed. It's important to practice getting shots like
this without being able to see the camera's LCD or look
through the viewfinder.

Nikon F6, 17–35mm F2.8 lens, f/5.6 at 1/15

RIGHT: I was upstairs packing my camera bag, getting ready
for a short portrait session. I came downstairs in time to see
this scene unfold. I reached over the banister and fired off one
frame; that's all it took.

Nikon D2X, 80–200mm F2.8 lens, f/5.6 at 1/100 sec.

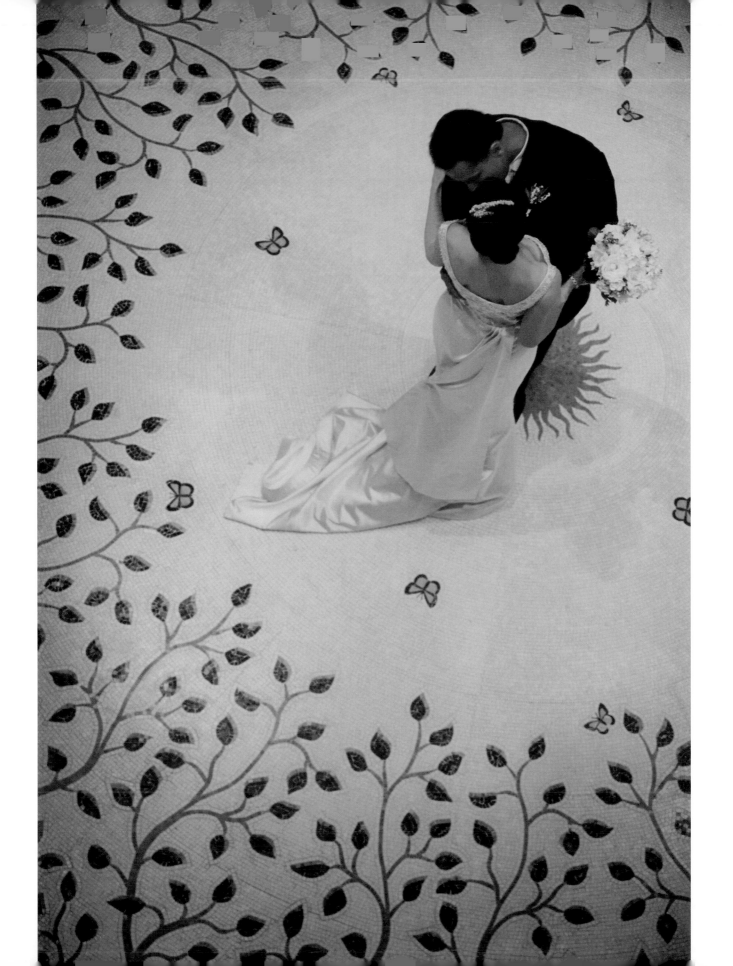

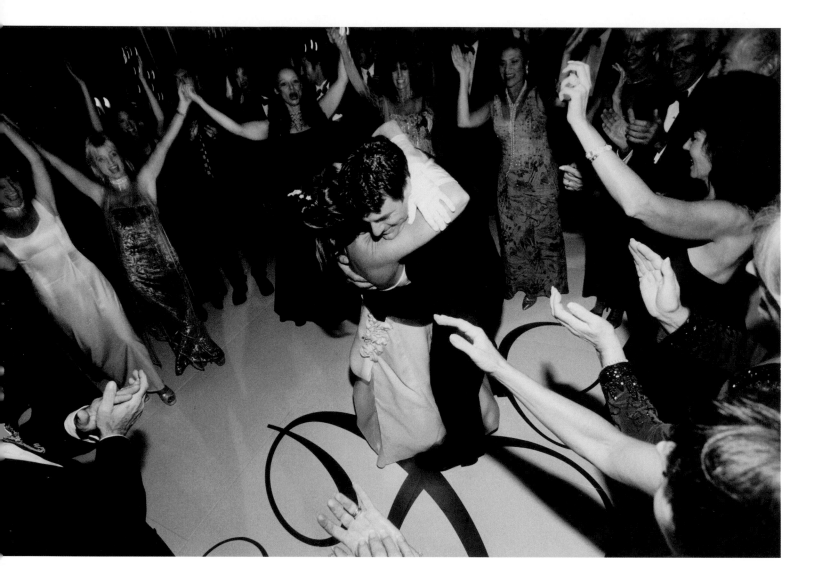

*This is another photograph taken with the camera held up in
the air, this time with an on-camera flash. Notice that the couple
is in sharp focus while the surrounding guests are slightly soft.
I achieved this by "dragging" the shutter while the flash froze
the couple in focus, which means keeping the shutter open
long enough to create the background softness.*

Nikon F6, 17–35mm F2.8 lens, *f*/6.3 at 1/20 sec.,
Nikon Sb80 flash

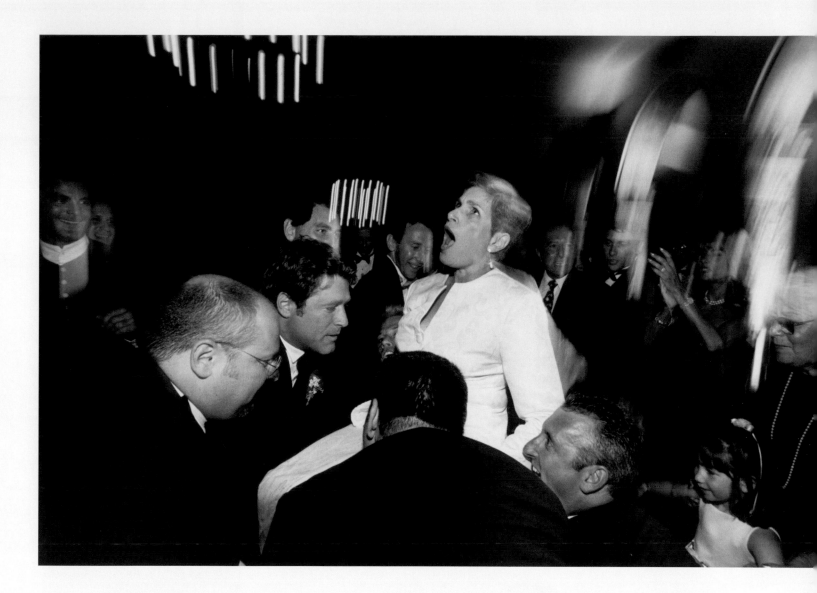

This image was taken by panning the camera along with the motion of the subject while she was lifted up during the traditional dance of the hora, creating a blurry background while dragging the shutter and shooting with a flash. When panning like this, always move in the same direction as your subject or the subject will also be out of focus.

Nikon F6, 17–35mm F2.8 lens, f/6.3 at 1/4 sec., Nikon Sb80 flash

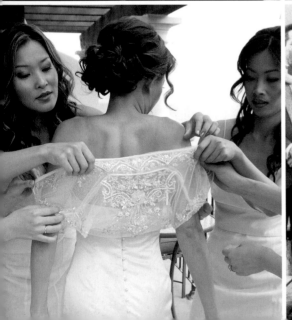

CHAPTER 4 *Make It Snappy:* Photographing Groups

Photographing groups of people is never an easy assignment. At a wedding, the challenge is even greater. Time creates pressure throughout the day, and there's just never enough of it. The photographer has to look for opportunities to capture images quickly in a way that will remain fun for the participants. Especially when time is so limited, it's important to seize moments that are spontaneous, natural, and photojournalistic, when the subjects least expect it.

There are points during the wedding day when the bridesmaids will all be together, just as there are moments when the groomsmen will be. Look for as many opportunities as possible to catch the groups interacting, without interrupting them for a pose. Knowing how to quickly pose a group is still important, but anticipating and capturing the isolated, unposed moments will hone your ability to be a true storyteller.

" A lot of stuff happens when you do formals. Having another photographer do the traditional shots gives you the opportunity to simply capture other moments as they unfold."

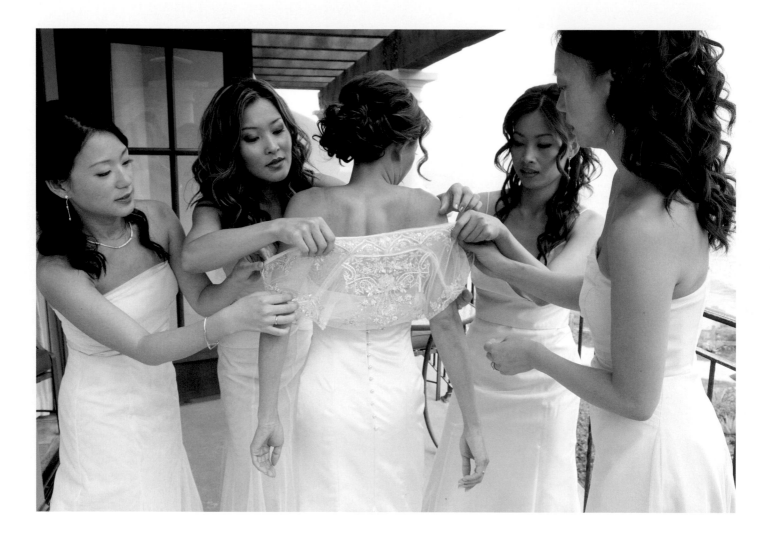

This bridal party was involved in a last-minute adjustment of the bride's gown—a poignant moment as well as a spontaneous group shot. I suggested the bridesmaids move the gown adjustment outside, where the light was better. Was this pure photojournalism? No, but that hardly matters in the end—it was still a real moment.

Nikon D200, 28–70mm F2.8 lens, *f*/6.3 at 1/125 sec.

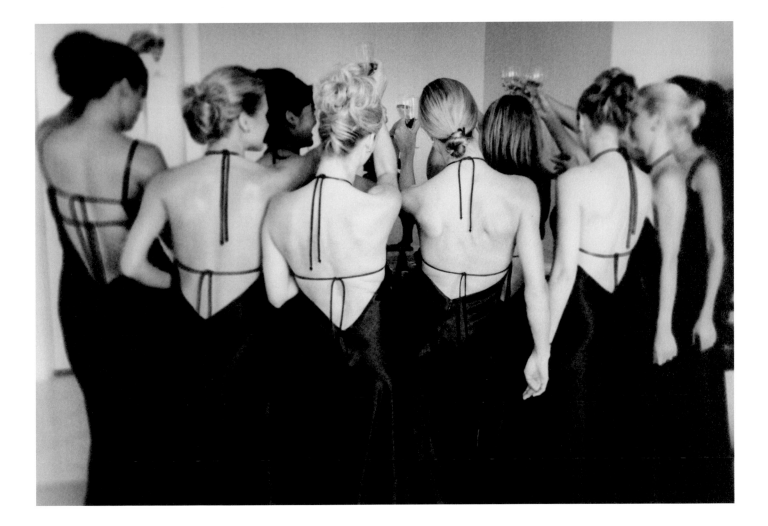

This kind of shot isn't meant to be the core image of the wedding album, but how many would have passed it up? You don't need to see the bride's nor any of the bridesmaids' faces to know they were exuberant. We're not suggesting that you avoid taking traditional group shots, but this image—together with others of the wedding party—added to the successful documentation of the event. Each showed another highlight of the day.

Nikon F6, 28-70 F2.8 lens, f/4.5 at 1/100 sec.

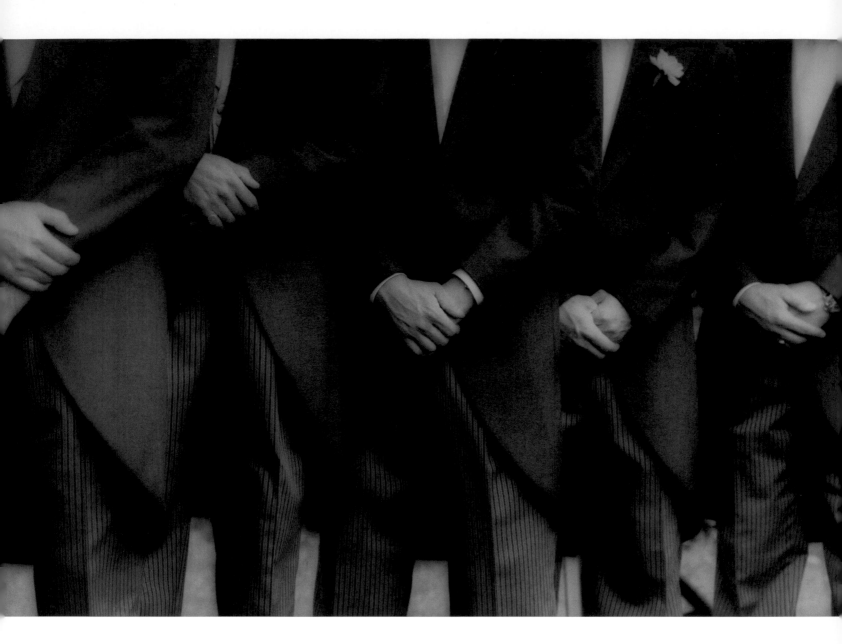

The wedding photographer's role is to convey intangible feelings and moments of intensity. This photo was taken during the ceremony, when all the groomsmen instinctively clasped their hands without prompting. Their posture speaks volumes about the seriousness of the moment. The use of sepia toning and slight vignetting during the printing process added impact to the final image.

Nikon F6, 80–200mm F2.8 lens, *f*/5.6 at 1/160 sec.

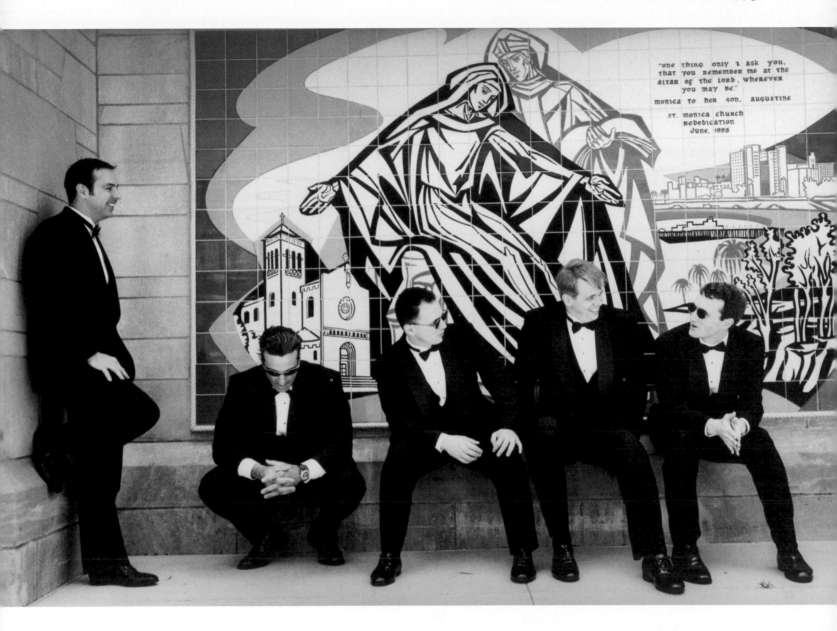

One word to keep in the back of your mind is "anticipation." Always keep your radar alert for situations that convey that particular mixture of tension and hopeful expectation. Here the groom is looking down pensively before the wedding, while his four groomsmen are relaxed. The contrast in emotion creates an unusually striking portrait. Compositionally, the background painting appears to be speaking to—even embracing—the men below.

Canon 1v, 24–70mm F2.8 lens, *f*/5.0 at 1/100 sec.

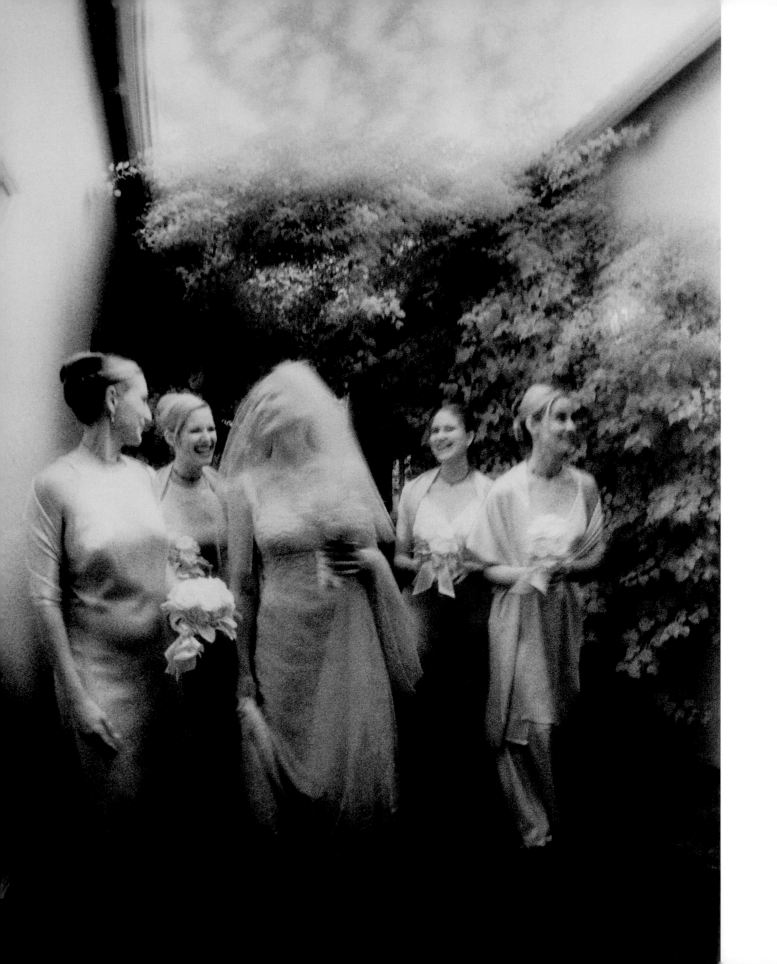

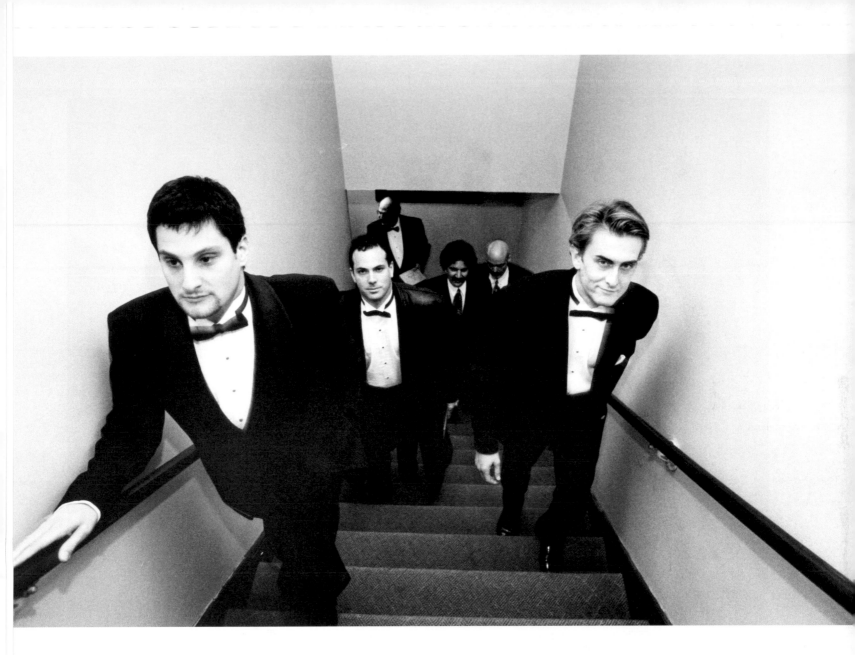

LEFT: *This bride and her bridesmaids are sharing a warm, relaxed moment, conveyed with a completely retro special effect by toning the infrared film. The shutter was dragged (a slower speed was used) in order to pull in all of the ambient light and the exposure made at f/4.0 for 1/20 sec.*

Nikon N90S, 17–35mm F2.8 lens, *f*/4.0 at 1/20 sec., infrared film with yellow filter

This group of groomsmen was downstairs having a drink before being called up to the ceremony. Without question there's a hint of, "You're not really going to photograph us now, are you?" But less than a second later, the image was taken and everyone moved into position for the wedding. Viewing candids like this can bring the subjects right back to the actual moment, as if it were yesterday.

Canon 1v, 24–70mm F2.8 lens, *f*/6.3 at 1/15 sec.

This group took only minutes to pose, starting with the groom in the middle. Because it was posed quickly, everyone is relaxed, with terrific attitude. Note how they're on three different planes, and yet everyone can see the photographer.

Nikon D200, 28–70mm F2.8 lens, f/6.3 at 1/60 sec.

Even though this photo is completely staged, the subjects didn't have too much time to think. I simply had them stand where and with whom they were comfortable by saying, "Hey guys, go stand over there." You'll find that people will position themselves in their own comfort zone without any direction.

Canon 5D, 24–70mm F2.8 lens, *f*/8 at 1/125 sec.

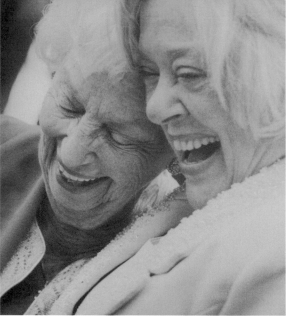
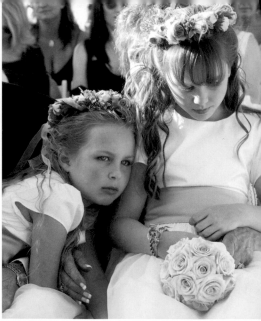
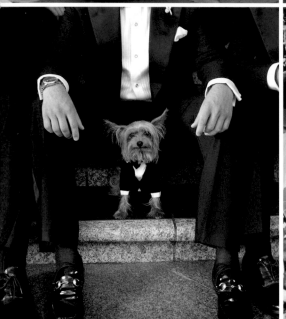

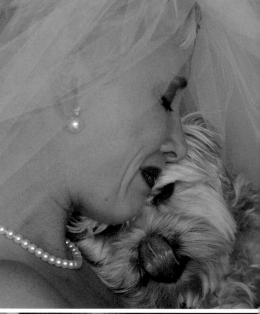
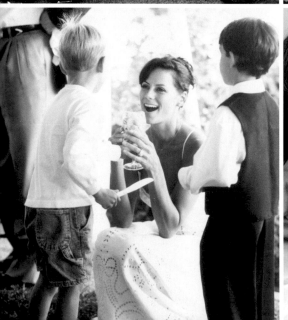
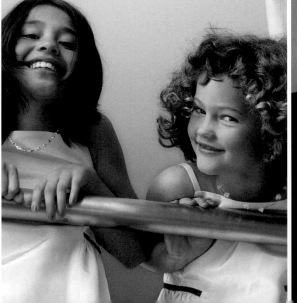
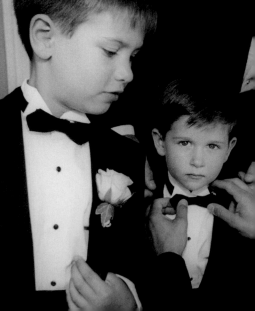

CHAPTER 5 *The Magic Three:* Kids, Pets, and Grandparents

Just as chefs often cook a myriad of dishes using the same repertoire of favorite ingredients, wedding photographers worth their salt will make use of three critical, magical groups of guests at any wedding that will always make the final album that much more special: kids, pets, and grandparents. We'll spare you our full theory on why they play such distinctive roles in our lives, but the short version is, they represent unconditional love. The interactions they inspire on any wedding day are all about pure emotion, and as such deserve to be thought through before the big event.

According to the American Pet Products Association, an estimated 70 million households in the United States own a pet, which amounts to approximately 75 million dogs and 90 million cats. No wonder pet photography is third in line after brides and babies! Every wedding photographer is likely to photograph at least one nuptial each year with a pet somewhere in the party.

Now, if you put all the pets together with all the children and grandparents and try to calculate how many smiles and tears will be produced at given a wedding, you're guaranteed a series of winning images. Train yourself to be a keen observer of the oldest and youngest guests and to anticipate the moments that are going to bring a tear to Grandma's eye, a smile to a proud grandpa, or a big yawn to one of the younger set. Remember that it's not just about two people getting married; it's about two communities coming together, and it's important to pay attention to all the relationships. Here are some of my favorite representations of "the magic three."

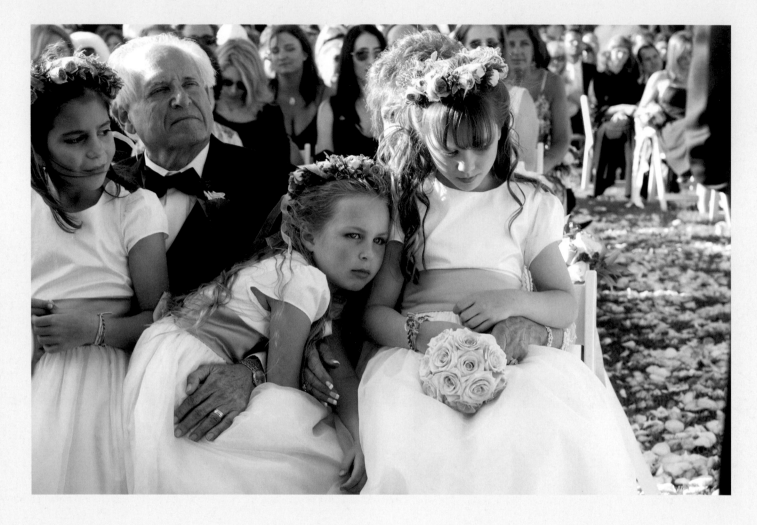

When you see any grandparent with grandchildren, your radar should go into high gear. Pay attention to the magical chemistry between them and be prepared to capture those moments when they notice you the least. This shot was taken during the ceremony. As a guiding principle, always remember to turn around and observe what's going on behind you.

Canon 5D, 24–70mm F2.8 lens, *f*/7.1 at 1/125 sec.

"You'll never get the real persona of your subjects if you wait for them to smile and go into 'camera mode.'"

When you come to a wedding with an open mind and heart, even the littlest guests will be comfortable around you. Don't be afraid to take advantage of natural light, even when it's harsh. You don't always need soft, wraparound light in order to create magic—just wait for kids to show you their true selves.

Canon 5D, 24–70mm F2.8 lens, *f*/8.0 at 1/100 sec.

You can almost hear this little flower girl thinking, "Someday I'll be in that dress!" This candid was shot facing into the available natural light. The meter picked up the light from the window, which led to the underexposed foreground and highlighted the object of desire—the gown.

Canon 5D, 24–70mm F2.8 lens, *f*/6.3 at 1/60 sec.

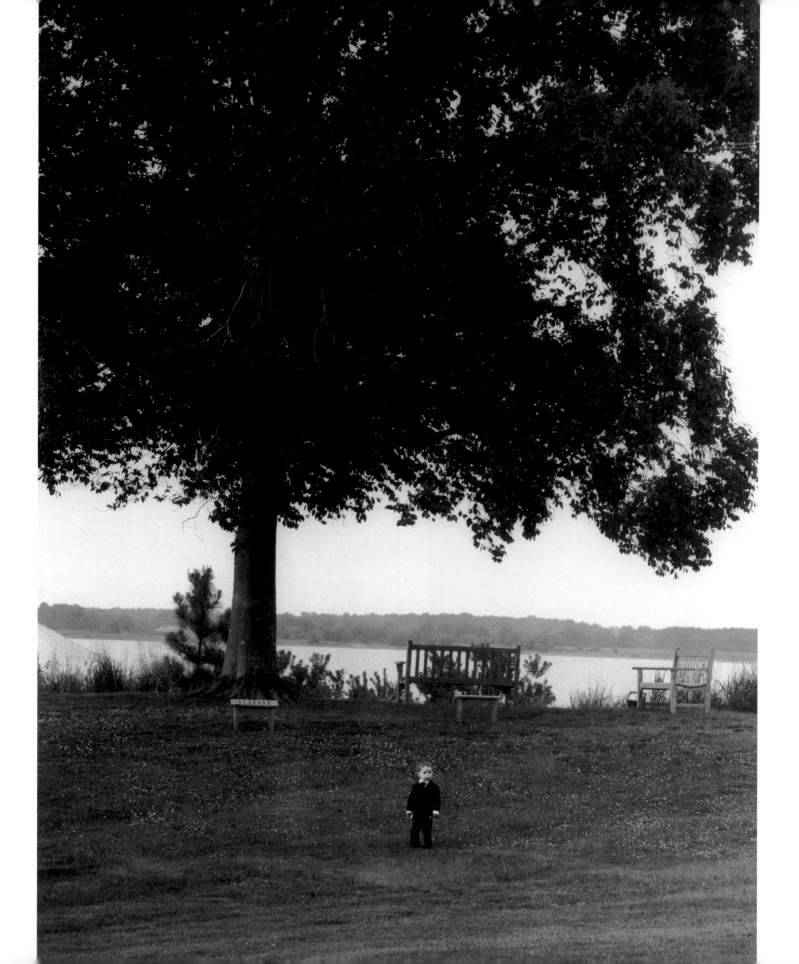

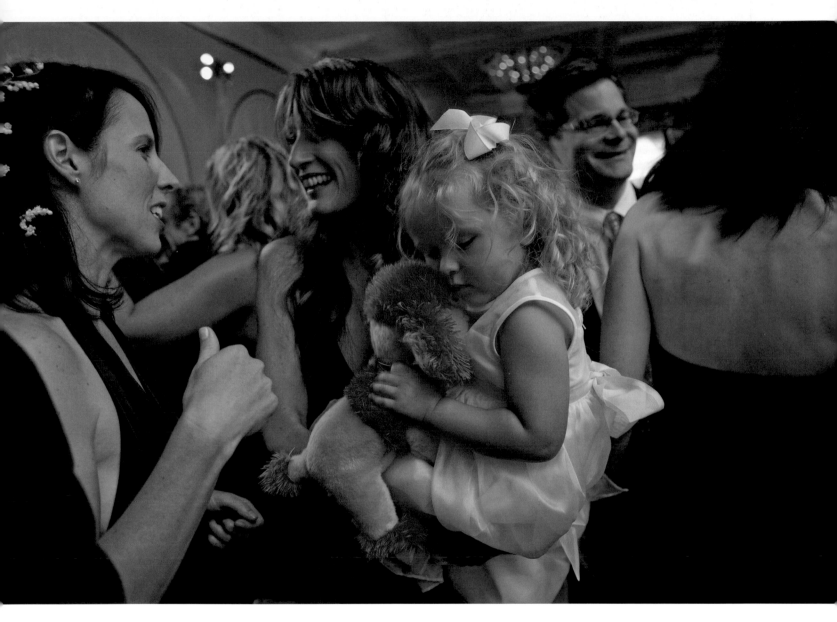

LEFT: *This image violates a few photography basics and didn't score well when submitted to an international professional print competition, partly because of its unconventional composition. However, I've found that the dramatic contrast of a little dude set against a very tall tree always makes people smile.*

Canon 1v, 70–200mm F2.8 lens, *f*/8.0 at 1/200 sec.

In the midst of all the drama, tension, and energy, one little girl found an oasis of solitude in her mother's arms. Train yourself to look for such moments of contrast, which will create images that are unique and unconventional.

Canon 5D, 24–70mm F2.8 lens, *f*/4.0 at 1/40 sec.

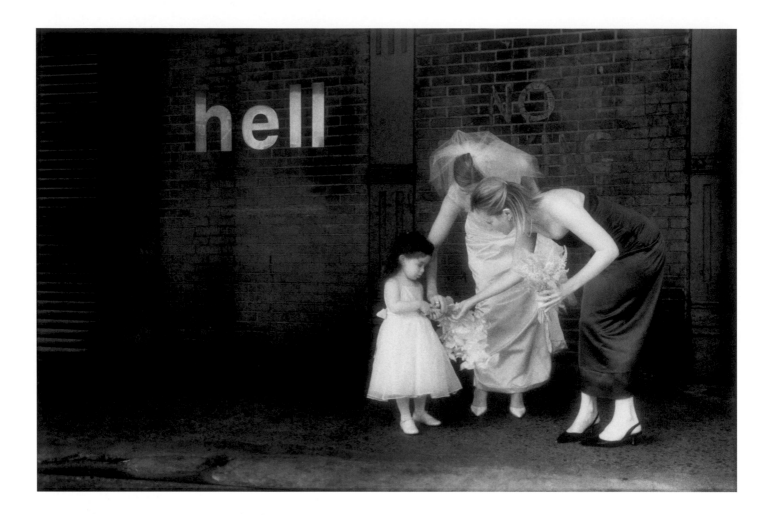

This image was taken in Hell's Kitchen, a neighborhood in Manhattan, while we were walking to the venue. Unfortunately, the bride's dress tore, which instantly set up a moment of drama as she, her bridesmaid, and the flower girl inspected the damage. The scene was irresistible—I had to capture it. When the bride saw the photo, it brought back that memory, which in hindsight was a pleasure for her to reflect on.

Canon A2E, 16–35mm F2.8 lens, f/8.5 at 1/125 sec., infrared film with yellow filter

RIGHT: Little boys and bow ties—always a charming combination. A useful trick when photographing groups is to try to make a connection with just one subject in the image. The connection often comes naturally with kids; all you have to do is smile and make eye contact.

Nikon F6, 28–70mm F2.8 lens, f/6.3 at 1/100 sec.

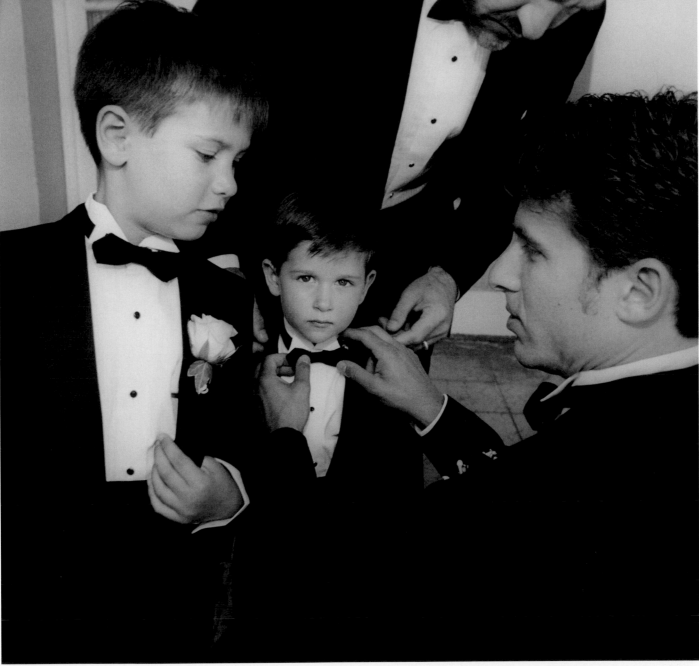

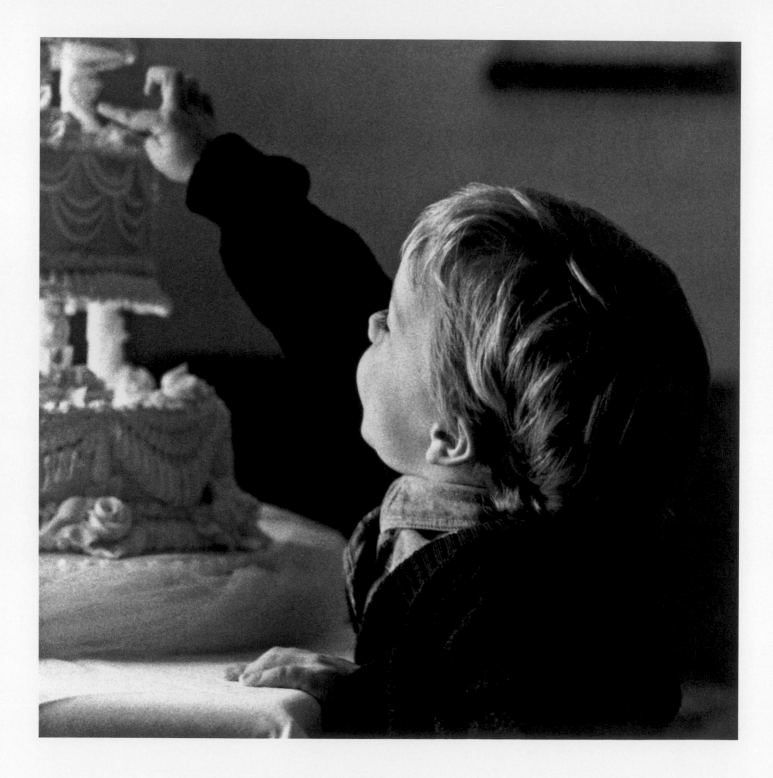

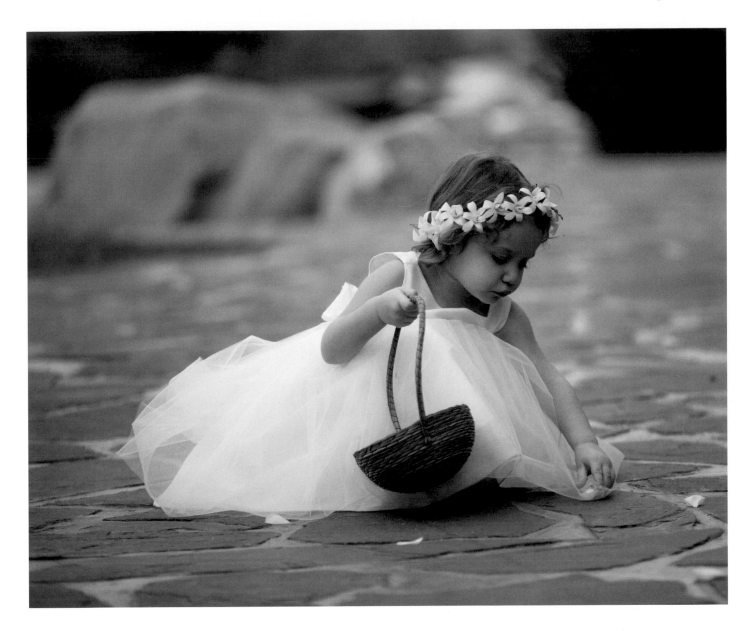

LEFT: *This little boy kept looking to see if anyone was watching before putting his hand "in the cookie jar." Watching out of the corner of my eye, I waited until that perfect moment and then— click—BUSTED for all time!*

Nikon F6, 28-70mm F2.8 lens, *f*/3.5 at 1/80 sec.

Here's a perfect example of the benefit of having a second photographer. During the ceremony this flower girl just drifted away from the scene, and since I had backup, I was able to follow her. Knowing that the other photographer is getting the more necessary shots allows you to capture moments that would be missed if you were on your own.

Canon 5D, 70-200mm F2.8 lens, *f*/2.8 at 1/300 sec.

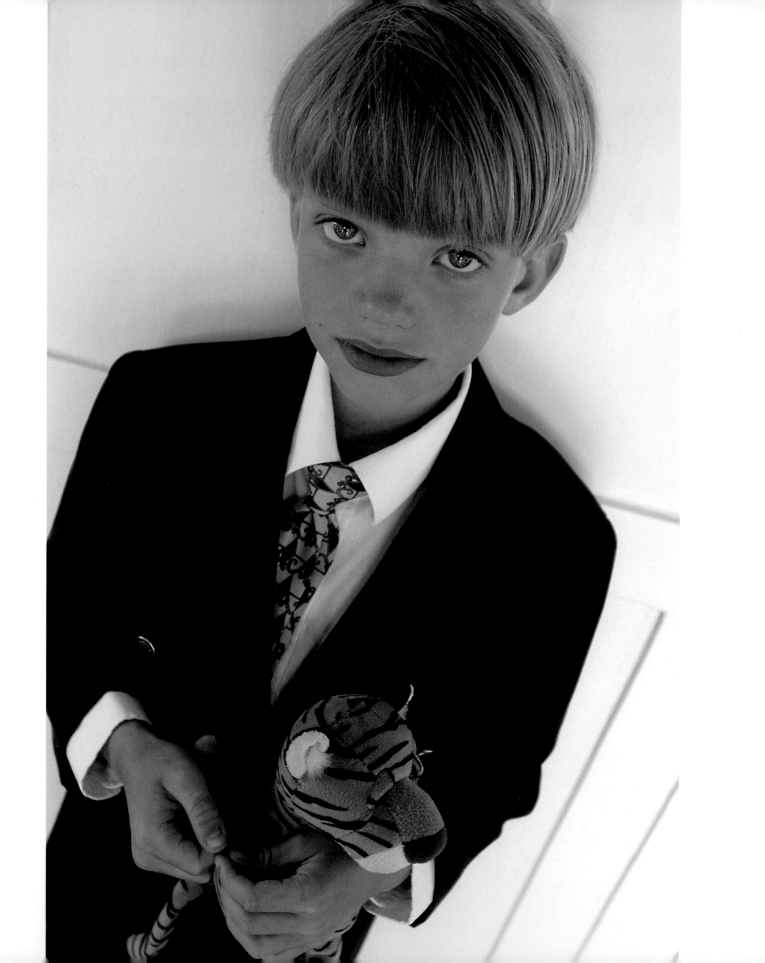

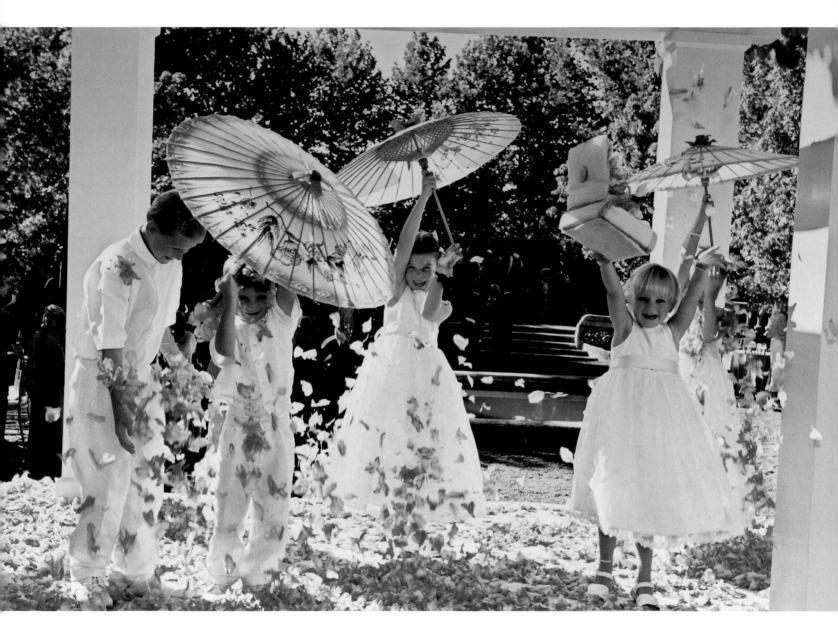

LEFT: *This little boy was standing by himself as formal portraits were being shot. I snapped this photo so quickly that he never had time to smile.*

Nikon D2X, 80–200mm F2.8 lens, *f*/5.6 at 1/200 sec.

You don't have to ask kids to do anything—just watch them and capture what unfolds. Remember to look their way throughout the day and be prepared to shoot quickly.

Nikon D2X, 28–70mm F2.8 lens, *f*/8 at 1/160 sec.

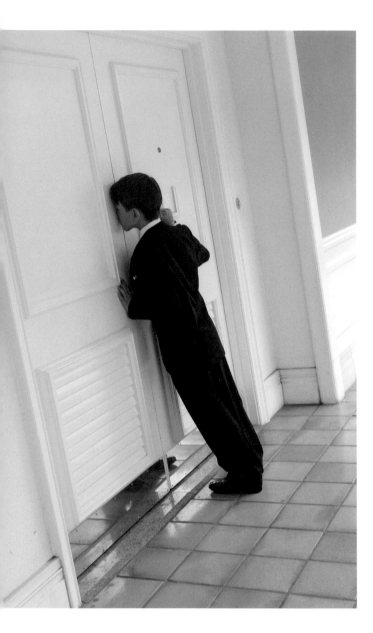

A wedding ceremony is often prime time for kids to fidget and horse around, and sometimes these challenging moments present interactions well worth capturing. Anticipating these instants and moving quickly are the keys to saving them for posterity. This is also one more testament to the importance of looking behind you while photographing the bride and groom.

Nikon D2X, 80–200mm F2.8 lens, *f*/7.1 at 1/50 sec.

Sometimes just walking down the hall at the venue presents opportunities to catch a timeless image. If you were asked to capture the word "curiosity," it might look something like this. Nobody heard this boy knocking, so he was stuck peering through the crack in the door and yelling, "Mom, let me in!"

Nikon D2X, 80–200mm F2.8 lens, *f*/5.6 at 1/200 sec.

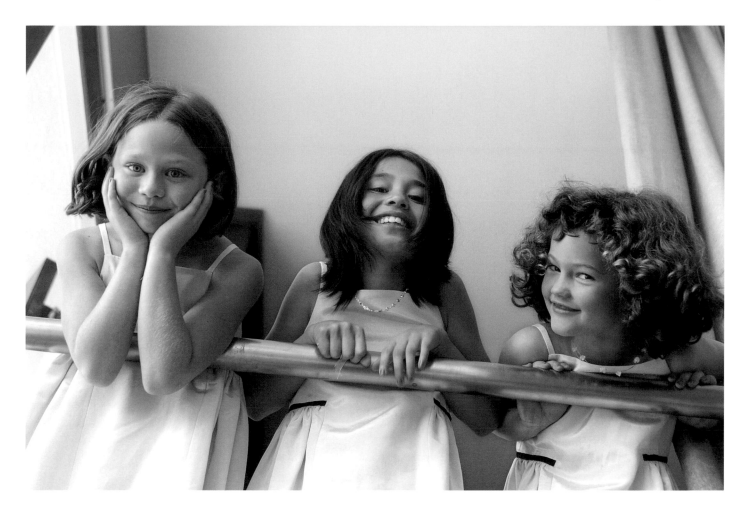

"Flow with the moment. Sometimes one shot is enough, but other times many frames are needed to tell the story and follow the subjects through to a conclusion."

One of these girls yelled from overhead, "Photographer!" I had only a split second to react, but the image became a priceless component in the final wedding album.

Nikon D2X, 28–70mm F2.8 lens, f/6.3 at 1/80 sec.

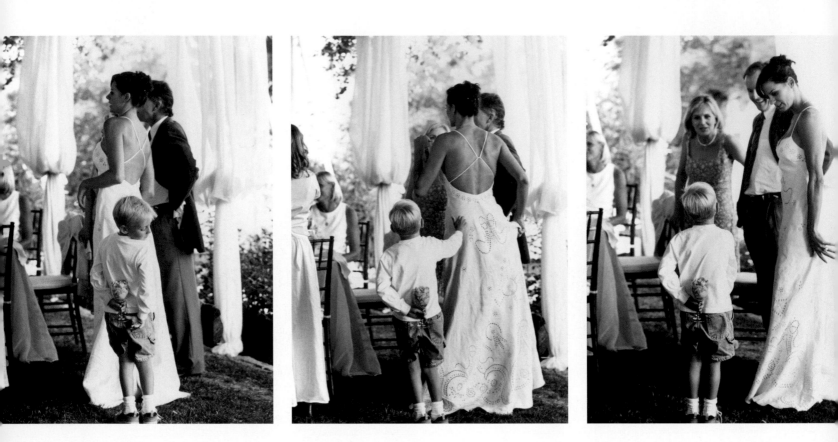

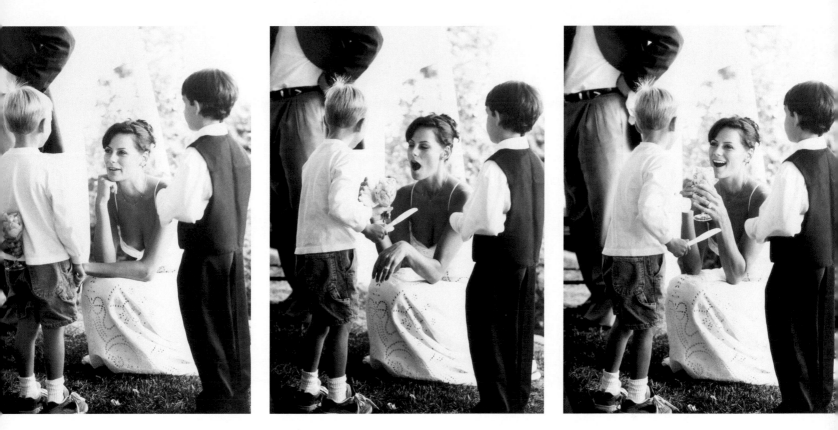

This little boy was the favorite nephew of the bride, and she was his favorite aunt. He came in while she was getting ready and asked, "Do I have to wear this tuxedo?" The bride let him off the hook, and he wore his shorts and sneakers instead. To thank her, he cut a few roses from the venue's garden but got in trouble with the security guard. He then took the petals and put them in a glass to give his aunt. Later, the bride said to me, "If these were the only images from wedding, you nailed it!" They hang, in this order, in a frame on her wall. Remember, great images aren't only about lighting or seizing the moment; they're about giving the bride the opportunity to recall poignant moments from the day.

ALL IMAGES: Canon 1v, 70–200mm F2.8 lens, *f*/5.6 at 1/125 sec.

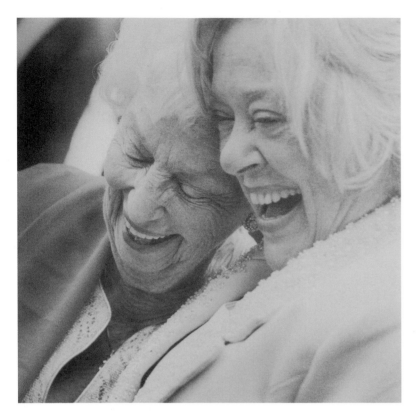

Laughter is always priceless. During this ceremony, the officiant said something particularly funny, and these two grandmothers collapsed into a fit of "church giggles"—a truly winning shot. Remember, turn around and look for all *the possible images; don't just focus on the bride and groom.*

Canon 1v, 70–200mm F2.8 lens, *f*/6.3 at 1/160 sec.

Argue all you want about breaking the "rule of thirds" (which simply divides an image into three imaginary horizontal planes). Just remember, you have to know the rules before you're allowed to break them! In this composition, the grandparents are sitting alone in the back of the church doing what grandparents do— waiting for something to happen.

Nikon F6, 80–200mm F2.8 lens, *f*/4 at 1/40 sec.

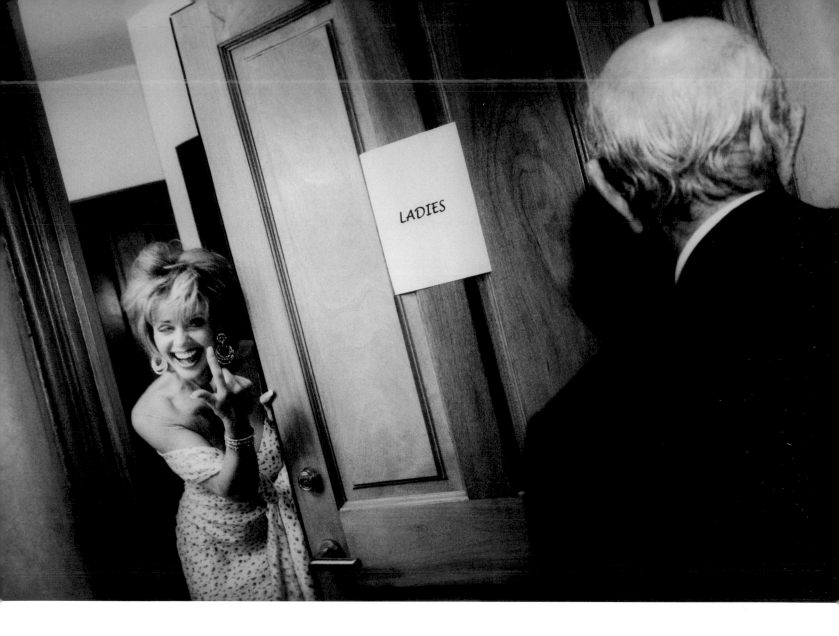

Grandpa was in search of the bathroom when he was offered unexpected help—and an invitation—from a happy guest. Grandpa froze, and the photographer seized the opportunity.

Nikon F6, 28–70mm F2.8 lens, f/5.6 at 1/50 sec., Nikon Sb80 flash

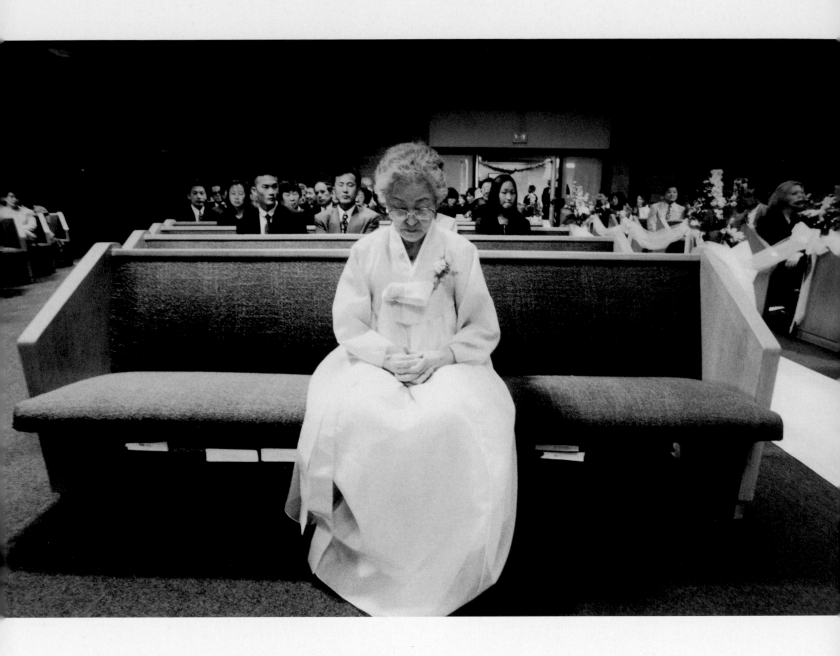

This grandmother was sitting and waiting for the ceremony
to begin. Photographed with high-speed black-and-white film,
the quiet, pensive mood was further enhanced in the printing
process by printing it slightly dark and using a little vignetting.

Nikon F6, 17-35mm F2.8 lens, f/4.0 at 1/20 sec.

RIGHT: *It's unusual for the youngest and the eldest guests to
team up at a wedding. This was how the event started, just
before the official procession. Having at least two cameras
ready to go at all times, this one with a long zoom lens, made
taking this image possible.*

Nikon D2X, 80–200 mm F2.8 lens, f/4.5 at 1/100 sec.

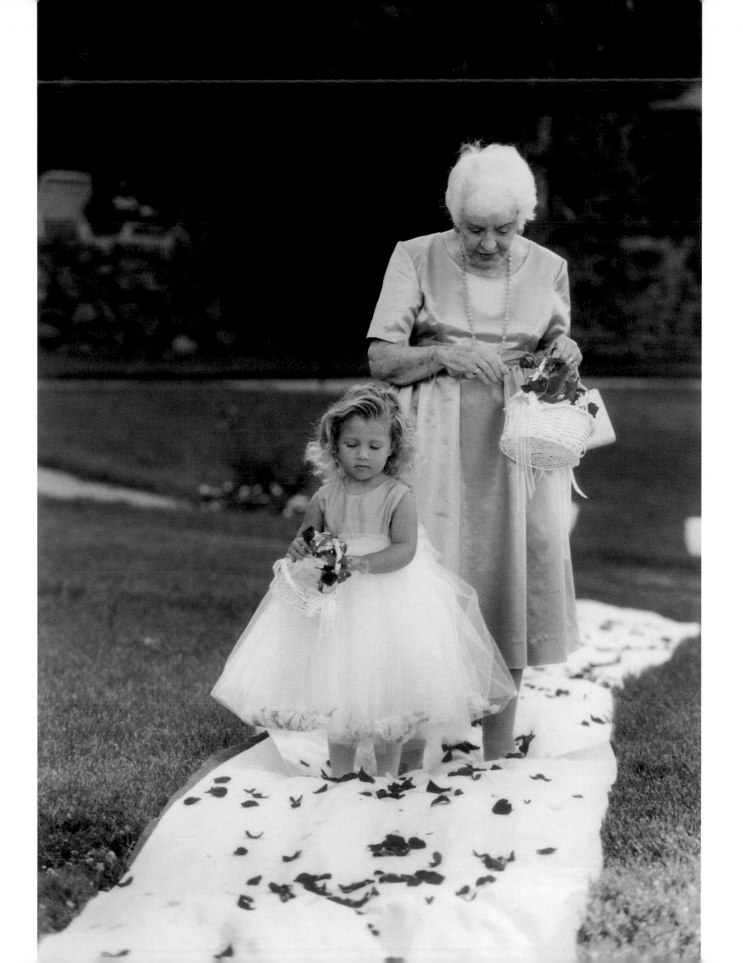

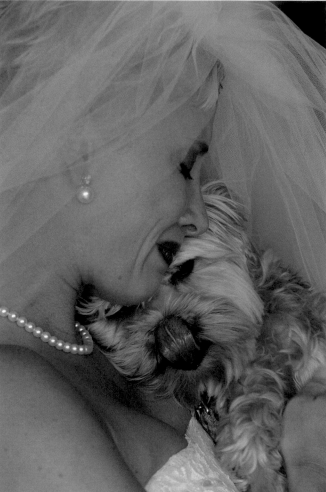

Not every ring bearer is a little boy. This bride shares a moment with her canine ring bearer—and adored pet—before walking down the aisle.

ALL IMAGES: Nikon D2X, 80–200mm F2.8 lens, f/4.5 at 1/200 sec.

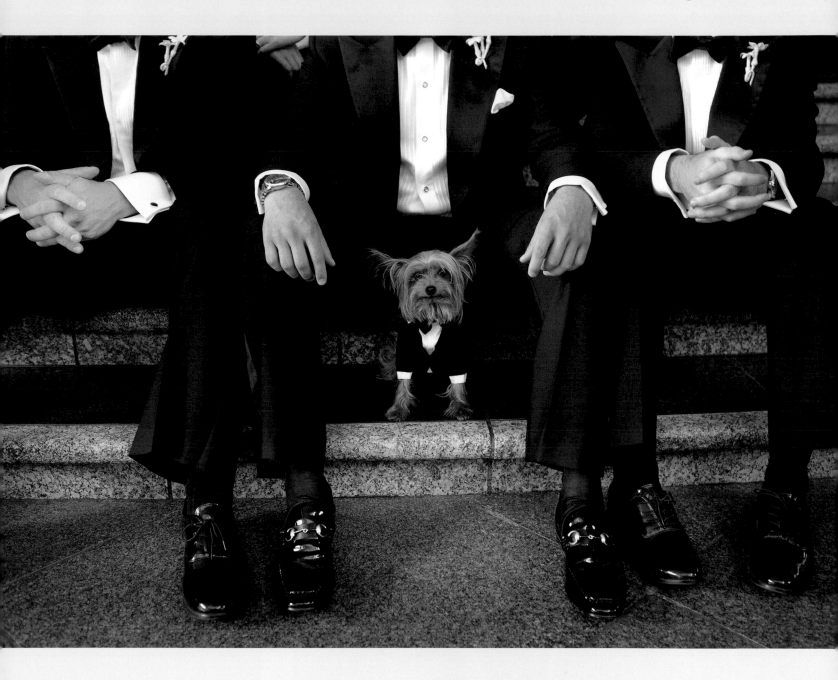

The family dog always deserves his moment in the spotlight.
This moment actually came during a formal group shot of the
groom and groomsmen. Dogs often take direction very well,
but this guy needed no direction—I couldn't have posed it
better if I tried.

Canon 5D, 24–70mm F2.8 lens, f/6.3 at 1/125 sec.

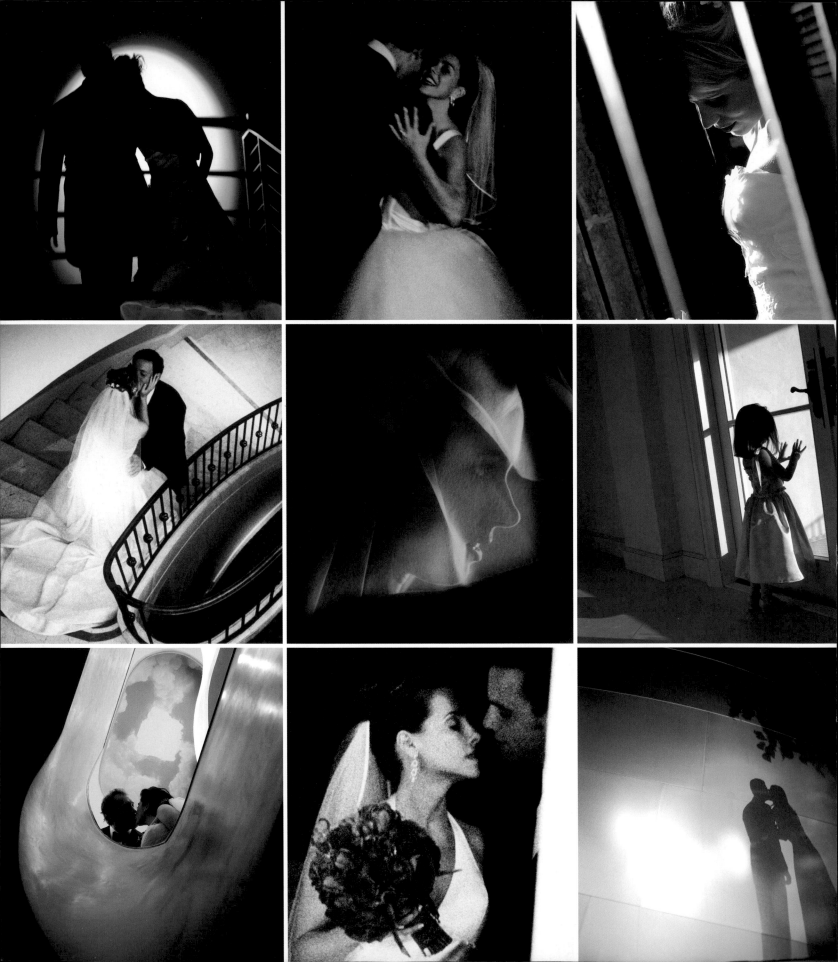

CHAPTER 6 *Looking Beyond Your Subjects:* Shadows and Light

Learn to look beyond your subjects—literally. Often the most powerful point in a photograph isn't the subject, but just beyond him or her, in the shadows. It's about learning to see and training your eyes to perceive texture and contrast. Too many photographers panic when faced with uneven light. But shadows and contrast in lighting are two of your best allies for creating truly amazing prints. Learn to understand every aspect of how your equipment performs and how your subject will look using lenses of different focal lengths. When working with low light, you need to use high ISO film, which is more sensitive and thus requires less light to expose your image. Film with this higher sensitivity therefore allows you a wider range of aperture and speed selection. Virtually everything I photograph is in "Program" mode. If you consistently and diligently practice with every lens you have at your disposal, you will develop enough experience and confidence to anticipate the result without needing to see it first. You can't develop confidence without constant rehearsal and experimentation.

We can't overstate how important it is to understand the basics of photography—lighting, composition, and exposure—*before* you can understand what it means to use Photoshop or other editing software on your images. Most of the tools and techniques in Photoshop were originally based on darkroom techniques, so this should be every photographer's universal rule: Always understand your equipment and the technical aspects of photography from the get-go. Remember, your clients are relying on you to translate their unforgettable day into an unforgettable wedding album, and you don't have the luxury of cleaning up your mistakes later; the right photograph needs to be created when you click the shutter, not your computer mouse. Experiment as much as you can to master the craft and become the very best artist you can be.

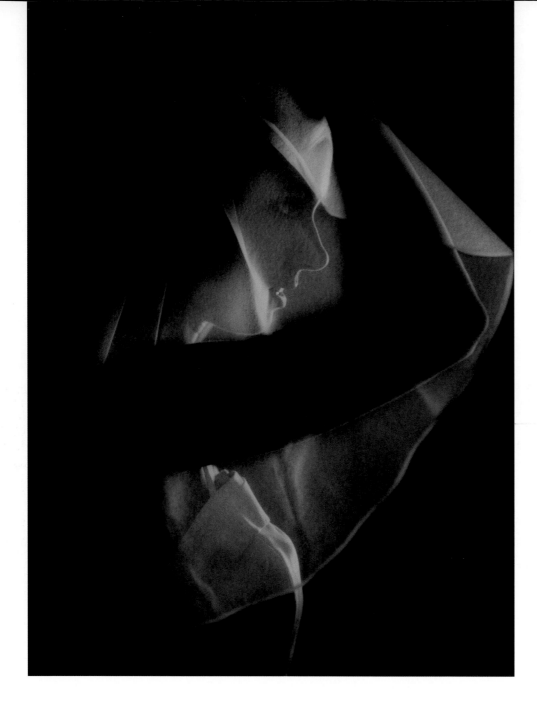

Here the bride is looking in the bathroom mirror; the rest of the magic was effected in the darkroom. The printer saw the result in his mind's eye and created an image that otherwise might not have made the cut. This is a prime example of an image that simply would not work if it were shot in color. With black and white, light is light; you're not distracted by colors in the background that don't work together. It's photographic simplicity at its best, taking advantage of the various shades of gray in the tonal range. You have to constantly practice your craft to see the potential of images like this.

Nikon F6, 80–200mm F2.8 lens, f/4.0 at 1/125 sec.

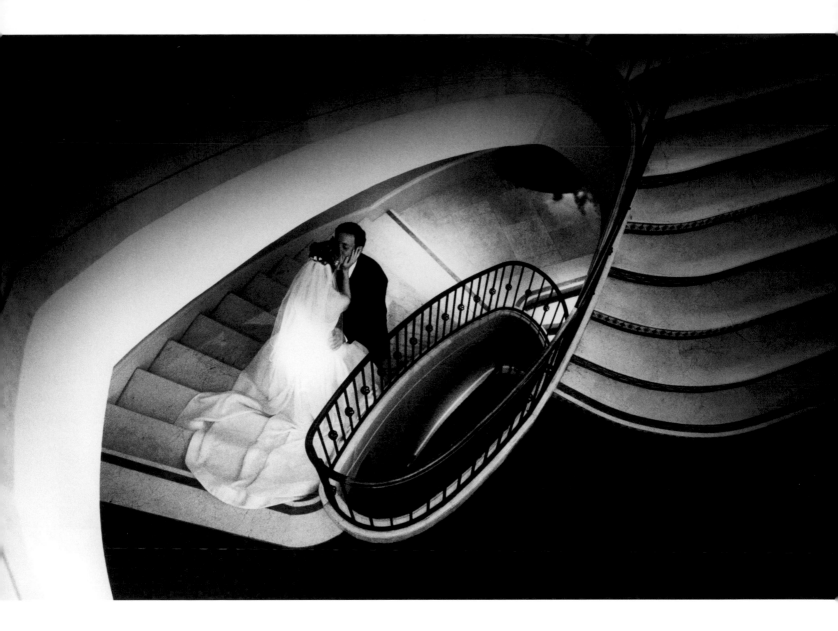

The bride and groom were actually waiting for me to come down to take their formal portrait—but this was a perfect moment! This image was heavily burned in and vignetted in the darkroom, a technique that brings the focus where it's intended, on the bride and groom kissing. Your eyes settle first on the couple, and then wander outward to take in the rest of the image.

Nikon F6, 17–35mm F2.8 lens, f/6.3 at 1/50 sec.

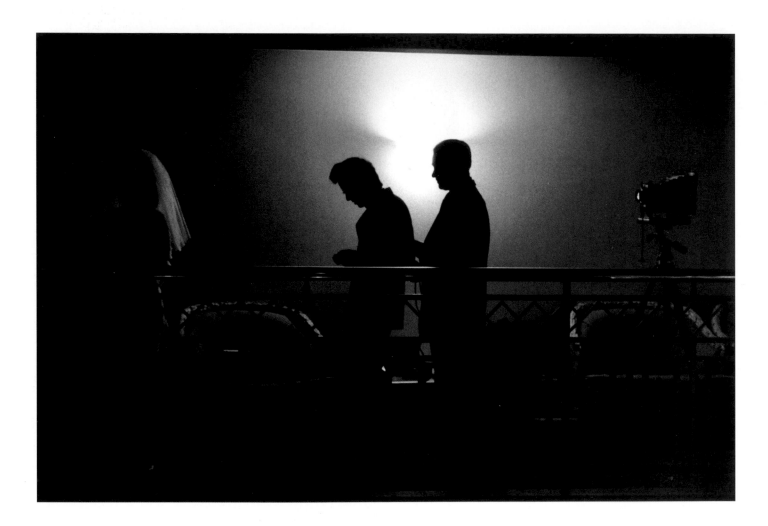

The brother of the bride was a professional photographer and brought his camera to do a traditional portrait, as shown here. All we see of them is their silhouettes, which proves that sometimes it's the absence of light that makes a photograph more memorable.

Nikon F6, 80–200mm F2.8 lens, *f*/4.0 at 1/100 sec.

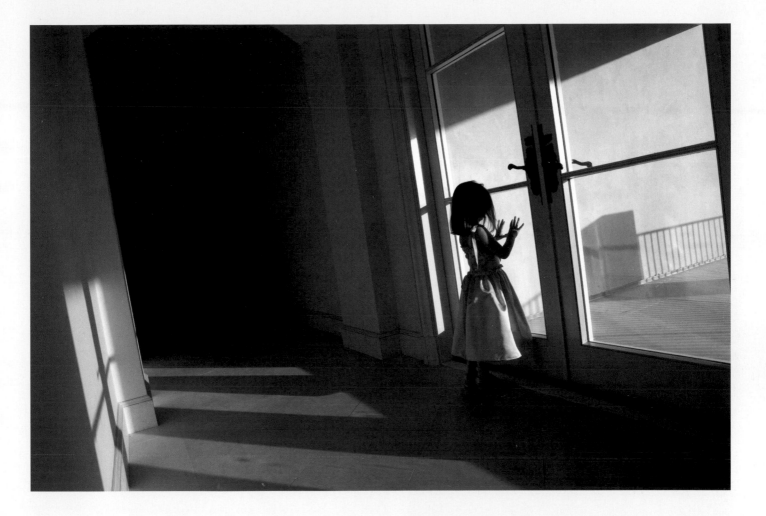

So much of photography is about light. Just before the ceremony, this flower girl stopped at a hallway window to watch the arriving guests. It's so important to be prepared for anything you see because you will catch some of your best images as you're walking by. The shadows and contrast in this room created a dramatic silhouette of the subject, perfectly capturing the anticipation.

Canon 5D, 24–70mm F2.8 lens, f/5.6 at 1/80 sec.

This groom was nervously watching the ceremony being set up, without any idea this photograph was being taken. Because this image was shot with the 70–200m F2.8 lens, the ISO had to be pushed to 1000 so the tree in the foreground would be as sharp as the background. The decision had to be made on the spot as an alternative to using the manual setting to change the aperture.

Canon 5D, 70–200mm F2.8 lens, *f*/8.0 at 1/200 sec.

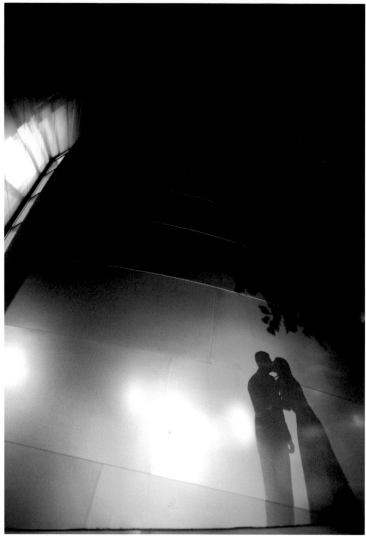

Later that evening, I photographed the newly married couple against the same backdrop, which appeared quite different at night. An initial photo of the bride and groom kissing was taken from the front, but this second image, which I spotted right after the first, is the one that conveys mystery.

Canon 5D, 16–35mm F2.8 lens, *f*/3.5 at 1/15 sec.

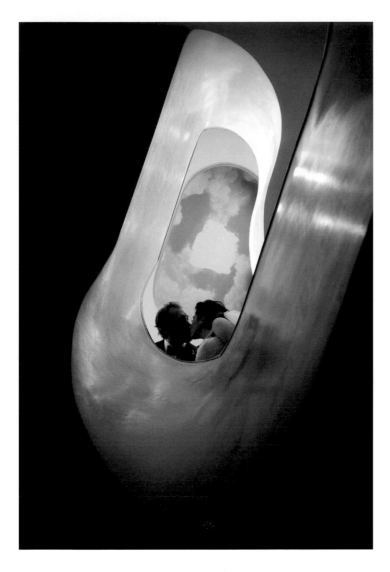

This was the last shot of the wedding as the couple left the venue. The spotlight was actually trained on the wall so people could find the restrooms! Seeing the potential for utilizing shadows and light, the trick here was to set up the camera with the center focus locked. Notice how the railing is out of focus; the focus is instead on the subject, in between the bars. Normally, the autofocus feature would lock on the railing, and the subjects behind it would be out of focus.

Canon 5D, 70–200mm F2.8 lens, *f*/3.5 at 1/20 sec.

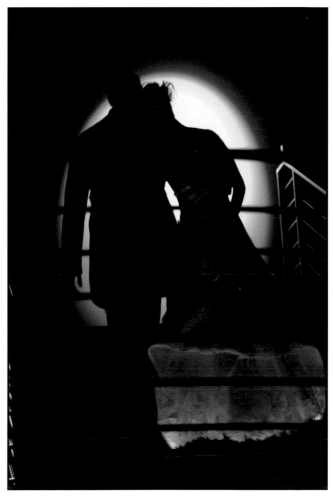

Here I'm at the bottom of the stairwell looking up, as the bride and groom kissed on their way up the stairs. I actually missed the shot initially, but had my camera on "neuro-chrome"— in other words, I locked the image in my head—and asked them to kiss one more time. Although it's not true photojournalism, I don't want to limit myself to one particular style when the goal is to capture the very best images.

Canon 5D, 16–35mm F2.8 lens, *f*/5.6 at 1/50 sec.

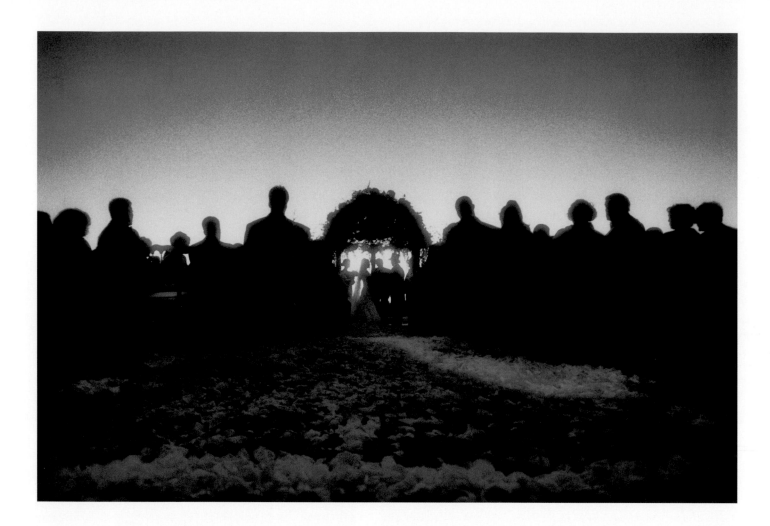

Infrared film enhances a moment out of time. This was taken at sunset, as I went on a quest for silhouettes. Lying on the ground created a unique perspective—with the petals in the foreground and the groom's top hat in the center—that makes the viewer feel as though he or she could literally walk into the scene and wander down the aisle. This image also illustrates the importance of working with a master printer who adds a whole new dimension to each image he touches. This photo is a good example of Robert Cavalli's craftsmanship, as he dodged and burned the print to bring out the highlights as I saw them in my mind's eye. He placed additional emphasis on the top hat and the petals leading up to the bridal party.

Nikon N90S, 17–35mm F2.8 lens, *f*/4.0 at 1/30 sec.,
infrared film with yellow filter

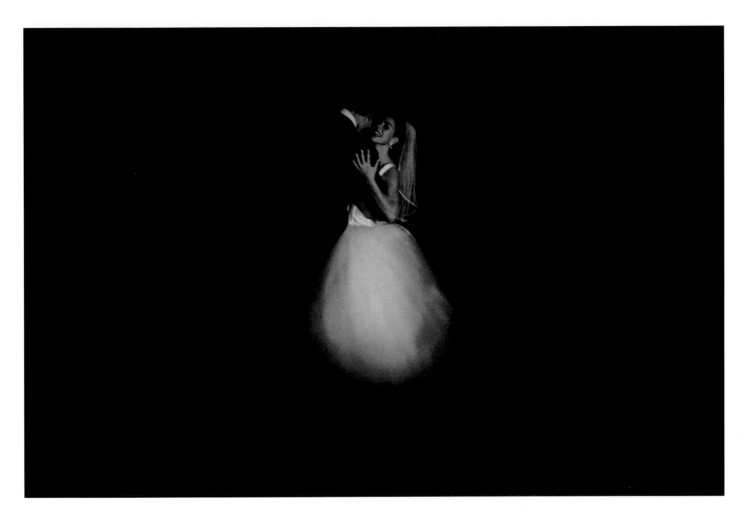

"If you can see the final image in your mind's eye, then you can see not only the light, but the absence of light."

Not every image comes easily—it took six frames to get this one right. The subjects kept moving in and out of the light, and most of the pictures were blurred. It doesn't matter that five out of six shots didn't work—the key is to persevere until you get the shot you want. Most photographers would have used flash for a shot like this, feeling as though they were shooting into a black hole. But if you can see the final image in your mind, you can envision how not only the light but the absence of light can be effective.

Nikon F6, 17–35mm F2.8 lens, f/2.8 at 1/4 sec.

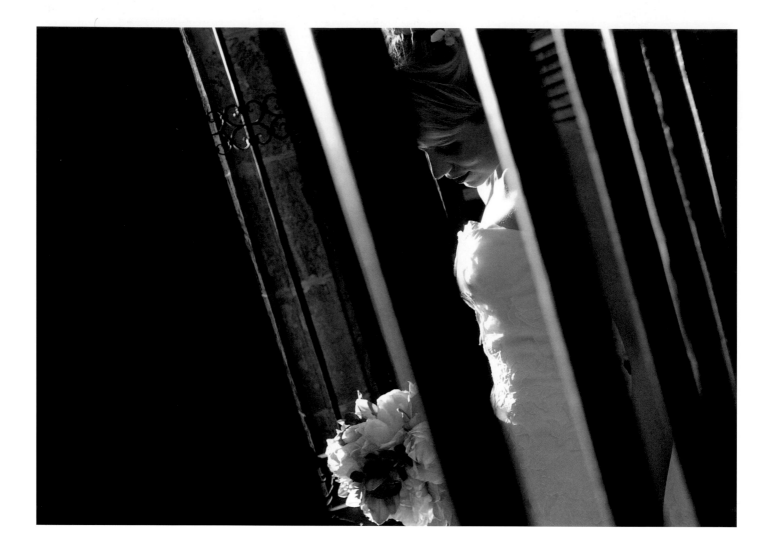

This bride is just enjoying a quiet moment and waiting for something to happen; the blurred gate in the foreground enhances her isolation. Notice the use of center focus again, this time locked on the subject's face and rendering the bars out of focus so your eyes are naturally drawn to her. The power of this image derives from the play of the shadows, the depth of field, and the simple fact that the bride had no idea her picture was being taken.

Nikon D2X, 28–70mm F2.8 lens, f/5.6 at 1/100 sec.

RIGHT: This image was taken in low light with fast film, and the grain creates an artistic, retro look. Notice the guy in the foreground? Hardly—the bride and groom are about to kiss, and that's all that we see. Once captured on film, there was no reason to remove any of the extraneous elements.

Canon 1V, 70–200mm F2.8 lens, f/4.0 at 1/125 sec.

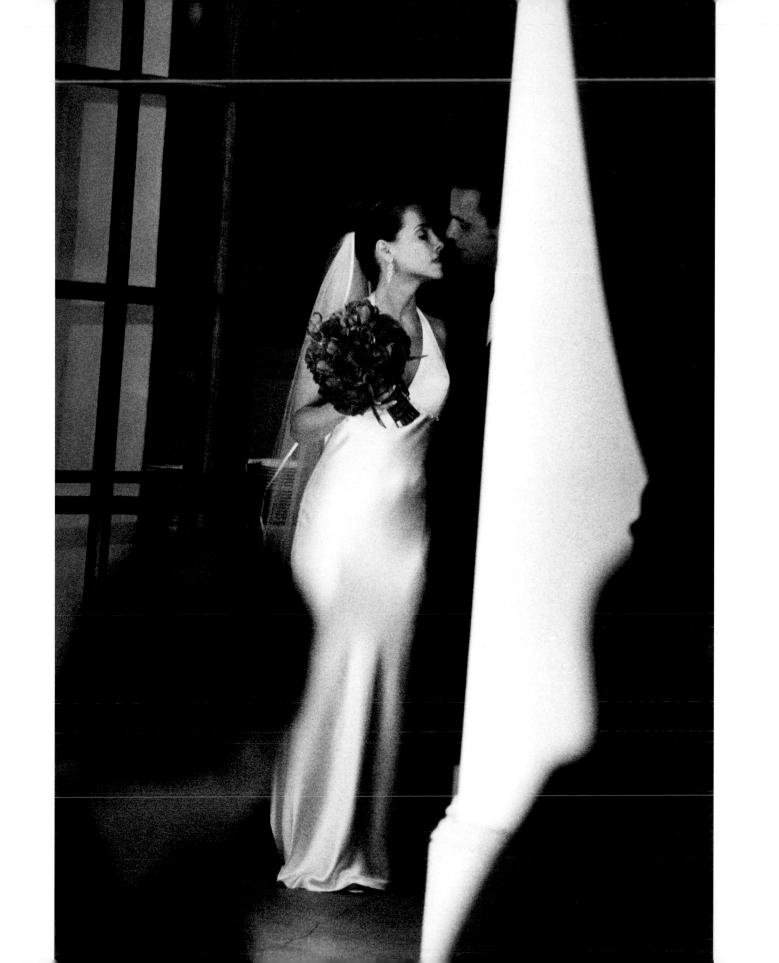

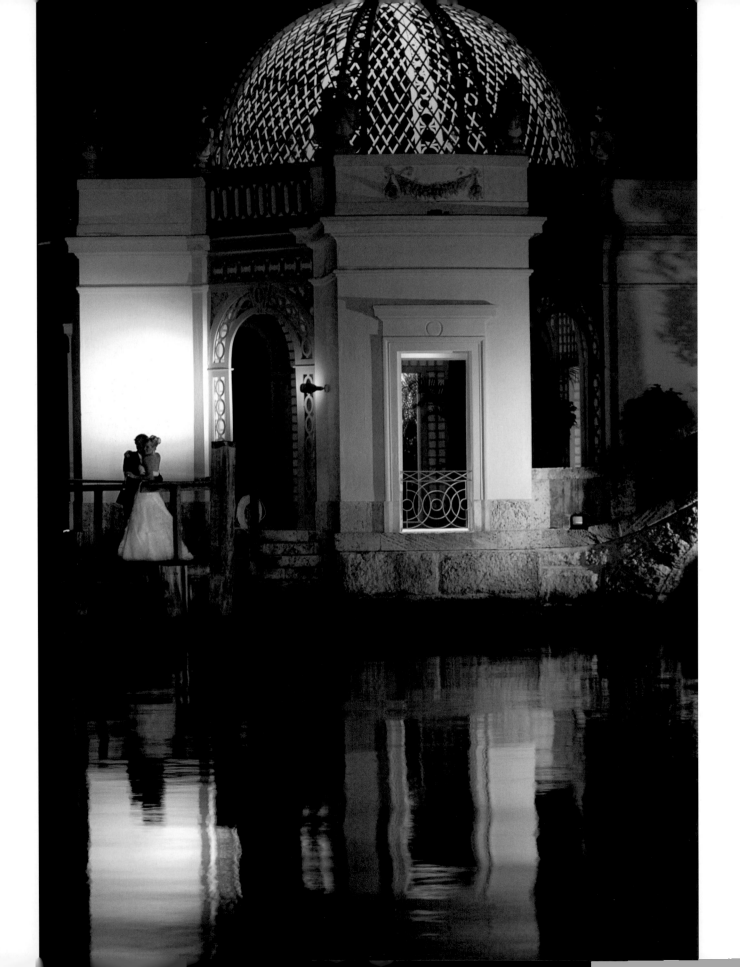

RIGHT: *The bridesmaids were enjoying a toast, and I first photographed them from the front. However, the more powerful image was actually cast on the wall behind them. The shadows tell a better story, right down to the maid of honor holding two drinks. Had I not had a second camera set up and ready to go, the moment would have been missed.*

Canon 5D, 24–70mm F2.8 lens, f/6.3 at 1/125 sec.

LEFT: *As another extreme, this shot was taken from a distance, on the other side of the pond in the foreground. I rarely use a tripod, so for this image I lay on the ground and used a rock to steady the camera. Notice how the perspective—taken from the lowest possible camera angle—makes the scene feel like a fashion shot. Don't let your equipment, or lack thereof, hold you back from experimenting. A tripod would have been nice here, but by the time I had one set up I might have missed the moment. If nothing else, it might have annoyed the bride and groom to be interrupted and have to wait while I set up the camera.*

Nikon D2X, 80–200mm F2.8 lens, f/2.8 at 1/15 sec.

CHAPTER 7 *Starstruck:* Working with Celebrity Clients

It's only natural: If you don't normally photograph celebrities, you're likely to envy people who do. It's part of our culture. Whether because of the roles they play or their influence in society, celebrities represent a lifestyle many aspire to achieve. But be careful what you wish for! You just might get it.

Photographing celebrities is a double-edged sword, with serious benefits and challenges. On the plus side, photographing celebrities, especially at personal events such as weddings, gets your name out there. Wedding photography is a word-of-mouth business, and a satisfied, high-profile client showing off photographs that his or her peers admire is a powerful endorsement. Having your name appear in a photo credit in a national magazine is another strong brand-builder, potentially leading to worldwide recognition by millions of people.

Another advantage is that celebrities can also be easy to photograph. They're so used to being in front of the camera that they already know their best angles, and you rarely have to tell them anything once you start shooting. In other words, they need very little direction. They also tend to be considerably more savvy in terms of understanding lighting, location, and composition. A favorite client of mine to photograph is Jennifer Lopez. She's so relaxed and comfortable in front of the lens that she simply works with the camera in a beautiful way: She requires absolutely no direction. J-Lo is a prime example of a celebrity who knows how she looks best on film.

The downside is that the restrictions can be stifling. For example, no matter what you or the celebrity do to prevent it, paparazzi will find a way to interrupt the event. Often, you have to work around dozens of security people to photograph your client while maintaining his or her privacy and safety. Also, you're not just trying to satisfy the celebrity client, but also the business manager, the publicist, and the attorney—

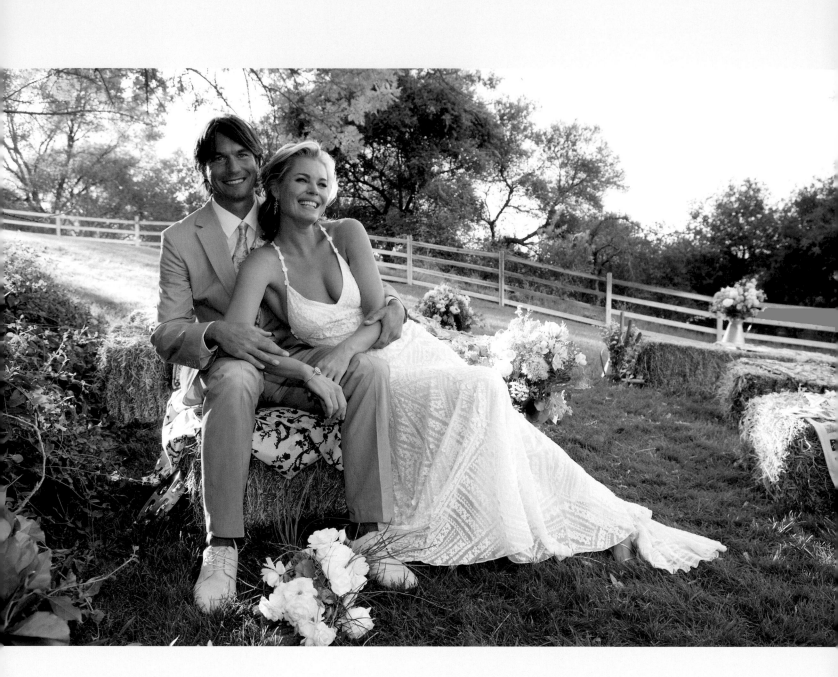

Rebecca Romijn and Jerry O'Connell chose this image, taken about a half hour after everyone had left for the reception, for public release. To fill light their faces, the flash was set at –2/3 of a stop, essentially fooling the camera meter and adding just enough fill to lighten the shadows.

Canon 5D, 24–70mm F2.8 lens, *f*/6.1 at 1/60 sec., with Canon 580EX II fill flash –2/3 of an f-stop

RIGHT: *This was the image* People *magazine chose after working with Rebecca and Jerry's publicist. Although released celebrity wedding images are often posed, this one was full of naturally expressed, irresistible joy. I moved backward relatively fast, maintaining the same distance from the couple as I went.*

Canon 5D, 24–70mm F2.8 lens, *f*/5.6 at 1/40 sec., with Canon 580EX II fill flash –1/3 of an f-stop

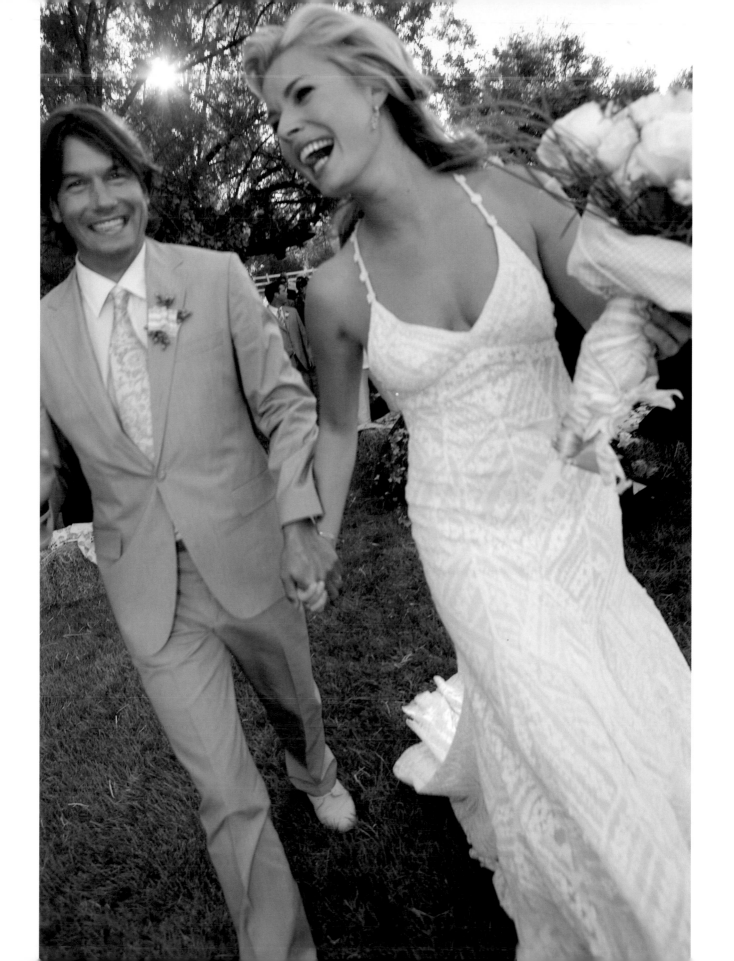

all on whose terms the photographs can ultimately be released to the public. The publicists are especially important because of their concern over the client's image and how it is presented.

You also must shoulder a great deal of responsibility if an image leaks out. Think about how, as a photographer working with the general population, you take for granted the number of people who might be involved in the production of a wedding album. You never think about security breaches such as somebody stealing and selling an image or an idea from the way you posed a subject. With a celebrity, however, an image that is leaked out can spell the end of your career as a celebrity-wedding photographer. It's not an understatement to suggest your client would "own you" if you didn't perform at the level of the terms of the contract.

Celebrity clients really are different in the way they collaborate. They rarely want to shoot engagement sessions, but they'll schedule multiple meetings and phone calls with the photographer with the goal of getting to know one another. Most celebrities want their wedding photographed photojournalistically—in other words, naturally, as the day unfolds. Professionally, they have all too much experience being stifled in all-day photo shoots under hot lights, so when it comes to their personal lives, the last thing they want is anything posed. They do not want their wedding day to become just another formal photo shoot. Sure, there's a small percentage of celebrities who want to pose for portraits, but the majority want to follow a documentary approach rather than a scripted event. They want to convey emotion, not calculated reaction or direction.

There are no standards when it comes to the size of a celebrity wedding. Although the event will always be as private as possible, some weddings have as few as forty guests, while others have as many as five hundred. Usually the wedding will be held on a private estate with very limited access.

The issues of privacy and security, as noted above, add a level of complexity

The wedding was over, the guests had left, and Tiffani Thiessen and Brady Smith were sitting and relaxing for a moment, reflecting on the day. I was looking for something a little different than the typical bride-and-groom portrait and liked the reflection in the door behind them. Notice the difference in mood that is conveyed when Tiffani and Brady are more relaxed, as opposed to smiling down the barrel of a lens. Both are effective images, but the bride liked the one on the right a little more. The image on the left was released to the press after being chosen by the publicist.

Canon 5D, 24-70mm F2.8 lens, f/6.3 at 1/125 sec.

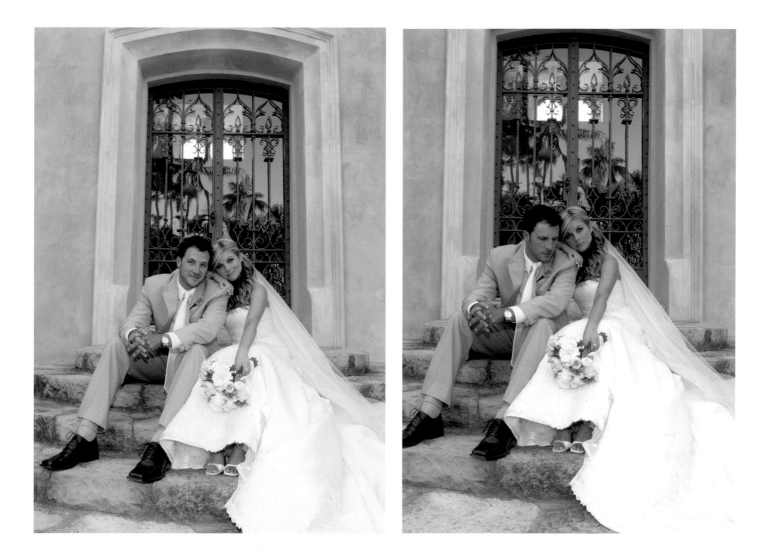

on the day of the wedding. Celebrities typically hire everybody from ex-law enforcement officials to—in one case—ex-Israeli special forces. They want both protection and privacy, not only for themselves but also for their high-profile guests. (It's important to remember that many guests at a celebrity wedding are celebrities themselves.) Thus, it's very common for guests not to be told beforehand where the wedding is to be held. They may be instructed to meet at a parking lot, where their cameras and cell phones are often taken away, and

"When you work with a celebrity, you're there not only to satisfy the client, but also the business manager, the publicist, and the attorney. Every celebrity has an image that has to be protected."

then board a bus to the venue accompanied by an escort from the sheriff's department, to make sure there are no traffic problems. Once at the venue, there will often be weather balloons positioned at different levels to keep helicopters from flying into the area. Even so, the paparazzi still manage to get in and can often be seen hanging off the side of a hovering helicopter, trying to get a shot with a long lens. We once had a situation where the paparazzi got wind of where the wedding was going to be and dressed in camouflage gear. On dirt bikes, they rode up to a point on the side of a mountain overlooking the venue and camped out overnight. At the venue, I caught the flash of light reflecting off a lens on the mountainside at least a quarter mile away. The police were dispatched, and two paparazzi were arrested for trespassing.

Once the events are under way, it's important to give both the bride and groom equal time, just as you would at any wedding, regardless of which has the most celebrity status. Too often, photographers spend all their time working with the bride (if she's more famous) and miss the opportunity to adequately photograph the groom. You also have to work fast. When shooting formal portraits, your goal should be to photograph the entire wedding party, parents, and the bride and groom within fifteen minutes. As always, it's not about capturing perfect images but perfect moments.

Digital technology is a huge benefit when photographing celebrities, simply because of their need and desire to instantly review the photos. Before the night is over, all media cards should be downloaded and ready for the couple to see. Typically—especially at a big celebrity wedding—it's wise to select the best images every half hour or so and put them into a folder on your desktop.

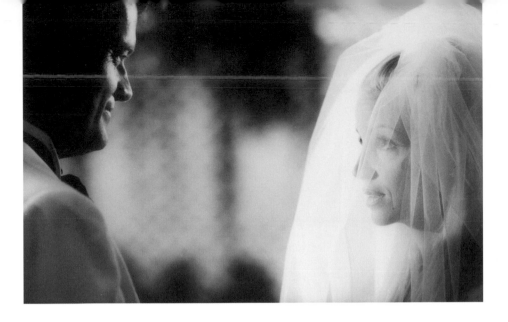

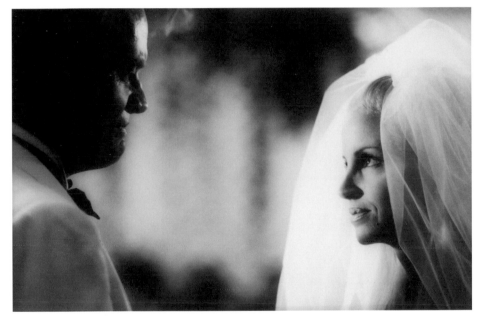

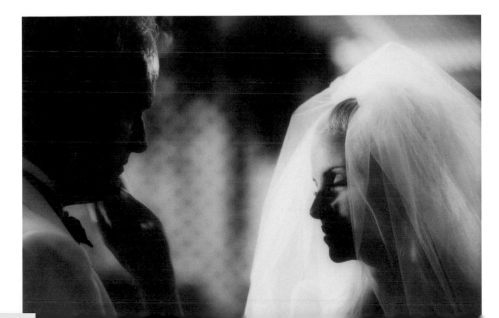

We're all familiar with Kelsey Grammer's abilities as an actor, so what a privilege and great responsibility it was to be allowed to capture and crystallize a moment he and his wife, Camille, will remember the rest of their lives. Relationships with celebrities are not only a privilege but can often lead to other projects. Years after I photographed Kelsey's marriage to Camille, he asked me to document the last three episodes of his show Frazier in a photo book as a surprise thank-you and Christmas gift for the cast and crew. While I was on set shooting, they were all told I was just archiving moments of the show. Sixty full albums were made by GraphiStudio and presented to each person in a leather briefcase inscribed with "Frazier, the Final Days." I hand-signed and numbered each book as an artist's approval.

ALL IMAGES: Nikon F3, 85mm F1.4 lens, f/4.0 at 1/100 sec.

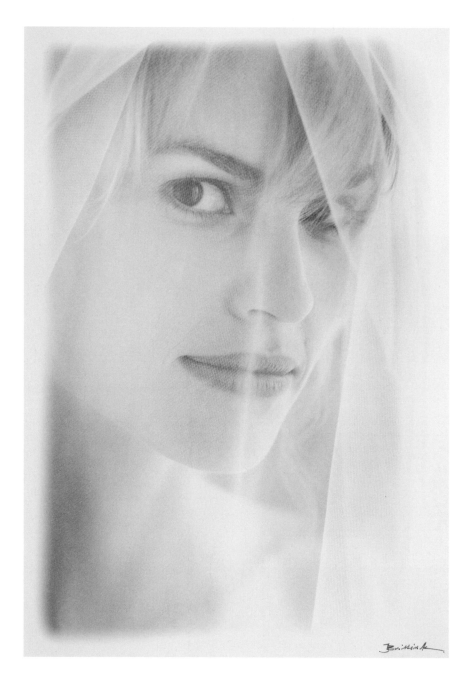

Hilary Swank had just put her veil in place when I whispered to her, "Hey, Hilary." She looked my way, and "click!"...that's all it took. As with just about every image in this book, this was photographed full frame, shot exactly as the image was seen in the viewfinder. Robert Cavalli added fadeaway borders to give it an old-time feel. Notice that this image is signed. When I show my work, I show only signed images. I'm an artist, and I want to suggest that to my clients without saying it out loud.

Nikon F6, 80–200mm F2.8 lens, f/4.0 at 1/125 sec.

RIGHT: Jessica Simpson was taking a few minutes to relax before her wedding to Nick Lachey started. There was a window to her right with sumptuous light coming in. I needed her to look toward the light, so I jumped on a chair to get the correct angle. It's always better for you to move into the right position than to ask the subject to move. Jessica was the perfect subject for infrared film, and the shallow depth of field enhances the image. This is the way the photo appeared pretty much right out of the can. It was not released to the press, but it did become one of the bride's personal favorites.

Nikon N90S, 85mm F1.4 lens, f/3.5 at 1/40 sec., infrared film with yellow filter

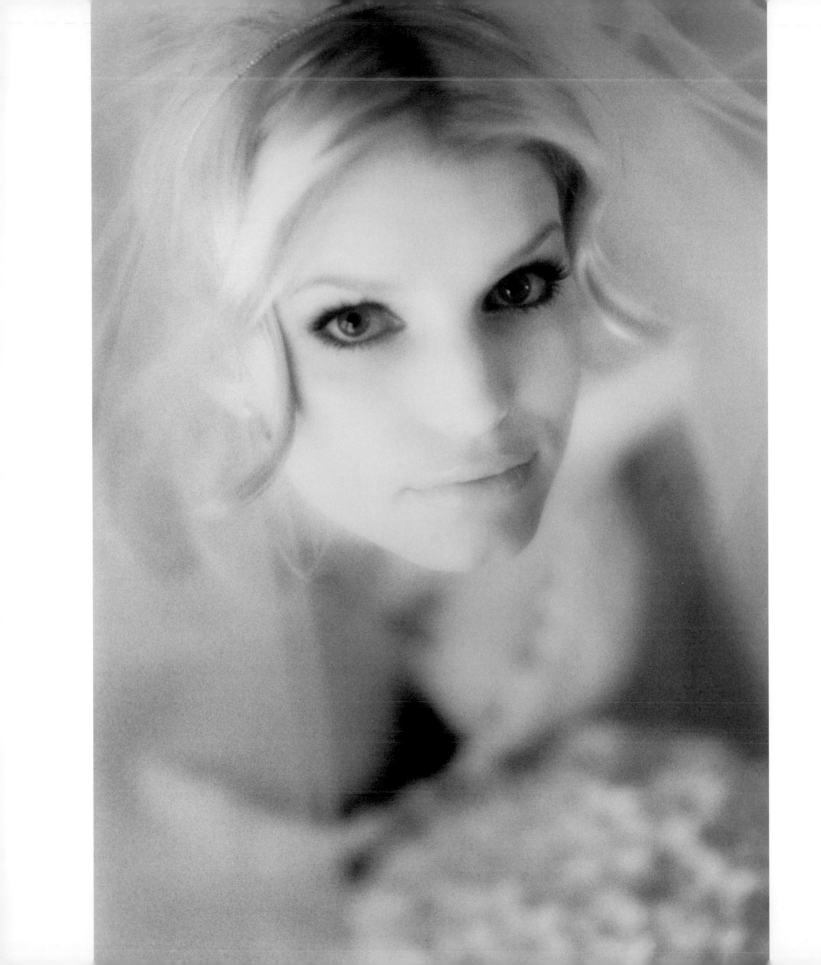

By the end of the evening, you should have fifty to sixty images ready for the celebrity client to review.

When working with celebrity clients, you often must meet one important final goal. The publicist, typically working closely with the bride and groom, has to approve one of the very best images to release to the press. This review session can be very difficult. As at any wedding, everyone is exhausted. They're still on an emotional high, but physically, the wedding is over and it's time to kick back and relax. In the old days, with film, it took a few days before the selection could be made. Now things are more complicated. Shooting both digital and film, I'm careful to make sure the "money shots" are taken with digital, even though some of the more artistic shots will be printed in the lab. This is another reason to always shoot with at least two cameras. It's not only to make use of different focal length lenses set up on each camera, but film versus digital. They serve different purposes and provide two types of finished product.

It's important to note that the celebrity images used in this book have been reproduced with the strict approval of the subjects. Confidentiality with every client, as discussed earlier, is critical. Celebrities appreciate being treated like regular people; after all the hero worship, they're human, just like the rest of us, and would like the same respect. The relationship starts with trust and finishes with some incredible experiences, all documented with your eyes, your heart, and your camera.

This is Christina Aguilera's wedding to Jordan Bratman, and this was taken during the recessional. Experience tells me to be ready at all times, because couples often stop to kiss while leaving the ceremony, which is a wonderful moment to capture for the final album. Dragging the shutter pulls in all of the ambient light in the venue. The flash, fired during a long exposure, freezes the subject, and as the shutter stays open after the flash goes off, all the beautiful light from the room fills the rest of the frame. If shot at a smaller aperture, such as f/8, and a faster shutter speed, this image would have been nothing but a black hole with no added warmth.

Canon 5D, 24–70mm F2.8 lens, f/6.3 at 1/4 sec., Canon 580EX II flash

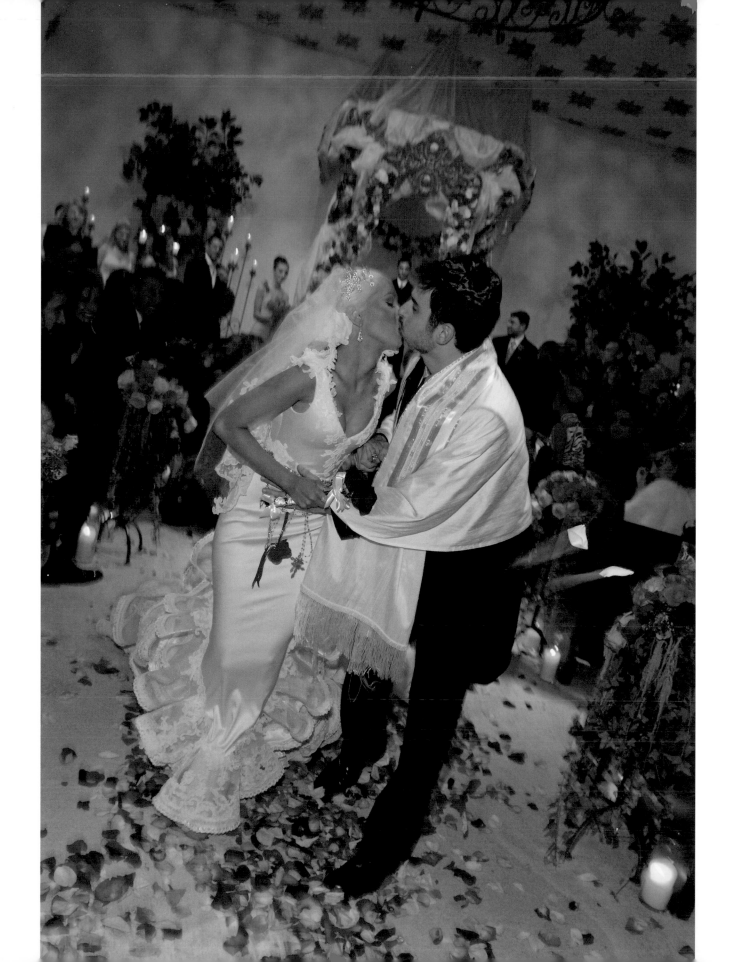

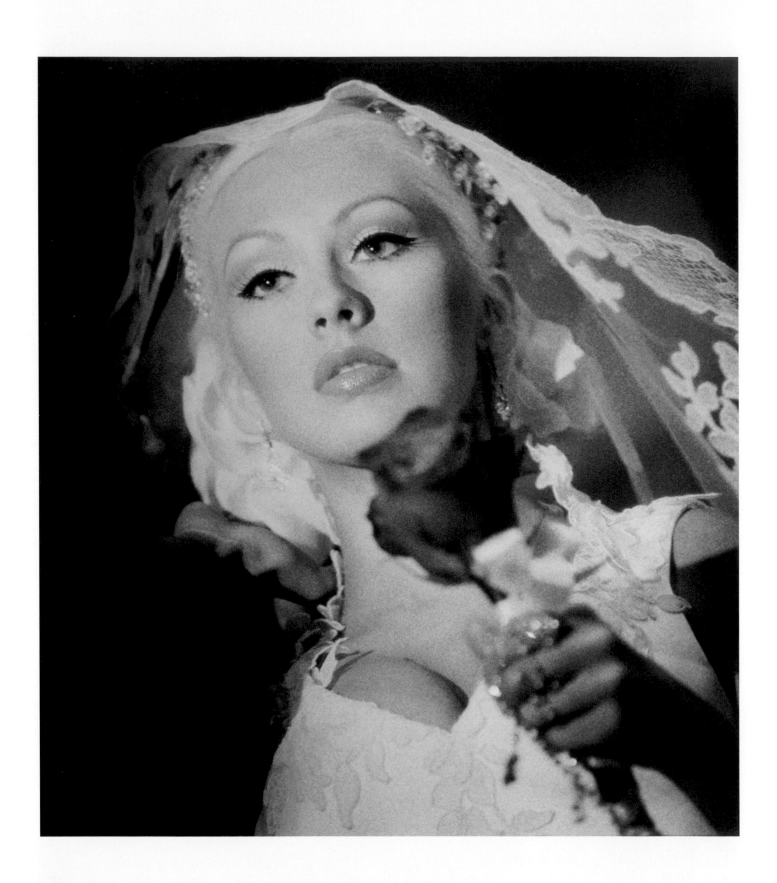

LEFT: *This image of Christina Aguilera was taken with Kodak 3200 T-MAX film and was actually a reflection in a mirror. There was no room for me to get close enough to get this shot, so the only thing I could do was follow her reflection in the mirror and grab shots from a distance, with the lens racked out to 200mm. There was sufficient light, but it was way too harsh, leaving dark shadows in her eyes. I asked the videographer to move in front of her so I could borrow his light. He gave me ten seconds of light— I got what I needed, and so did he! Working with celebrities, you never know when an image will be used later on. This one was chosen as the back cover photo for the insert in Christina's CD* Back to Basics.

Canon 1v, 70–200mm F2.8 lens,
f/4.5 at 1/80 sec.

RIGHT: *Christina had no idea I was taking this photograph. She was getting a pedicure and was simply lost in a dreamy moment. The original full-frame image actually showed clutter on the bed and other peripheral distractions, so I decided to have it cropped during printing. A tight crop helps you focus on what's important in the scene. This became one of her favorite shots from the day.*

Canon 1v, 70–200mm F2.8 lens,
f/5.6 at 1/125 sec.

CHAPTER 8 *A Gallery:* Selected Favorite Images

Every photographer has images that become personal favorites, but what gives an image the power to make a lasting impression? As you'll see in the following selected photographs, the answer is, a little bit of everything: composition, lighting, subject matter, humor, and sheer impact. Sometimes it's the degree of difficulty we perceive; other times, it's the simplicity. With many of these images, notably the black-and-white ones, it's also the skill behind the way it's been printed. This is where a long-term relationship with a printer comes into play, in this case, with expert printer Robert Cavalli.

As you look at the next collection of images, know that there's a story behind each one that inspired its creation, which often illustrates the importance of being prepared, expecting the unexpected, and adjusting to the challenges of each moment. Very few images in this gallery were actually planned, which is often why it's so much fun seeing them again and again.

"Use your camera as a painter might use a paintbrush, the difference being that a painter starts with a blank canvas, and a photographer with a full one!"

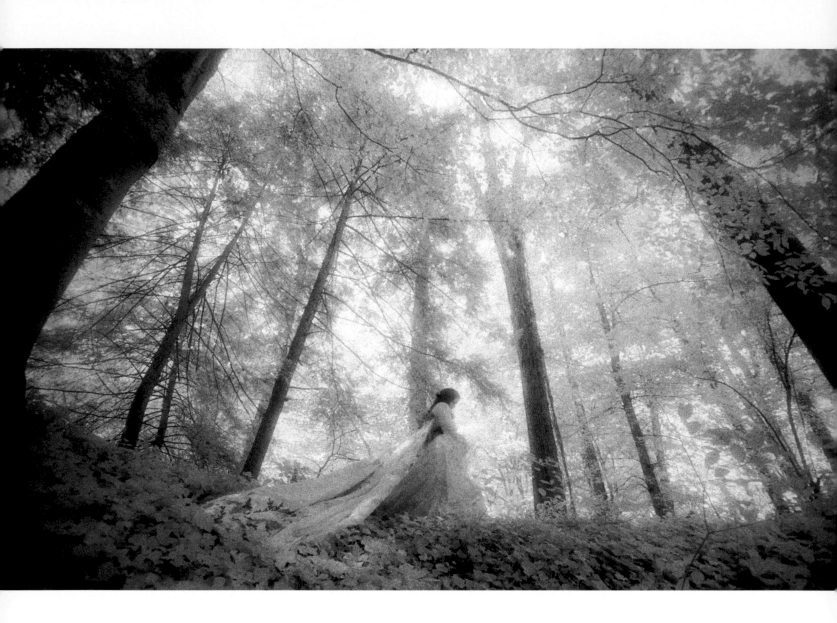

It was a spring day in Atlanta, and the combination of infrared film, a wide-angle lens, and the Nikon N90S was simply unbeatable. I headed down to the bottom of this hill, which was almost a sheer drop. From that position, the ceremony was going to take place behind me in the next hour. Finding the location was purely accidental—I was looking at the ceremony area, and this scene was being played out behind me. Yes, the image was set up in my mind's eye first, but all the directing I had to do was ask the bride to walk across the top of the ridge.

Nikon N90S, 17–35mm F2.8 lens, *f*/8 at 1/100 sec., infrared film with yellow filter

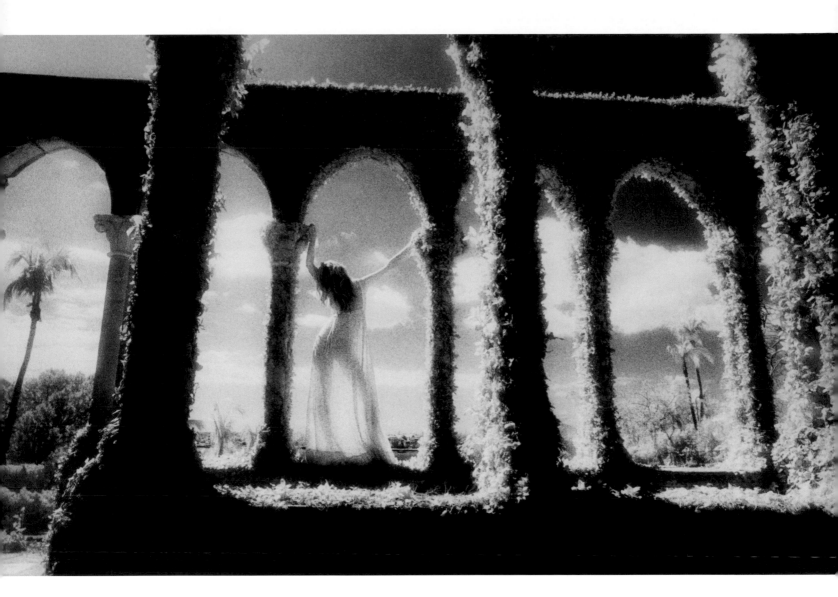

"Consider everything: the time of year, the lens you're using, even the angle of the sun and elevation. They all play a role in how you should rate the film."

This image was captured in the Bahamas the day after the wedding. The bride wanted a photograph of herself in the sexy negligee she had bought to wear for her husband. I scouted for locations and met with her the following morning. I was looking for something out of the ordinary and found this little area above the hotel. I imagined it from a low camera angle that didn't immediately evoke the Bahamas—I wanted the unexpected. It was also the perfect opportunity to use Kodak infrared film, rated at ISO 320, using a medium yellow filter. The camera was set in Aperture Priority mode.

Nikon N90S, 17–35mm F2.8 lens, f/11 at 1/80 sec., infrared film with yellow filter

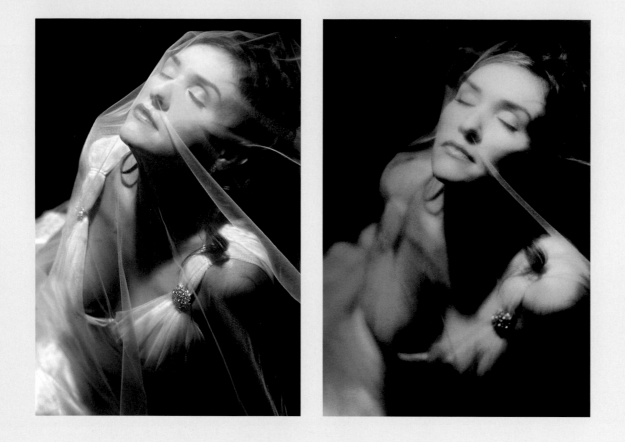

ABOVE: *Improvising is the key to finding images that are unique. Here, the bride was getting ready in a meeting room of the hotel that had a huge table in the center. People were already gathering outside the room, and there was no place to capture such an intimate image. So I improvised by unscrewing all the light bulbs in the ceiling except for one spotter and asked the bride to kneel on the table, looking up into the light. On the left is a regular digital file and on the right, a photo taken with infrared film. Photographer Dean Collins used to have a favorite line: "Beauty is in the eyes of the checkbook holder!" In other words, personal taste is left entirely up to the client. In this case, the client preferred the drama of the black-and-white print, done by Robert Cavalli; Imagexperts printed the color image.*

LEFT: Nikon F6, 85mm F1.4 lens, *f*/3.5 at 1/80 sec.
ABOVE RIGHT: Nikon N9OS, 8mm F1.4 lens, *f*/4 at 1/60 sec., infrared film with yellow filter

RIGHT: *This shot was taken in Mexico, and the bride was a wedding photographer who had attended one of my seminars. This is the day after the wedding, which actually worked to everybody's advantage. Clouds were rolling in, it started to rain, and the groom was barely cooperating. I stood under an overhang and simply directed the bride to give him some attitude. The rest became history when the image was chosen for a Rangefinder magazine cover. Think about what happened here: It is an example of "trash the dress" at its very best, but entirely by accident. The rain, the fact that the wedding was over, and the groom's lack of cooperation all played a role in creating a unique and memorable image.*

Nikon D2X, 80–200mm F2.8 lens, *f*/6.3 at 1/160 sec.

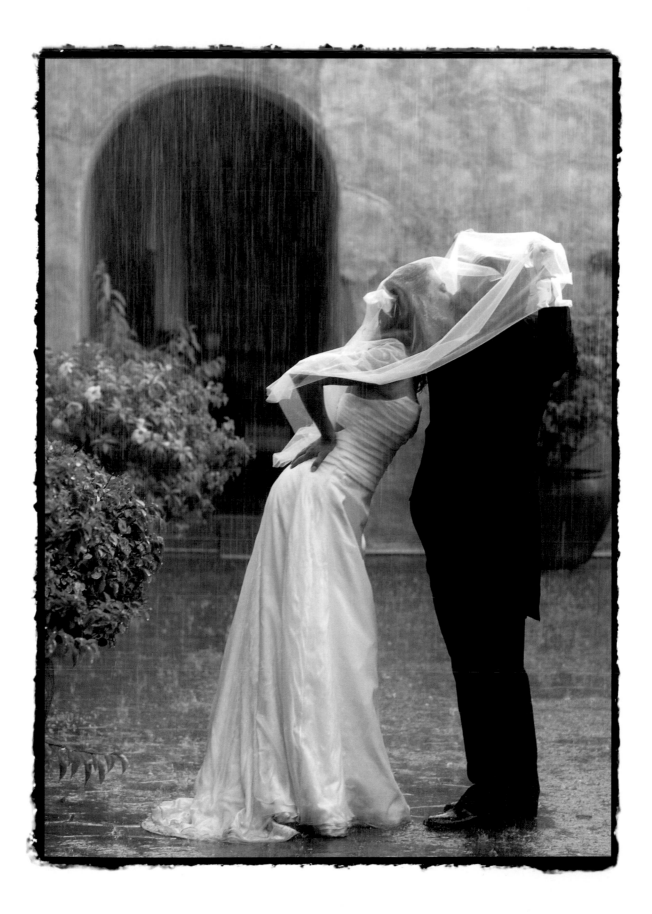

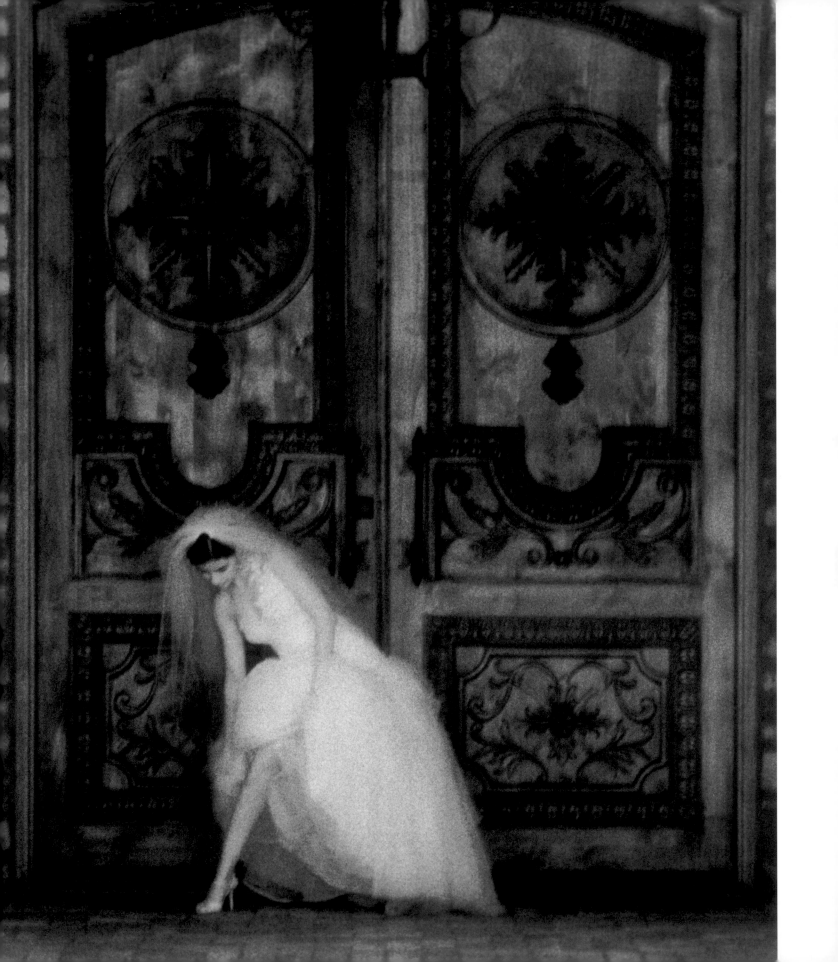

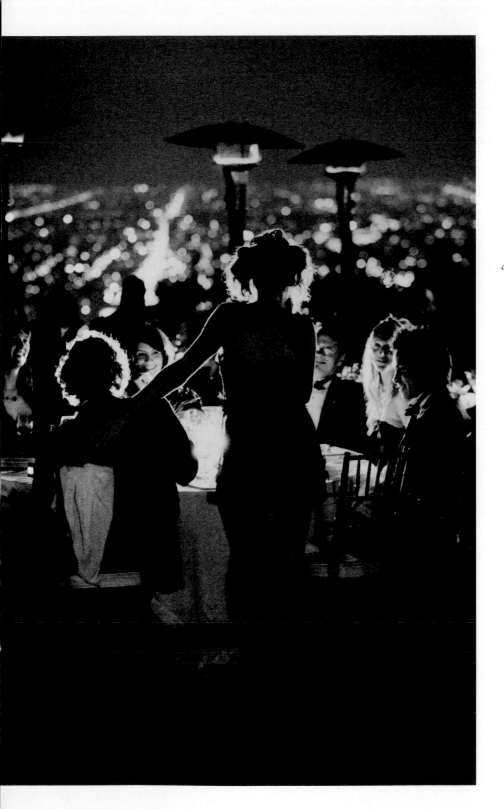

Here's the maid of honor—and yes, that's the minidress she wore down the aisle—toasting the bride and groom in the Hollywood Hills overlooking Los Angeles. To give the image a grainy 1930s look and feel, I shot it at ISO 6400.

Nikon F6, 80-200mm F2.8 lens, f/2.8 at 1/50 sec.

"When using a handheld camera at slow shutter speeds, I usually hold my breath. Then I let half of it out and shoot three frames. At least one of the three will usually be sharp!"

FAR LEFT: *All I did here was ask the bride to fix her dress. Infrared film has become a virtual calling card for me over the years. This is a split tone using sepia and blue toner. Sepia adheres to the highlights first and then drifts into the shadows, whereas the blue toner goes toward the shadows first. The printer literally pulls the image from the toner as it migrates into the highlight or shadow. Consider this a great example of "old fashioned Photoshop" applied in the darkroom.*

Canon A2E, 24-70mm F2.8 lens, f/6.3 at 1/80 sec., infrared film with yellow filter

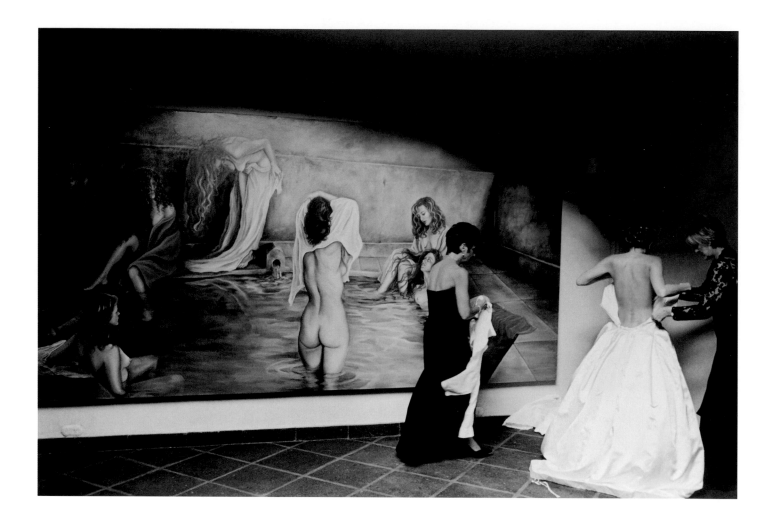

Nikon D2X, 28–70mm F2.8 lens, *f*/6.3 at 1/80 sec.

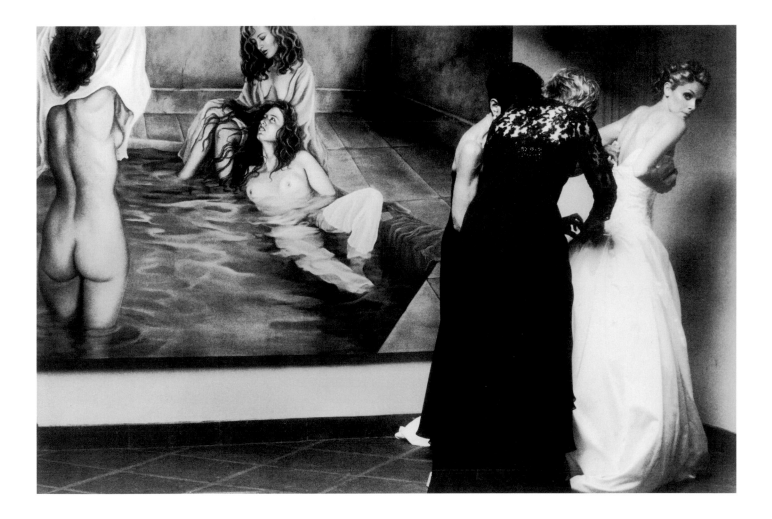

These photos were all about being in the right place at the right time. I had to go looking for the bride, who was down the hall. With two cameras at the ready, I photographed the first one in color (at left), at which time the bride heard the shutter click and turned around. Too late! I was already shooting with my second camera, capturing the black-and-white image. Both photos were taken full frame. I focused on the bride and then, while holding down the shutter, shifted to the left, locking the point of focus on her.

Nikon F6, 80–200mm F2.8 lens, f/5.6 at 1/100 sec.

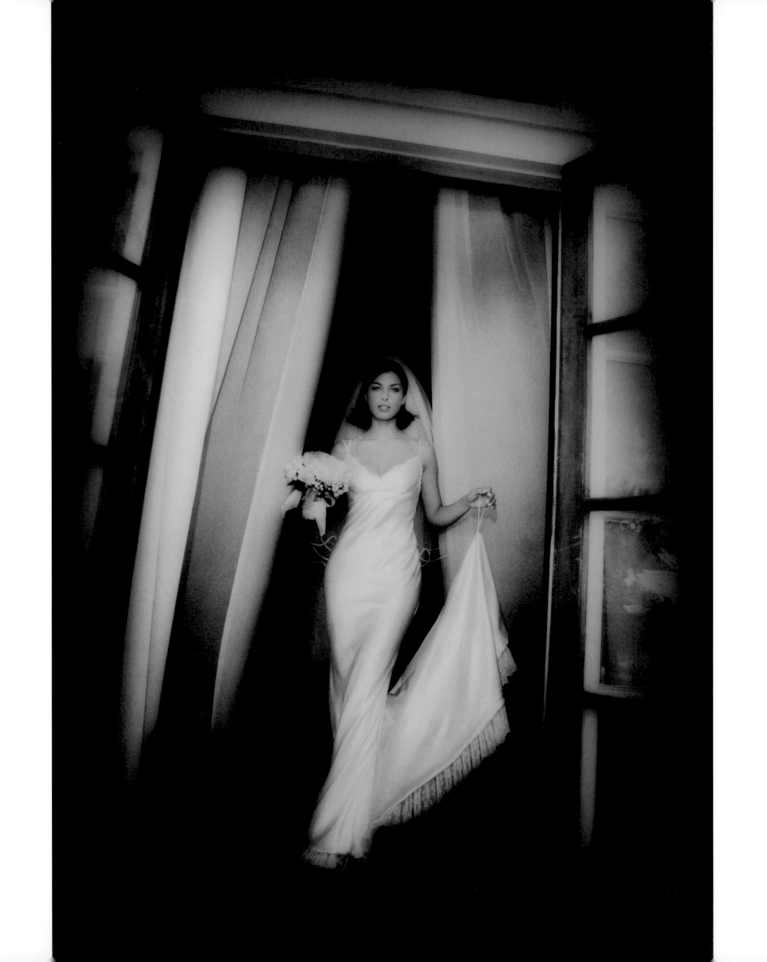

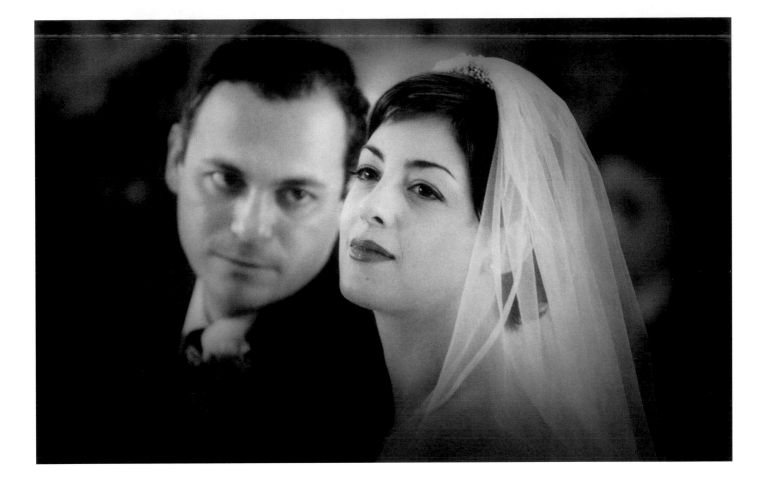

LEFT: *I was walking with the bride, heading for a portrait session with her, when I noticed the billowing curtains ahead of us. Seeing the image in my mind's eye first, I ran ahead and got in front of her. She then walked through the drapes. This is one of the few images in this book where I used a flash. The camera was set in Program mode, and I shot the flash at –2/3 of a stop, giving the image fill, just under the ambient light (notice the very slight shadow cast by the bride's hand on the curtain). A one stop diffuser softened what would normally have been harsher light.*

This image is also a testimony to Robert Cavalli's skills as a printer. The glass panes in the doors were filled with outdoor reflections. By creating the vignettes in the glass, he was able to remove all distractions, allowing us to focus strictly on the subject. This is one of the few prints in the history of WPPI's (Wedding and Portrait Photographer's International) annual print competition to score a 100 and win the Grand Award.

Nikon F6, 28–70mm F2.8 lens, *f*/6.3 at 1/125 sec., with Canon 580EX II flash

ABOVE: *This shot was captured during the ceremony. The bride had not seen her husband look at her this way before. She cried seeing this image and discovering a tender moment she never knew had taken place.*

Nikon F6, 80–200mm F2.8 lens, *f*/3.5 at 1/80 sec.

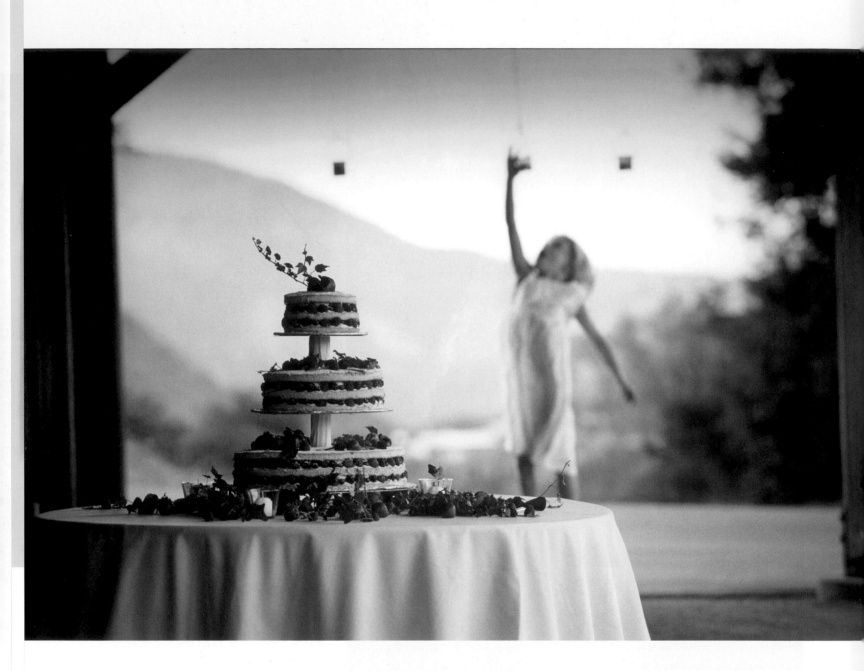

I was doing a detail shot of the wedding cake when this little girl started jumping and trying to touch the candles hanging in the background. In an instant, what had started out as a static still life of the cake became a truly dynamic moment and added to the story of the day.

Canon 1v, 70–200mm F2.8 lens, f/4.5 at 1/200 sec.

RIGHT: A grandfather with his granddaughter is a hard pair to beat for high impact. It was so dark in this church that I had to shoot with ISO 3200 film, rated at 6400, handheld at f/2.8 at 1/30 sec. The softness of the image, from the motion of the subjects walking, only adds to the impact.

Nikon F6, 80–200mm F2.8 lens, f/2.8 at 1/30 sec.

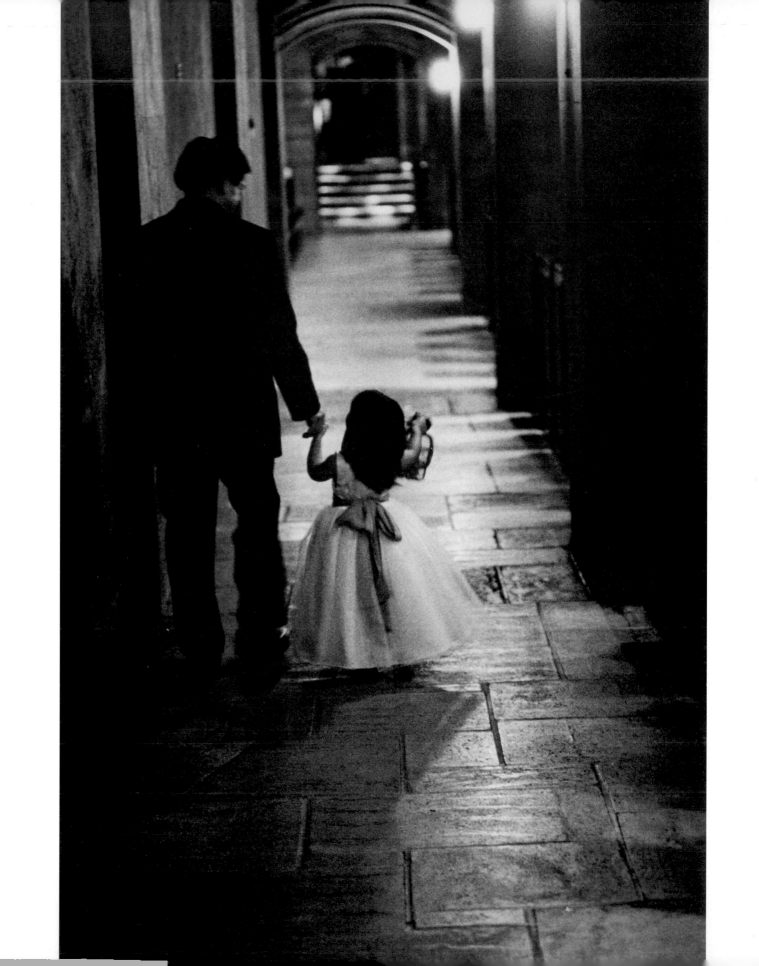

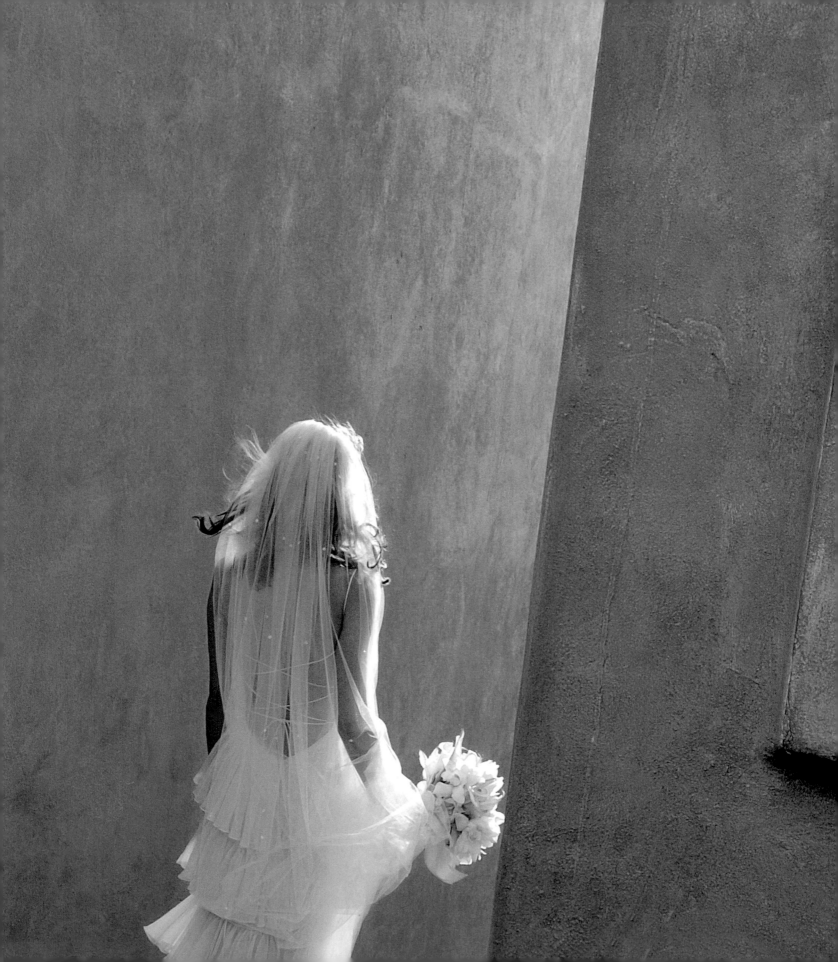

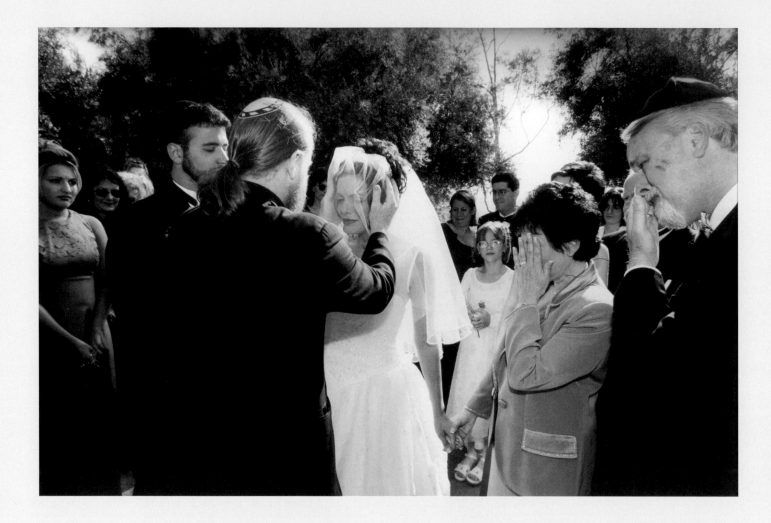

PRECEDING PAGES: *Many people have asked whether I dropped the bride into this shot with Photoshop. Absolutely not! It was photographed exactly as shown here. I had just finished a traditional portrait session with the bride and groom before the wedding. The groom looked at the bride and said, "See you down below, honey!" and the two went off in different directions for the ceremony. As I turned to leave, the wind and sun hit the bride head-on as she started to walk down the stairs. The next time I saw her, she was walking down the aisle.*

Canon 5D, 16–35mm F2.8 lens, *f*/8 at 1/160 sec.

ABOVE: *Mom's crying, Dad's crying, the officiant is embracing the bride, and Dad has lipstick on his cheek. Photojournalism is all about finding such decisive moments.*

Nikon F6, 16–35mm F2.8 lens, *f*/8 at 1/125 sec.

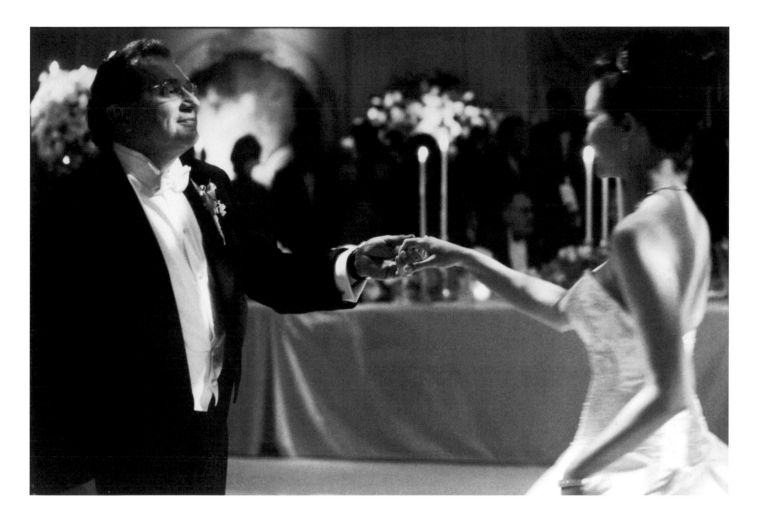

"There's no such thing as a perfect image, only a perfect moment."

Have you ever seen more pride in the eyes of a groom? This was taken with the lens wide open, inside the hotel, with available light. The couple kept moving in and out of the various light patterns. The softness of the bride reveals her movement while the shutter was open.

Canon 1v, 70–200mm F2.8 lens, f/3.5 at 1/15 sec.

CHAPTER 9 *Behind the Scenes:* Equipment and Work Flow

With today's technology and the advancements in digital photography, as well as in film, it's important for everyone who wields a camera to understand photography first and image editing à la Photoshop second. Think about the importance of that statement. You probably got into photography because you enjoy working with people, relish the magic of capturing moments and emotions on a piece of film, or simply want to be an artist. If photography is just a job to you, then put this book down and start reading the classifieds—you won't survive in this business!

A big challenge today is that too many photographers are taking too many shortcuts, with the attitude that "we'll fix the image on the computer later." Did you get into photography to spend hours and hours behind a computer monitor adjusting exposure, composition, and color balance? Then why not learn to get it right in the first place? Digital technology is incredible, but if you understand photography and your equipment, you can go beyond the merely technical. Photoshop should be used to help *enhance* wedding photography, not create it.

This is an example of an image that was shot in color and then converted to black and white in processing. I had noticed this fantastic checkerboard floor in the kitchen of the wedding venue, but the fluorescent lighting overhead was ugly. Still, I saw the perfect black-and-white image in my mind, with the juxtaposition of the flooring, white walls, and the couple's attire, and I set up the shot knowing I would convert it later.

Canon 5D, 24–70mm F2.8 lens, *f*/5 at 1/100 sec.

Let's start by taking a look at the gear you need to have in your bag before shooting your first wedding. Back in the mid-1990s, when my career began, everything was centered on film, so it would have been impossible to become a successful photographer and not understand photography. My camera bag had two Nikon F3 film bodies, Nikon 28–70mm F2.8 and 80–200mm F2.8 lenses, and one Vivitar flash. (I didn't have enough money for a professional flash system when I started out.) As my business grew, so did my gear, including the addition of 17–35mm F2.8 and 85mm F1.4 Nikon lenses. The N90S body joined the family strictly as a setup for infrared film. Exotic lenses, such as a macro and a fish-eye, were added later, followed by a dedicated Nikon flash system.

Today I shoot exclusively with Canon equipment, starting with two Canon 5D bodies, two Canon 1v bodies (set up normally with Kodak T-MAX 400 and 3200 films), and a Canon A2E body set up with Kodak infrared film. Canon's 580EX II is the flash system of choice, usually set up in bounce mode and rarely shot directly at the subject. I keep two of them in my bag.

When it comes to lenses, use the very best and fastest glass you can afford. The faster the glass, the sharper the image! But don't overextend yourself—let your equipment grow with your skills. Lenses in my bag start with the

> *"Don't try to create the perfect image. If you understand exposure and composition, the image will become perfect all by itself."*

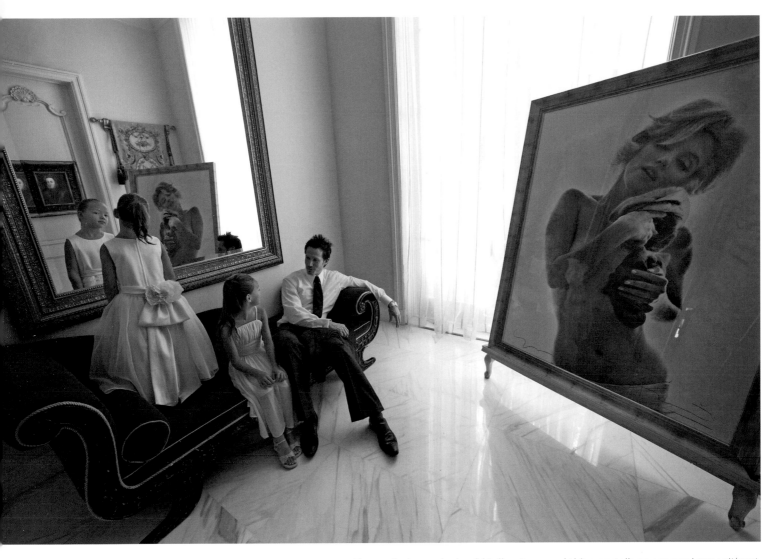

Every photograph should tell a story, and this one tells an unusual one without the benefit of manipulation. At first glance it looks like I dropped in that image of Marilyn Monroe on the right after the fact, or somehow colorized it—but I did nothing of the kind. This wedding took place in a gorgeous mansion, and the giant Marilyn photo was a permanent fixture of the room—and it created a perfect, slightly surreal echo of the little girl's reflection in the mirror. Always expect the unexpected and be ready with your camera.

Canon 5D, 14mm F2.8 lens, *f*/5.6 at 1/160 sec.

workhorse: Canon's 24–70mm F2.8 IS lens. That is followed by Canon's 70–200mm F2.8 IS, the 85mm F1.2, a 16–35mm F2.8, a 14mm rectilinear F2.8 fish-eye (distortion free compared with your normal fish-eye, used primarily in architecture), 60mm macro, and 50mm F1.2 lens.

Digital technology has obviously added a little more gear to think about. I capture my work on 8GB memory cards. Unless it's a celebrity wedding, images are downloaded at home that night. At a celebrity wedding, an assistant will download them to a MacBook Pro laptop throughout the wedding using Aperture software to process the files from RAW to JPEG format.

Once the wedding is over, of course, the work continues. On the film side, normal coverage typically consists of fifteen to twenty rolls, both black and white and infrared. On the Monday morning after the wedding, I hand-carry the film personally to the lab. The fast film and infrared rolls go to Robert Cavalli, and the 400-speed black-and-white film goes to Imagexperts in Los Angeles. I deliver it myself because I want to be the one to tell the lab exactly how to process each roll. I remember how I shot it and how I rated it, so I could never trust somebody else to pass on my instructions. Besides, if a problem arose later on, I would never want to blame somebody else for giving the lab the wrong information! For me, one of the most important parts of the job is to follow through with every aspect of the wedding, including postproduction. There is no substitute for my expertise—my clients have booked me and no one else. Often clients ask whether I'm going to shoot their wedding myself or send one of my assistants. I assure them that I am always there in person. Because I'm so invested in what I do, it's important for me to follow through on every step of the process.

Your relationship with your printing lab and all of its staff is critical, all the way down to knowing exactly who is going to print your work. I have worked with Robert Cavalli almost from the very beginning of my career as a photographer.

A large part of the impact of this image is thanks to using a wide-angle lens. The wedding took place in Mexico, and I happened to walk by the pool as this young man was waist-deep, lighting floating candles as the sun set. He was perfectly aglow, as were the palm trees, and that together with the reflections in the pool created an ethereal effect.

Canon 5D, 14mm F2.8 lens, f/2.8 at 1/10 sec.

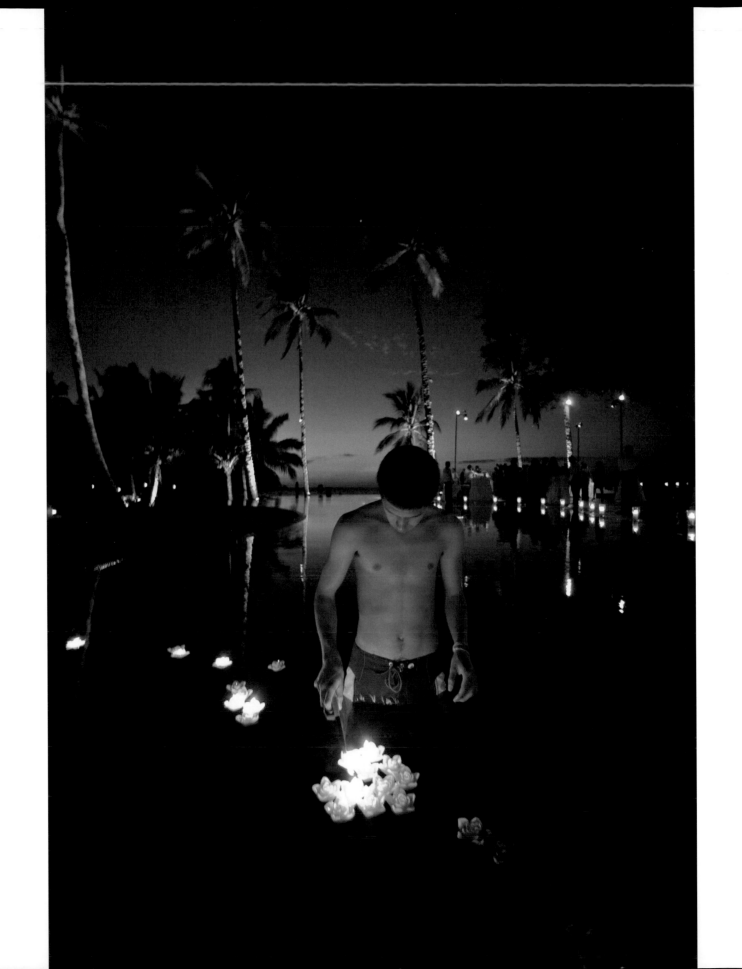

Robert is the Cecil B. Demille of printing; he makes a "big print" even bigger. As you look at the images in this book, keep in mind that all the black-and-white prints were made by Robert, whose work enhances them in limitless ways.

Virtually all the color images in this book were photographed with Canon equipment and printed by Imagexperts, with whom I've been working for close to ten years. Owners Jane and Zaid are simply amazing people who run one of the very best labs in the country. I refuse to spend any time processing images at the computer myself. I want my lab doing the editing work so I can market myself, keep fine-tuning my skills, and concentrate on what I do best: telling stories.

For the digital files, every Monday morning my associate Kevin Lubera converts all the RAW files to JPEGs. He color-corrects them and, if necessary, converts some of them to black and white. Which images should go into black and white is often determined by Kevin's eye. For example, some images with uneven light, often taken during the reception, look better in black and white; they're too difficult to color-correct and maintain in color.

The files then go to Pictage, an online photo sharing and professional photography services company, for proofing and online service. Either my wife, Marilyn, or my assistant, Urbanie, will edit the work, which is a luxury. Marilyn used to be a director at Peter Fetterman Gallery in Santa Monica, and coming from an art background, she understands the look I want. She and Urbanie, because they're women, look at my work more with the eyes of a bride; in that sense, they're highly in tune with what the client is likely to want and the way I like to tell the story.

Robert Cavalli creates proof sheets for review. I select the images I want and send them over with the film to Imagexperts, who print the proofs from these selections as well as the film they've already received; they create scans as well.

The next step is to get everything online. Pictage already has the digital files at this point, so I send a disk of the scans of the film files done at Imagexperts to

Here's an example of a "wow" image I would print, matte, and mount on the wall to greet my clients when they come to see their proofs. The moment captured in this print was completely spontaneous; we were stuck in traffic on the way to the reception and the bride was getting increasingly anxious about being late. I saw the Robert Indiana "LOVE" sculpture just ahead of us, grabbed some umbrellas, and said, "Let's go!" Within minutes we had dashed through the rain, fired off a few frames, and gotten back to the car—which still hadn't moved an inch. But by then the couple was laughing and flush with the thrill of spontaneity, which will always be remembered through this image.

Canon 5D, 14mm F2.8 lens, f/2.8 at 1/30 sec, with a Frezzi light

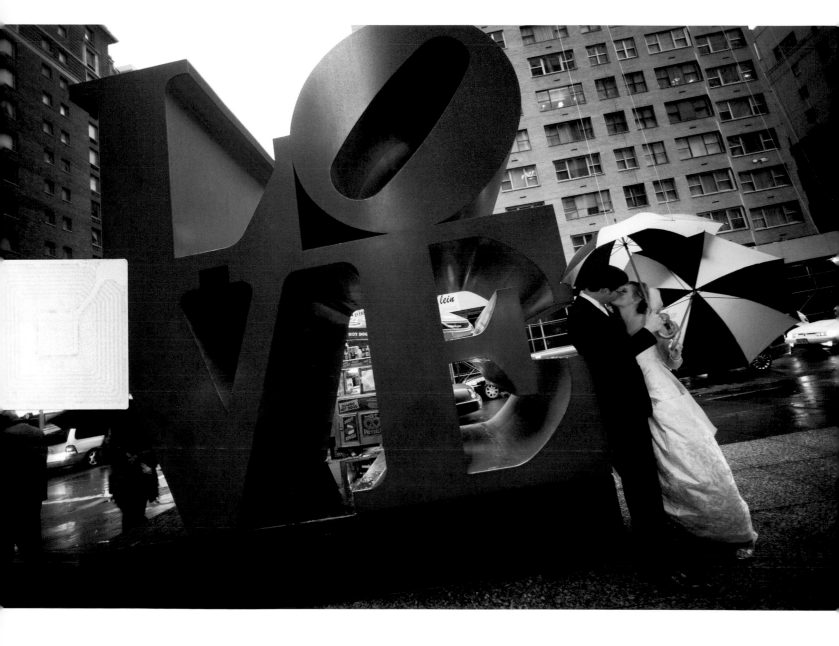

Pictage to add to the online gallery. This cuts out the risk of negatives going back and forth from lab to lab. Once everything is complete, the client gets the benefit of both seeing paper proofs and online hosting. Online hosting is ideal for sharing images with family and friends, but clients seem to prefer paper proofs for picking favorites for the final album. My clients expect something tangible to work with, and paper proofs add to the craftsmanship of the final products, whether individual fine art prints or the album.

Whenever possible, I encourage clients to come by the studio to pick up their proofs. I rarely deliver proofs to the client. Having them in our studio allows me to better answer their questions and helps them better understand the quality of the finished images.

While most of the images for the album are printed in the lab, I also create 20 x 24" prints of some of my favorite shots in the studio on a Canon 6100 photo printer. Imagine this: You're the bride and groom and you come to the studio to pick up your proofs. Before you've seen one single image, there's a matted 20 x 24" print from your wedding—my favorite photo of the event—on the wall. The impact is phenomenal. Rarely do they leave without purchasing that print, and the excitement I've generated feels amazing. In those rare times when they don't buy the print, it hardly matters—I've only wasted one sheet of paper.

In addition to the image on the wall, I select one more favorite and present it to my clients as a signed 8 x 10" image printed by Robert Cavalli. By showing them the final quality of the product, they'll understand what the finished images will look like. Plus, because the image is signed, it's also a thank-you for allowing me to photograph their wedding.

At the client's leisure, after they've picked up their proofs, they spend time selecting their favorite photos for the album. This can typically take up to a year or more. While some photographers might look at this as a drawback, I look at it as a

plus; this way, they have ample time to look at the images and fall in love with them! They usually come back with several hundred favorites because they simply could not narrow them down. Urbanie then steps in to help them further edit the images— down to one hundred fifty or so—and then design their album. She puts the images in chronological order and tells the story of the day, making appropriate layout suggestions. The client will usually come back for final approval, or sometimes will look over a PDF we've sent them showing the final design.

The books are then printed by GraphiStudio in Italy, another significant partner in the process. Graphi will send me the PDF of the final book, and I'll do a final review just to make sure some of the better fine-art pieces haven't been overlooked. Why GraphiStudio? No matter whose books they're compared to, whether printed in the United States or abroad, clients love their quality. I always show samples from at least three different manufacturers, and clients always gravitate toward the GraphiStudio books. Plus, the crew in their U.S. office is outstanding to work with!

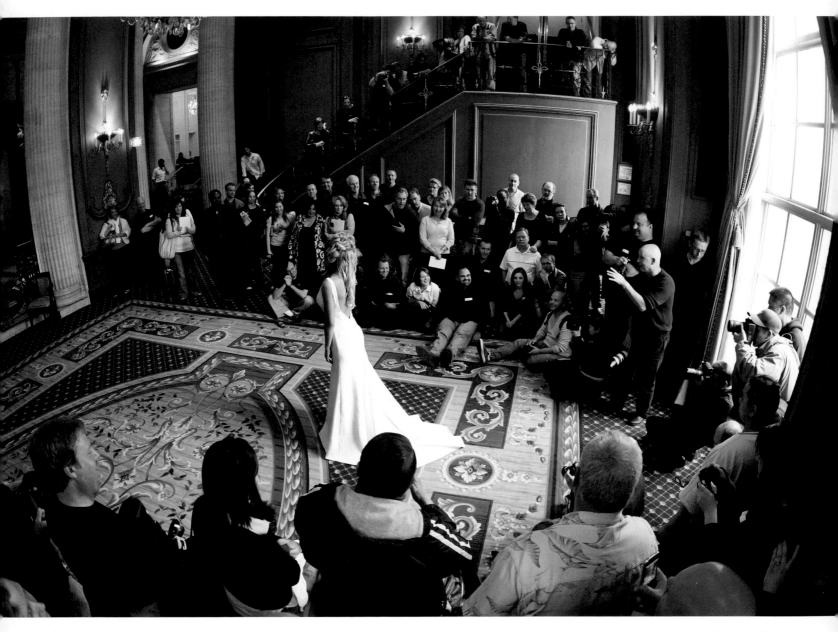

CHAPTER 10 *Making It Work:* Building Your Business

By far the most important way to build your business is through word of mouth. At every wedding, there are potential clients among the guests and participants, so with this in mind, I try to establish a relationship with every member of the wedding party. It's not uncommon for me to photograph a wedding where at least four previous clients are in the wedding party. *Never* forget that your strongest ambassadors are your previous clients. Conversely, in a word-of-mouth industry, a few serious mistakes can do irreparable damage to your reputation. However, if you do a great job, word will get around and your business will certainly grow. It's important to establish a philosophy, or work ethic, with every client—and then to always exceed their expectations. There's a great saying about portrait photography versus wedding photography: "If you mess up a portrait session, you can always reschedule and photograph the client later on. Mess up a wedding and you need to leave town!"

Beyond your own clients, however, there are several ways to network in the industry. Events, such as the WPPI's (Wedding and Portrait Photographers International) annual convention, are some of the best ways to meet other photographers and potential sponsors, home in on the manufacturers whose products you use the most, and start building a reputation. We recommend you attend every relevant convention you can find time for.

The key to successful networking at any trade show or convention is to avoid selling yourself overtly. Don't approach the show as a way to collect business cards but rather as a way to get to know people and let them get to know you. Carry a small portfolio or a few images with you, to be shown only if someone asks. Stay humble, stay focused, and

Joe giving a demonstration at a photography convention.

© Kenny Kim

learn to listen. Also, just be yourself. It's one thing to work a convention and make sure people know who you are, but if you're simply relaxed and being yourself, people will *want* to get to know you. Your goal is to meet new people, get familiar with the latest products, and pick up on new ways to make your imagery even better. Once you've started attending conventions and shows, the next step is to get involved in the industry. Move away from the sidelines and step in to take part in the convention.

Being involved means not just participating but also supporting your peers. When you support other photographers, you create a network of people who essentially watch one another's backs. A few years ago I had some health problems and couldn't teach a class for which I was scheduled. Three of the most recognized

wedding photographers in the country offered to help teach the class for me—Cliff Mautner and Bambi Cantrell taught the class while Denis Reggie coordinated and paid all the expenses. This is about going beyond the traditional definition of networking: It's about building relationships and trust. It's about being as true to yourself as you are to your friends.

The next ingredient that goes into networking is quality. Start by evaluating your business. Make a list of every manufacturer who makes a product you use or wish you had. Write down everything from printer, to paper, camera, tripod, strobe, and even neck strap. Also make a list of the services you're using. Are you outsourcing and working with a terrific lab? Is there a lab you haven't used but have heard a lot about? What about online hosting? Who built your website, and do you need a new or improved one? This list now becomes the core of the manufacturer's network you want to start building and a vital part of attending any trade show. Your goal should be to meet a few staff members from each manufacturer that creates the tools you'll use to build your business.

Let's do one more list: Who are the photographers you most respect? Whose work and philosophy has had the biggest impact on your style? Who are the photographic icons you hear the most about from your peers? These photographers should make up your hit list every time you attend a workshop or a convention. Find a moment at every show to simply introduce yourself and let them know you admire their work; then follow up a week later with a very short e-mail. I can't think of one industry icon who isn't approachable if you see him or her at a convention. There are great stories out there about people who called Ansel Adams's studio and didn't realize they were actually talking to Ansel.

© Kenny Kim

Thanks to the Internet, the world has become a much smaller place. You have access to virtually every photographer in the world, right from your keyboard. Facebook, MySpace, LinkedIn, and dozens of other websites offer photographers the opportunity to exchange ideas, images, and support through the daily technical and business challenges everyone faces. Getting to know people in this industry isn't always a matter of chance exposure. Instead, it's about making a point to be in the right place at the right time and repeating that scenario again and again.

Last but not least, what does your work look like? What are people saying

Joe addressing packed crowds during a 13-city speaking tour.

© Kenny Kim

about you and your portfolio? Would you hire yourself? So much about successful networking depends on who you are and whether people want to include you in their network. Networking relies on good solid business principles relating to trust, communication, and follow-up.

But nothing will happen if you don't get out into the market. Nothing will happen if you use the economy or cost as an excuse to not attend a convention. In short, you can't build your reputation or your business by sitting on the sidelines.

CHAPTER 11 *What Not to Do:* Learning from My Mistakes

Every photographer will share his or her success stories, but people rarely talk about their mistakes, as I intend to do in this chapter. Photography is an art form, not a science; thus, so much of the way I photograph today is thanks to learning from challenges faced years ago and the resultant need to experiment.

First, let's look at my background. Like so many of today's photographers, I entered the field relatively late in life—not until 1995, when I was forty-four years old. At that point, I already had a couple of other careers under my belt: I had been vice president at a record company and a graduate student working toward a PhD in psychology. I had held a few miscellaneous part-time jobs along the way, one of them in a photo lab. There really wasn't much in my background related directly to photography except a love of the psychological aspects of human behavior.

What drew me to photography was my love of working with people. I appreciate the human experience and believed there were few things more personal—and that would allow me to better express myself as an artist—than photographing a wedding. So the first mistake of mine to learn from is to follow your dreams *when* you start having them, whatever they are. I love this industry so much that I wish I had started earlier in life. At the same time, for those of you out there like me, it's never too late!

Weddings are in the details, and the more details you capture, the more memorable the story. The checkerboard pattern of these place cards, punctuated by a decorative paper butterfly, casts a unique perspective on what could otherwise be a potentially uninspired photo. The more you practice and learn, the more you fine-tune your own perspective.

Canon 5D, 16–35mm F2.8 lens, *f*/5.6 at 1/60 sec.

In the beginning, I was hungry for work and took every job that came through the door. Often I was working with a shot list, which is what the client required. I was taking mostly boring, posed images. I hated it! I now know that If you want to be the best you can be, you have to do what you love the most. I was just starting out and needed the cash, so I thought, how could I refuse possible clients? What I didn't realize is that if I had positioned myself better, people would have hired me because they liked what I was creating. I thought people wanted to see mainly posed work, so that is what I showed them. And when I got hired, they hired me on the basis of what they saw in my portfolio. As a result, they requested more and more posed work. It was a vicious circle. It finally occurred to me that if I showed the images I loved the most to the right clients, that would be what they'd expect me to shoot. All I had to do was change the way I presented my work. I mean, you go to Baskin-Robbins expecting thirty-one flavors of ice cream, not a burger and fries, right? So I started showing people my fine-art work and images with more emotion and a photojournalistic flair, and that's what they started asking for in their own wedding photos. After a few months, that was all I was shooting.

"Be honest and true to yourself. Don't try and make your work into something it's not just to get a job. Show the work you love to do, and get hired because of that work. Only then will you be free to produce images you (and others) love."

Interestingly, all those formal portraits I had taken early in my career gave me a solid foundation for understanding lighting, posing, and composition. It doesn't matter what kind of wedding photographer you want to be; sooner or later you're going to have to shoot some traditional poses—at least I knew how to get them done the right way.

The guests had just been seated, and the flower girl decided to check out the scene before taking her walk down the aisle. It was a wonderful moment to see this tiny, ethereal creature juxtaposed against the depth and grandiosity of the church. The signage in the foreground added visual interest.

Canon 5D, 14mm F2.8 lens, f/2.8 at 1/30 sec.

Another thing I would have done differently, at least initially, is to spend less money on equipment. When I first started, I went far into debt buying equipment. If I had it to do over again, I don't think I would have opted for top-shelf products right away. I could have started with less equipment instead of throwing all my money at my gear before I really knew how to use it. I honestly thought that the equipment made the photographer. The truth is, the photographer, and his or her clients, make the photographer! I would have had a much easier first few years had I kept my overhead down and learned more about the equipment that was available *before* running out and buying everything I thought I needed.

So many options are available for photographers today when it comes to gear. For example, you can use rental gear. I never rented anything, which would have been such a great opportunity. I could have rented a lens I wanted to try and built the cost into the package. Then, once I learned how to use it and knew what the return on my investment would be, the timing would have been right for a purchase. I bought a tilt-shift lens that I used only twice. It simply took me too long to use. Had I just rented it, I could have saved the money and put it into another piece of equipment. My ego at the time just wouldn't let me have anything but the very best. Don't get me wrong—I would never compromise the quality of my work, but I could have started with a couple really good lenses and ramped up gradually.

Here's another tip: When I started as a wedding photographer, I was working three part-time jobs, including one at a photo lab. I cannot overstress the added benefit of having lab experience in one's background. I learned all about printing and the importance of building relationships with the people who print my work. Although I do very little of my own printing nowadays, it wouldn't be any different if all my work was manipulated on the computer and then printed in the studio. I'd still build a relationship with whoever on my staff printed every image.

While transitioning from working three jobs, one of them in the lab, I was

Here's one take on a formal portrait: I asked the bride to stand near a window in front of an exquisite arrangement of orchids. Shooting in lower light and using high ISO film offers greater depth of field, so I was able to tack in sharp on her eyes, leaving the orchids just slightly out of focus.

Canon 5D, 85 mm F1.2 lens, f/3.2 at 1/125 sec.

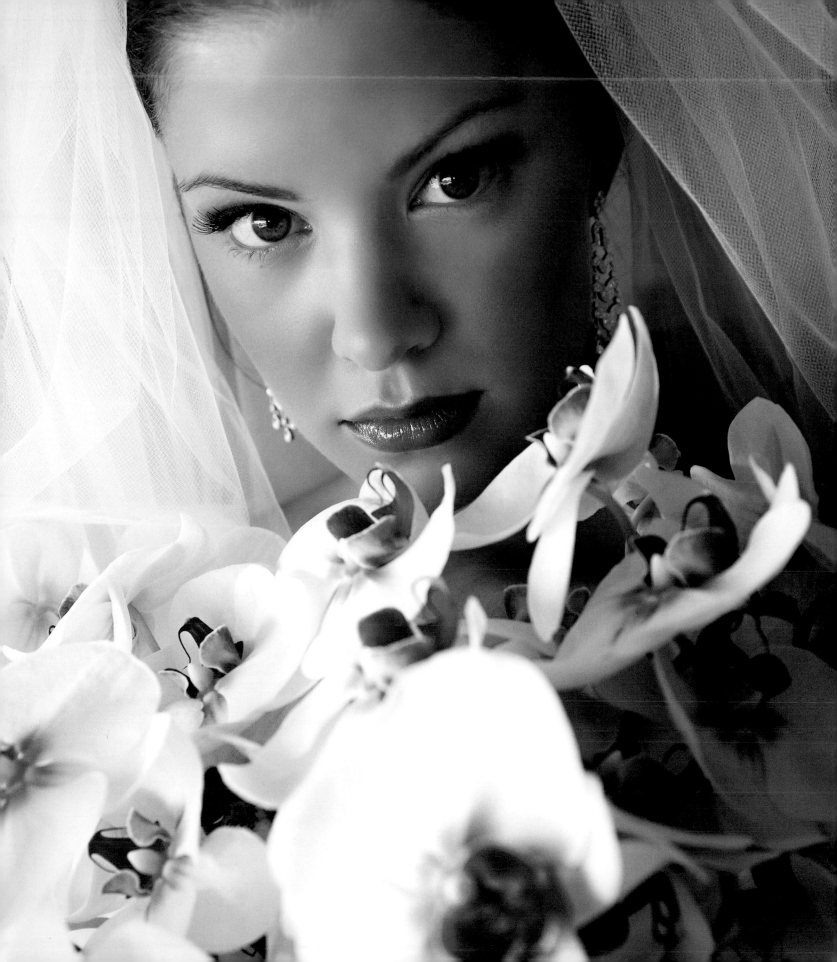

worried about getting enough work and afraid of charging too much for my services. So I started out charging $700 for a wedding. I soon realized that, on an hourly basis, the baker got more for the wedding cake! I realized I was selling myself short when I noticed that I was booking every single job I pitched. There wasn't one client who turned me down. Why? Because I was so cheap. If you're closing on every single pitch, your prices are frankly too low. It took me a solid year of starving before I realized I needed to raise my prices. I went up to $1,500, and for a few months business really dropped off—so many referrals were from brides who'd been ecstatic that I shot their wedding for such a modest fee. A year later, I was booking twice as many weddings at $1,500. The third year, I raised my prices to $3,000 and did twice as many as I had at $1,500. The bottom line to all of this I attribute to my good friend Denis Reggie, who for years has said, "Don't price yourself based on what you can afford. It was years before I could afford myself!"

My business today is fee-based, which some photographers would say is a mistake (I do not include the album in my coverage). For one flat fee, my clients get a set of paper proofs after the wedding, which they keep. They typically come back for their album a year later, and we discuss album pricing then. This doesn't work for everybody, but you have to remember my niche: I like being paid to shoot. I like to cover an event and walk away with the job complete, which is very different from photographers who include albums in their coverage. My clients typically come back and buy two albums. Very rarely do I garner any add-on sales for extra, smaller family albums. There are those who tell me that I'm missing out on additional sales, but "to thine own self be true." I love to shoot, to document the human experience, to get to know my clients, and have them know they can trust me—it's that simple. So this system works for me.

Earlier I touched on the importance of knowing how to create a portrait, even if it is one's least favorite assignment. After the first few years in the business, I had developed a strong, almost purely photojournalist look to my work, and that's

what I looked for in my clients' taste. But there are pitfalls to this approach. Learn to remember who your client really is, and don't listen to everything they tell you. Inevitably, even though the bride, for example, will tell you she doesn't want any posed images, somebody else (typically her mother) does want them. I shot a wedding once and did exactly what the bride told me: not one portrait from the entire wedding. All was fine until the mother, who was paying me, came back and asked, "Where are the portraits?" So, get to know your clients—all of them—not just the bride and groom, but especially whoever is paying the bills.

Today, no matter what a bride asks for, I'll convince her to sit for a couple of quick portraits, because—I don't care what anybody else says—weddings are still about tradition. Don't get so caught up in trends that you fail to see the message behind what you're selling, which is your ability to document a one-time event and be the eyes, and sometimes the heart, of a couple in love.

Last but not least, learn to manage your time. I'm still spreading myself too thin. I'm still looking back and wishing I'd turned down a job, just to have a slower pace in my life, and at times I've paid the price. You simply cannot be in two places at once. You can't travel all over the world and not have something slip through the cracks sooner or later.

It's crucial to pay more attention to your family! Ironically, a good solid marriage is a challenge when you're a wedding photographer, especially if your spouse isn't in the business. Being a wedding photographer and working every weekend is not exactly conducive to stable married life. When your spouse is home with the kids, you're viewed as out having a good time, no matter how hard you're working at those weddings. We all get smarter as we get older, and compared with years ago, today I'm a rocket scientist. Now, when I'm not shooting, I spend almost all my time with my family, often at the expense of spending time with friends. If I'm away from home, then I'm working, but if I'm home—I'm giving it my full attention. My wife, Marilyn, came out of the fine-art side of our industry, so it helps having her involved

Joe, son Sebastien, and wife, Marilyn.

© Kenny Kim

in certain aspects of my business. At the very least, she understands the pressure of a wedding, working with clients, and the importance of meeting their expectations.

Having said all that, don't let your business run your life—don't let the tail wag the dog. I know it sounds almost trite, but if you get to the point where you're working so hard that your personal life has evaporated, what good is it? We work to have the financial means to enjoy life, and if we can relish what we do and get paid for it at the same time, how great is that? But if you're working so hard and putting in so many hours that you can't take time to enjoy your family and friends, there's something wrong in your approach. There have been times when I've canceled a vacation because a big job came through. Looking back on it, it was a huge mistake. You need time to yourself, with your family and friends, and away from business. It helps you to keep a fresh outlook. I've finished some big jobs and then rolled right into the next one, knowing how badly I needed a vacation and a break, but by then it was too late, and the damage had already been done. There is no career field I'd rather be in than photography and no business I could love more. Even so, my business isn't who I am.

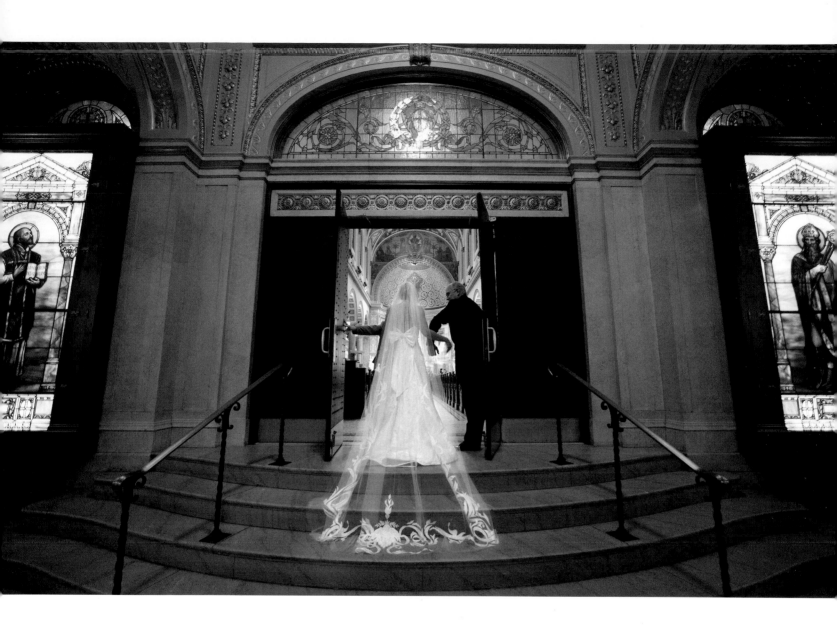

If you're not happy with what you're doing, don't be afraid to change it. If you don't like the look and feel of your portfolio, get out for a week, go to the annual WPPI convention, take a few workshops, and recharge your batteries. Photography is one of the most creative vocations on the planet, but your inspiration is totally dependent on having the heart and the passion for working with people and documenting the human experience.

It's very moving to photograph Dad walking his daughter down the aisle from this perspective. This portion of the ceremony is often shot from the first pew, at the front of the church, but I'm always looking for a different angle or perspective.

Canon 1v, 14mm F2.8 lens, f/3.2 at 1/15 sec.

INDEX